@LARGE

@LARGE
AI WEIWEI
ON ALCATRAZ

Edited by David Spalding

CHRONICLE BOOKS

SAN FRANCISCO

Published in association with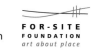

**FOR-SITE
FOUNDATION**
art about place

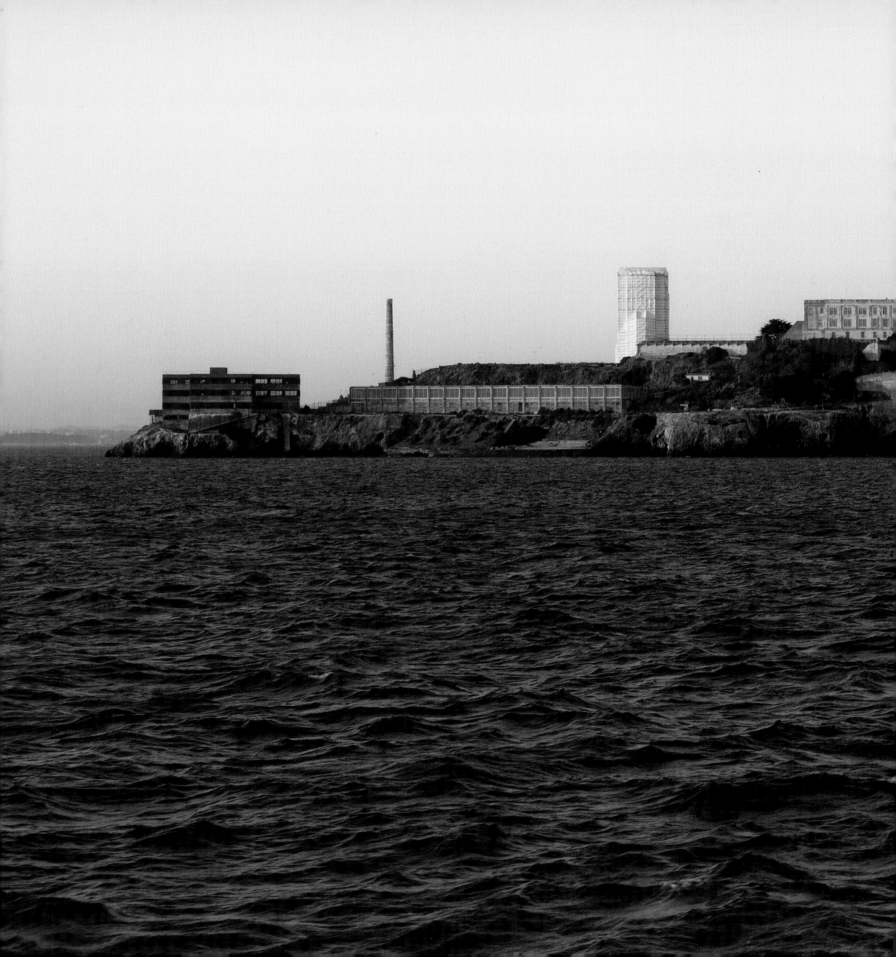

Contents

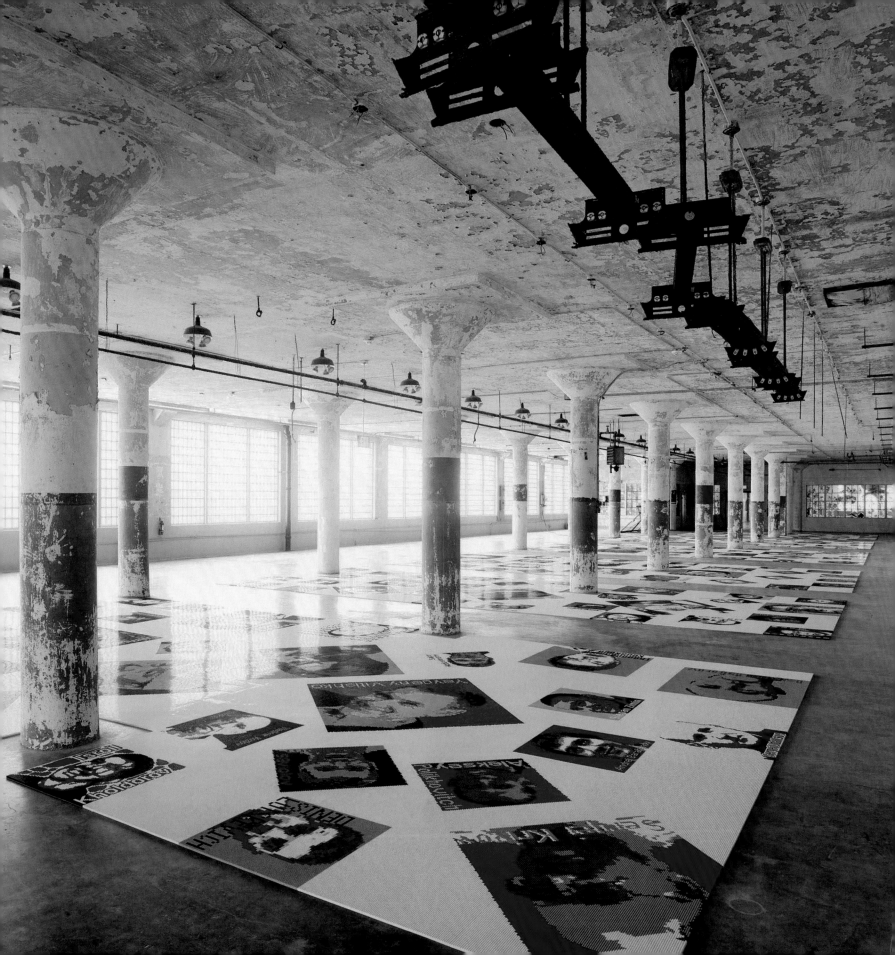

Preface

Frank Dean and Greg Moore

The first Ai Weiwei piece to appear in the Golden Gate National Parks was installed as part of *Presidio Habitats*—a yearlong art exhibition (May 2010–May 2011) organized by the FOR-SITE Foundation showcasing the work of artists and designers who conceived of homes for their animal "clients." Ai's project—for Western screech owls—consisted of classical blue-and-white porcelain forms evoking Chinese garden stools, each with an aperture to admit the feathered tenants. Hung from Presidio trees, the elegant ornamental vessels were a stark contrast to the rough, rustic backdrop of bark and coniferous boughs.

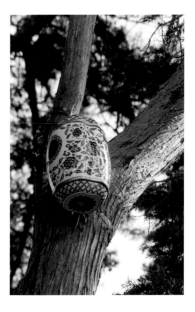

At first blush, *@Large: Ai Weiwei on Alcatraz*, a major exhibition that pairs a politically charged Chinese contemporary artist with a landmark American national park, seems just as incongruous. Ai, a superstar in the international art world who helped design the "Bird's Nest" stadium for the 2008 Beijing Olympics, is currently forbidden by the authorities to leave China. Alcatraz—over the years the site of a Civil War–era fortress, a military prison, a notorious federal penitentiary, and a momentous Native American rights protest—is now a popular national park site and refuge for waterbirds. But it is exactly the pairing's intrinsic conditions of contradiction that bring the two parts together—and make for the possibility of soul-stirring art.

Here in the Golden Gate National Parks, we have already seen memorable examples of such creative expression in a naturally rich and evocative setting. The aforementioned *Presidio Habitats*—a partnership between the Presidio Trust and the FOR-SITE Foundation—was one of the first major attempts to bring groundbreaking art to our parks. FOR-SITE, instrumental in bringing Andy Goldsworthy's art to the Presidio, also partnered with the Golden Gate National Parks Conservancy and the National Park Service (NPS) on *International Orange*, an exhibition at Fort Point of site-specific installations responding to the Golden Gate Bridge and celebrating the span's seventy-fifth anniversary. Fort Point, a National Historic Site, was also transformed into a stage for immersive theater in 2008 and 2013, when the company We Players presented an innovative *Macbeth* amid the fortress's brick columns, arches, and ramparts.

These artistic endeavors—along with Jeannene Przyblyski's multimedia tours of the Presidio and Lands End, and the yearlong *Mark di Suvero at Crissy Field* exhibition in partnership with the San Francisco Museum of Modern Art—all stand as early successes for our nascent Art in the Parks program. This collaboration of the NPS, Parks Conservancy, and Presidio Trust, alongside community arts organizations such as the FOR-SITE Foundation, encourages both emerging and established artists to create place-based artworks that illuminate the natural and historic resources of the national park in fresh and compelling ways.

Art has always been integral to the genesis—and success—of America's national parks. From the Hudson River painters to Ansel Adams and Chiura Obata, artists have produced works that helped romanticize, popularize, and ultimately protect the majestic landscapes that would become our national parks. Their legacy lives on today in the more than fifty artist-in-residence programs at parks across the NPS system (at Golden Gate, the program is offered by the nonprofit Headlands Center for the Arts).

While much of the art produced in these programs extols the abundant beauty of nature, *@Large*—our most recent Art in the Parks endeavor—invites visitors to examine some of the more provocative and harder

opposite: Ai Weiwei, *Trace*, 2014 (detail); installation: LEGO plastic bricks; part of *@Large: Ai Weiwei on Alcatraz*, Alcatraz Island, 2014–2015

above: Ai Weiwei, *Western Screech Owl Habitats*, 2010 (detail); part of *Presidio Habitats*, San Francisco, 2010–2011

edges of society: the implications of incarceration and the possibilities of creative expression as an act of conscience. Alcatraz, of course, was home to an infamous federal prison that counted among its inmates Al Capone, "Machine Gun" Kelly, Robert "The Birdman" Stroud, and other criminals who have achieved quasi-celebrity status. And Ai, although renowned in the art community and recognized among human rights activists for his civil disobedience, was imprisoned in 2011 for purported crimes.

Ai's personal experiences while detained by the Chinese government underpin *@Large: Ai Weiwei on Alcatraz*, the first art exhibition of its caliber and scale to be presented on the famed island. Developed specifically for the old buildings of the federal prison, Ai's art bolsters and supplements the interpretive story of this challenging, multilayered national park site—confinement and liberty, repression and release, despair and hope—and the role and responsibility of the individual to drive social change. To these fundamental themes, *@Large* lends additional depth and dimension, exploring the cost of, and right to, individual and creative freedoms, and the uses of art and incarceration in acts of political defiance and assertion.

Indeed, *@Large* presents an opportunity to shine a light on darker aspects of Alcatraz's complex history and share lesser-known sides of Alcatraz with the more than 500,000 people expected to see the exhibition. For example, during the military prison epoch of the island (1857–1933), a variety of political prisoners were held on Alcatraz, including communists, anarchists, conscientious objectors to World War I (e.g., Quakers and Hutterites), and Hopi Indians who refused to send their children to government boarding schools.

As you explore parts of the island usually off-limits to the public but open during the run of the *@Large* exhibition (such as the Hospital and New Industries Building), take a moment to reflect on those prisoners who have been hidden in the shadows of history, who have not been glamorized by Hollywood or pop culture, and who had their freedoms revoked for beliefs contrary to the political climate of the era.

In this meeting of iconoclastic international artist with iconic national park, it is ironic and appropriate that Ai is creating art for a place once renowned for its inescapability—while he himself cannot escape the confines of his homeland. But it is precisely this singular perspective, like that of a screech owl peering through the door of his strange house of fine porcelain, that gives Ai's work such power and resonance on the Rock.

We hope you, through this unique experience of world-class art in a world-class park, discover an equally eye-opening new worldview.

Frank Dean
General Superintendent, Golden Gate National Recreation Area (NPS)

Greg Moore
President & CEO, Golden Gate National Parks Conservancy

June 1, 2014

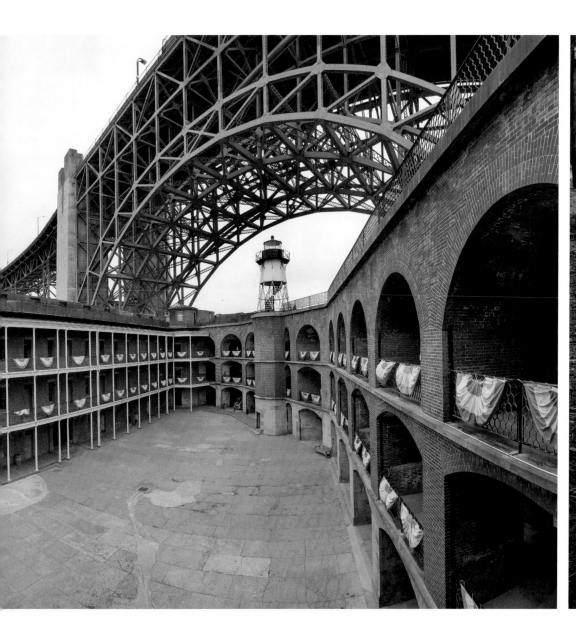

above, left: Allison Smith, *Fort Point Bunting*, 2012 (installation view); part
of *International Orange*, San Francisco, 2012

above, right: Andy Goldsworthy, *Wood Line*, 2011 (detail); San Francisco Presidio

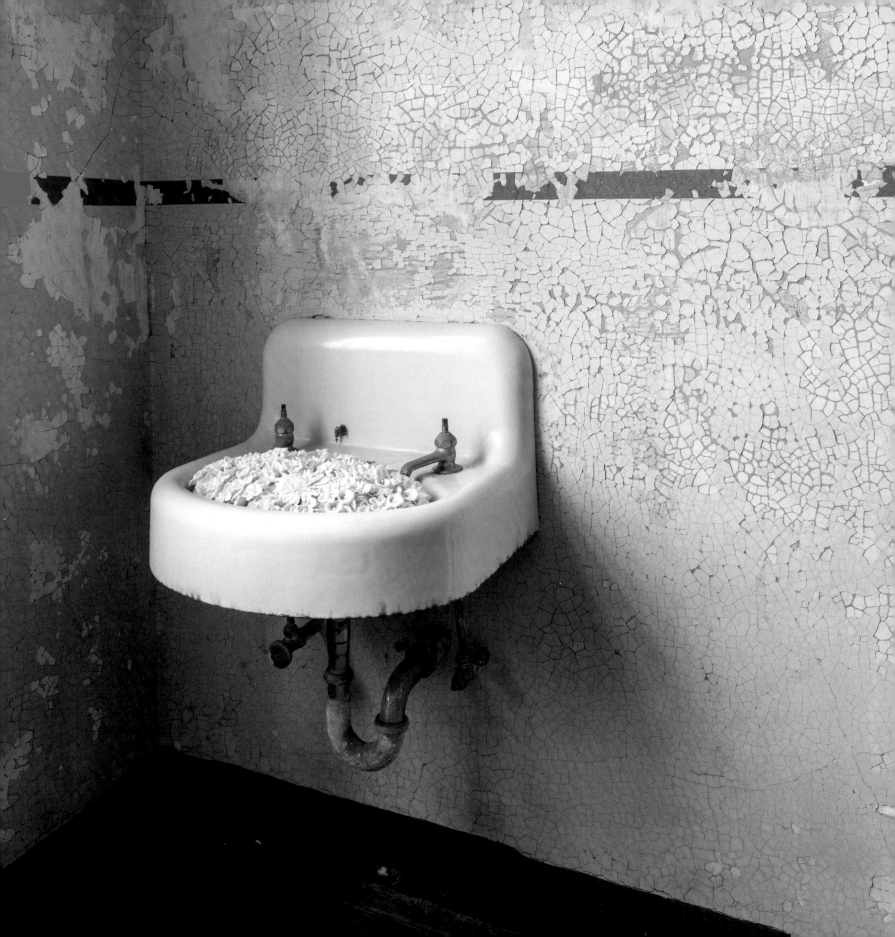

Introduction

Cheryl Haines
Founding Executive Director, FOR-SITE Foundation

Celebrating its ten-year anniversary in 2014, the FOR-SITE Foundation is dedicated to the creation, presentation, and understanding of art about place. Our exhibitions and commissions, artist residencies, and education programs are based on the belief that art can inspire fresh thinking and important dialogues about our natural and cultural environments. Through our collaborative partnerships, FOR-SITE has broken new ground and forged a model for engaging audiences by inviting artists to make site-specific works on national park land throughout San Francisco.

FOR-SITE began working with Ai Weiwei in 2009, first in the context of an exhibition titled *Presidio Habitats*, which took place in San Francisco's Presidio, a 1,491-acre national park site and former army post with sweeping coastal vistas and a rich history spanning more than two hundred years. For this exhibition, we invited an international cast of architects, artists, and designers to create site-specific works that addressed the animal life in the park. Ai Weiwei chose to design a home for the Western screech owl. Through the addition of a strategically placed aperture, the artist encouraged this small owl to inhabit what appeared to be a hybrid of a traditional Chinese garden stool and a blue-and-white porcelain vessel from the Ming Dynasty. These elegant and purposefully ornamental habitats hung together in a community of forms high up in the branches of a Monterey cypress tree, evoking a range of associations, including the Presidio's Pacific Rim orientation, San Francisco's Chinese heritage, and the transmission and transformation of culture through trade.

Next, FOR-SITE organized *International Orange* (2012), a large exhibition of site-sensitive commissions occasioned by the seventy-fifth anniversary of the Golden Gate Bridge. This exhibition, named for the unique paint color of the span, took place inside Fort Point, one of the few Third System forts on the West Coast, located at the south anchorage of the bridge. While the exhibition was being installed, I would often take a moment and go to the roof of the fort and consider the environment further, and my eyes would rest on the island of Alcatraz. I couldn't help but think how remarkable it would be to enliven this island site with a new conversation, one not only about detainment but also addressing the layered and complex historical legacy of the island.

Alcatraz, one of the most visited sites in America's national park system, hosts 1.4 million visitors a year. While its notoriety is associated primarily with its years as a federal penitentiary, as I studied the site more deeply, I realized that the island's story was much richer than I imagined, including not only the Native American occupation (1969–1971) but also the Civil War–era political prisoners and conscientious objectors to World War I who were once incarcerated there. As my research developed, I was captivated by the richness of the island's history and the possibility of making it visible to audiences through a curatorial intervention.

In 2011, artist and activist Ai Weiwei was detained (and feared "disappeared") by the Chinese government for eighty-one days due to his outspoken stance regarding the human rights abuses that have occurred there. Not long after his release, I went to visit him in Beijing. I asked the artist what small thing could I do to assist him after this experience. He said that he hoped that I could bring his ideas and art to a broader audience. I had been asking myself what kind of artist would be well suited to create work on Alcatraz. At that moment, I suddenly realized that this artist was the answer. Here was a remarkable opportunity to

opposite: Ai Weiwei, *Blossom*, 2014 (detail); installation: porcelain, hospital fixtures (sinks, toilets, bathtubs); part of *@Large: Ai Weiwei on Alcatraz*, Alcatraz Island, 2014–2015

engage someone who lived through the Cultural Revolution—a time when his father, the renowned poet Ai Qing, suffered terribly for his artistic stance; an artist who is not only an outspoken human rights activist but someone who has personally experienced being detained for his beliefs. I asked, "What if I brought you a prison?" His immediate response was, "I would like that." Thus began our discussions about this exhibition.

Convinced by the artist's initial response that there was tremendous potential in this conversation, I immediately approached the National Park Service (NPS) and its local partner here, the Golden Gate National Parks Conservancy, with the idea that this project could be an opportunity both to tell the Alcatraz story in a different light, appealing to many international visitors with greater themes, and to attract local visitorship, which is much less than one might imagine. Our partners at the Conservancy and the NPS were at once struck by the opportunities this project presented and were very creative and positive in their responses.

Working on this exhibition has been a great gift, enabling me to connect more deeply with the history of Alcatraz with the help of research assistants and historians who have added to my understanding of a site I've long found fascinating. But more important, I have learned a great deal about the current state of affairs regarding international human rights and freedom of expression and have become more aware of the many places where basic civil liberties are compromised.

Sadly, the freedom to express one's beliefs without fear of recrimination is far from universal. The exhibition draws parallels between prisoners and "free" citizens living under the authority of a repressive government. In both cases, communication is often restrained in order to control the populace. The works in *@Large* address these concerns eloquently with materials and methods that Ai Weiwei has not used in the past. In fact, the artist seized this chance to address new subjects, to broaden his field of vision beyond China, and to consider other countries with disturbing human rights records. The result is seven new installations commissioned specifically for this exhibition.

Of course, such broad ideas about human rights and freedom of expression are most effectively animated when considered with respect to individual lives. One of the most moving artworks in *@Large* is *Trace*, an installation comprising nearly 180 portraits of prisoners of conscience from around the world, all made from LEGO building blocks. The faces and names that appear in these portraits were selected with great care and with the inspired guidance of Amnesty International. The individuals identified here are from thirty-one countries around the globe. Many of them are serving lengthy prison sentences for merely voicing beliefs that are in conflict with their government's positions. They present a human face through which the basic tenets of this exhibition are presented, calling our attention to pressing societal and political issues. The portraits are laid out on the floor of the New Industries Building, a location where prisoners once worked at tasks such as washing the clothing from military bases throughout the Bay Area. While they worked, the prisoners were carefully observed by guards standing above on a highly protected walkway. These portraits are meant to be seen individually by viewers as they walk among them, as well as from the elevated position of the "gun gallery," where they become a sea of lost faces, overwhelming in their expanse.

One of the things that made it possible for me to organize *@Large* with an artist who cannot travel abroad—collaborating through countless online exchanges—has been the fact that the artist has an innate understanding of architectural space. Ai Weiwei has become all too experienced at working remotely over the past three years, and during this time he has realized several substantial exhibitions abroad while remaining unable to travel outside China. Whether despite of or because of these limitations, Ai Weiwei is extremely skilled at understanding space and locating opportunities for activation.

Stay Tuned is another artwork I hope will evoke a visceral, empathic response from the viewer. Located in A Block, which is in the main cellhouse and dates from when Alcatraz was a military prison, this audio installation activates twelve cells with inspiring oration and music made by people who have been detained for the creative expression of their beliefs. The voices speak from a variety of cultural vantages and native languages, including Czech, Farsi, Russian, and Spanish, creating in each cell a different immersive sound environment. Upon entering a cell and sitting before a mirror, the visitor is invited to spend some time listening and reflecting on the responsibility we all bear to demand fundamental human rights for those who have been silenced.

Communication is a key theme in the exhibition—both interpersonal communication as a basic human necessity and the role of communication in organizing social change. The choice of A Block for *Stay*

above: Main cellhouse

Tuned came from considering how prisoners in Alcatraz were prevented from communicating with one another. In fact, from 1934 to 1937, Alcatraz was a "silent" prison, a particularly cruel penal experiment that forbade all speech and reportedly drove some prisoners insane. Documented are instances in which prisoners tried desperately to communicate through the pipes or by leaving notes inside library books. These stories, and Ai Weiwei's own experience during incarceration, inspired both *Stay Tuned* and one of the most interactive pieces in the exhibition, *Yours Truly*. As the artist told me in one of our numerous conversations, "The most terrible thing about jail is not the treatment you receive but the isolation." Located in the Dining Hall—one of the few places where the prisoners could actually interact and communicate with one another—*Yours Truly* invites visitors to take repose at tables and benches, where they have the opportunity to send postcards to prisoners of conscience who are currently incarcerated throughout the world. The postcards depict the national (or widely recognized) birds and flowers from nations with poor human rights records. Visitors are encouraged to offer these prisoners words of hope, to share their thoughts about their experiences of the exhibition and the island, and to let them know that they and their struggles are not forgotten.

On many levels, this is an unprecedented project, with challenges that have ranged from an artist who is creating the work from afar to a highly complex visitor environment. None of it could have been possible without a truly inspirational and visionary artist and the remarkable team assembled by the FOR-SITE Foundation—incredibly skilled people working at the top of their various fields: Marnie Burke de Guzman, special projects director; Jackie von Treskow, program director; Alison Konecki, development and outreach associate; Jennifer Burke, visual design; Juliet Clark, writer and editor; Jan Stürmann, video production; Ari Salomon, web developer; and publications editor David Spalding. I'm also deeply grateful for the visionary leadership of the Golden Gate National Recreation Area/National Park Service—particularly Frank Dean, general superintendent, and Alcatraz site supervisor Marcus Koenen—as well as our partners at the Golden Gate National Parks Conservancy: Greg Moore, president and CEO; Kate Bickert, director of park initiatives and stewardship; Nicholette Phelps, vice-president, visitor programs and services; and Robert Lieber, vice-president, interpretive sales. I would also like to express my gratitude to our patrons, whose incredible generosity has enabled FOR-SITE to realize this exhibition: lead donors Roger Evans and Aey Phanachet and the Fisher Family, with significant support from Drusie and Jim Davis, the Horace W. Goldsmith Foundation, Mimi Haas, Outset USA, and Wendy and Eric Schmidt. Finally, it has been a great privilege and honor to be able to address these concerns with such caring and creative partners: we salute the work of Human Rights Watch and extend our thanks to Amnesty International for vetting our prisoners of conscience research with great care and exactitude.

I can only hope that visitors viewing this exhibition will be brought to consider the following questions: What are basic human rights? What constitutes freedom? What role does communication play in the creation of a just society? What can we do to ensure that we will be heard? And what is our individual responsibility to ensure freedom for one another around the globe? If just a handful of visitors begin to think differently about the concept of freedom or feel newly compelled to engage in or support social activism, *@Large* will have been a great success.

opposite: Ai Weiwei with FOR-SITE Executive Director Cheryl Haines outside the artist's Beijing studio, spring 2014

Artist's Statement

Ai Weiwei

The first word that comes to mind in relation to this project is FREEDOM. As an artist, I live in a society where freedom is incredibly precious. We strive for it daily and put forth a great amount of effort, sometimes sacrificing everything to protect this value, to insist on freedom. Freedom for me is not a fixed condition but a constant struggle. I think it is very important for artists to focus on the freedom of expression, a value essential for any creative endeavor.

Writers, poets, and artists of my father's generation could not liberally express their ideas without losing their freedom. They were punished for having different ideals, different attitudes, and different characters, and the punishment could be losing their life. My father was jailed and placed in exile, and I grew up in a remote and impoverished area where my family was sent as a result of forced relocation.

In 2011, I was detained by the Chinese government in an almost hostage-like situation, and since my release I have been held in what some would call a "soft" detention. The government has never formally charged me, but in China my name has been censored on the Internet, in the media, and even in exhibitions featuring my own work. Even after sixty-five years of rule, the government has never recognized the rights of the people. We cannot vote, and we have no independent judicial system or independent media apart from state control. *Freedom*, indeed, is a word that carries a great deal of weight for the Chinese people.

In *@Large*, we are presenting the likenesses or voices of almost two hundred political prisoners and prisoners of conscience who have very different stories and backgrounds. But these are all nonviolent people who have lost their freedom simply because they expressed their ideas, imprisoned for trying to improve their conditions through writing or peaceful protesting. Many of them might stay in jail for the rest of their lives or be forgotten by the general public, but in truth they are heroes of our time. They may be hidden in dark corners, in unknown places—their names are never spelled out proudly like those considered the founders of our civilizations. But while their work is less visible, it will never be less important. It is through their efforts that we can still live peacefully in a civilized society. This exhibition is an attempt to mark their names and their fight against oppression more visibly.

I have not been to Alcatraz, and I knew very little about the place before I was approached by the FOR-SITE Foundation to create *@Large*. Of course, I'd heard of it as a federal prison for the "worst of the worst," but since then I've also heard stories from people who have visited Alcatraz, and I was especially struck by events related to the Native Americans who once occupied the island to demand their rights to the land and to have their voices heard.

Creating this exhibition involved challenges on many levels. All of the works presented in *@Large* are new, site-specific works, and because I am still not allowed to leave China, we were forced to do the work without firsthand knowledge of the location, which would have been especially helpful in this case. Alcatraz is not a museum, and it was not easy to imagine how the works should be shaped and structured within the location's physical parameters. The spaces are, of course, restricted, so we had to make the work insertable and emphasize the historical nature of the site. This means that we have had to learn through the materials, the structure, the concept, the craftsmanship, and also through communication with our California base, including our partner and curator Cheryl Haines and the FOR-SITE Foundation. While some of these aspects have made the exhibition more difficult, they also relate to its message of restricted freedom, and I feel that they have only made the end product more meaningful. This is the first time Alcatraz Island has been given over to a contemporary artist to create an exhibition of this scale.

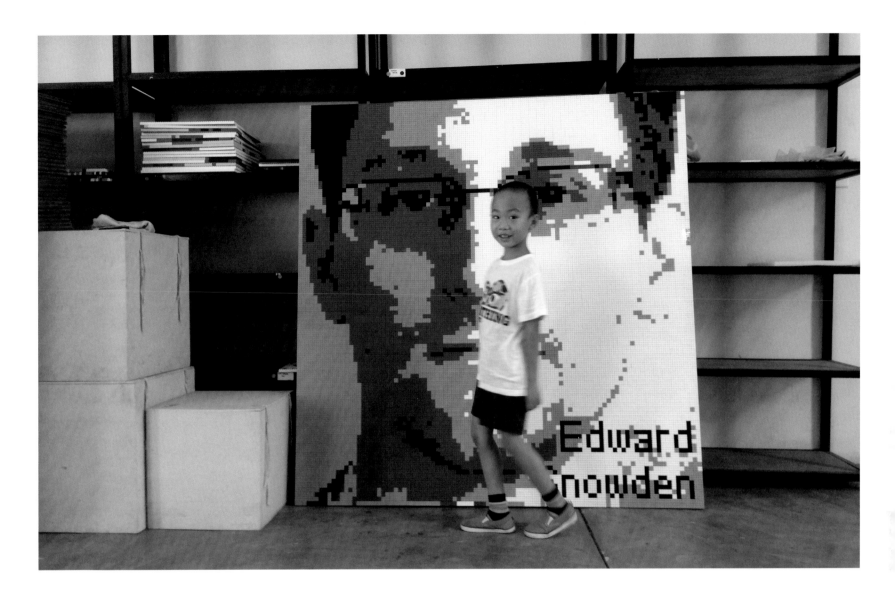

I hope *@Large* will help build understanding and awareness about our history and current conditions. Today the whole world is still struggling for freedom, and there is nothing ahead but more struggle; many of my friends are still in jail for utterly nonsensical reasons, and the power that put them there has no respect for the law. In such a situation, only art can reveal the deep inner voice of every individual with no concern for political borders, nationality, race, or religion. This exhibition could not come at a better time—though, when one is fighting for freedom, any time is the right time. Freedom is meant to be collectively protected and shared; you are protecting not only yourself but also others fighting for the same cause.

Any artist who isn't an activist is a dead artist. I try to make my works honestly with respect to my life, to reflect the place and time in which I live. I hope that when future generations see my work they will understand my struggle as an artist. I also hope that visitors to *@Large* will be conscious of artists' efforts to protect freedom of speech and expression, and that they gain an understanding of the purpose of art, which is the fight for freedom.

above: Ai Weiwei's son, Ai Lao, in front of a LEGO portrait
of Edward Snowden, artist's studio, Beijing, 2014

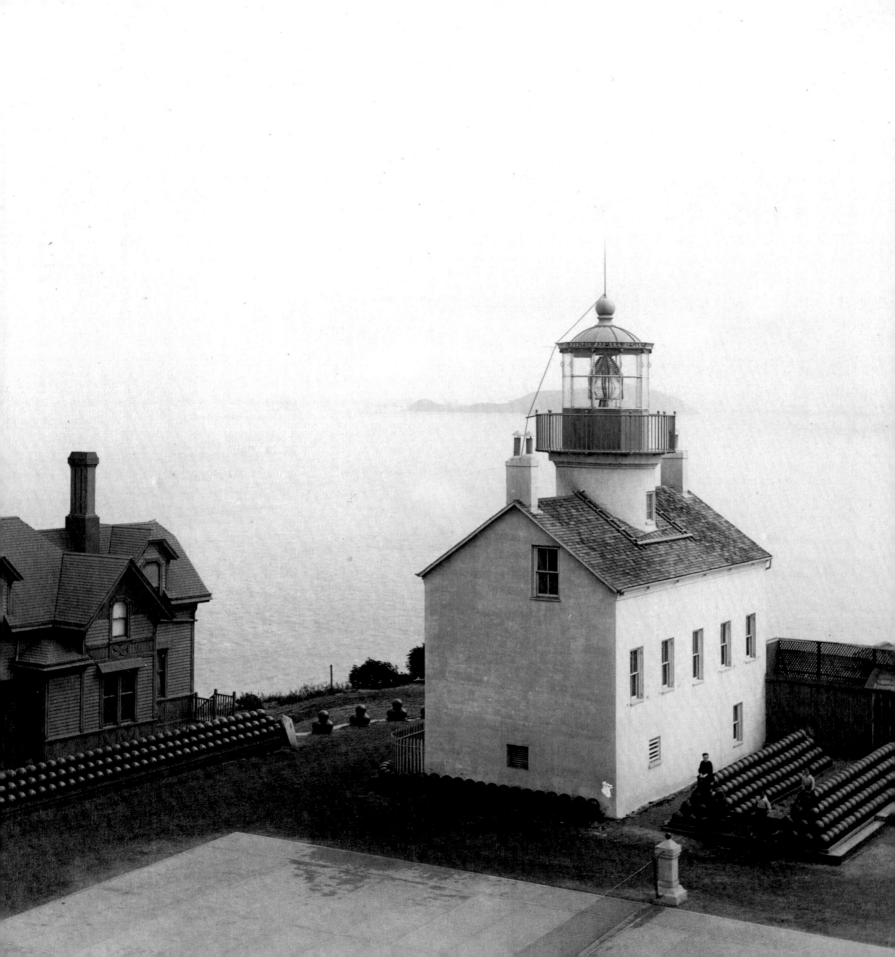

Alcatraz Timeline

1850 A joint army and navy commission recommends a Triangle of Defense to guard San Francisco Bay. President Millard Fillmore signs an Executive Order reserving lands around San Francisco Bay, including Alcatraz, for "public purposes."

1854 The Alcatraz Island Light Station begins service as the first lighthouse on the Pacific Coast.

1857 With the completion of the Guard House, the island serves as a military prison from 1857 to 1933.

1859 Capt. Joseph Stewart and 86 men of Company H, Third U.S. Artillery, take command of Alcatraz.

1863 The *J. M. Chapman*, a Confederate privateer, is seized and its crew arrested and imprisoned on Alcatraz. Lower Prison, a temporary wooden structure, is built. Soon, other prison structures are added on the island.

1865 Alcatraz troops are sent to San Francisco to preserve peace and prevent rioting after President Abraham Lincoln's assassination. Alcatraz cannons fire the official mourning for the dead president.

1870 Major George Mendell designs plans for earthwork defenses on Alcatraz.

1895 Nineteen members of the Hopi Tribe from Arizona are imprisoned on Alcatraz for resisting the policy of forced education of their children and land allotment programs contrary to their Native American beliefs.

1898 Spanish-American War results in prison overcrowding at Alcatraz.

1900 Upper Prison (Alcatraz's third prison) is built on the Parade Ground.

1907 Alcatraz is designated as the "Pacific Branch, U.S. Military Prison."

opposite: Alcatraz Island Light Station, c. 1890s

below, left: Hopi prisoners on Alcatraz Island, 1895

below, right: Military officers and their wives in the dock area, 1902

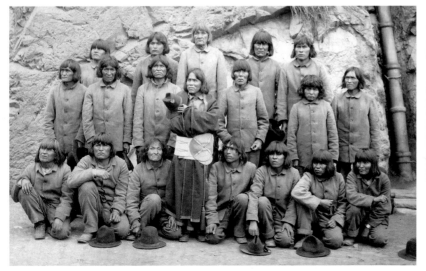

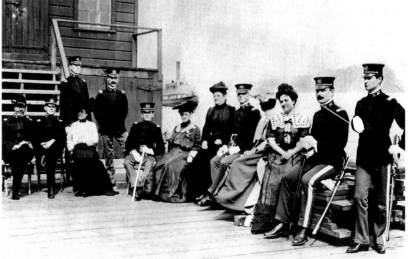

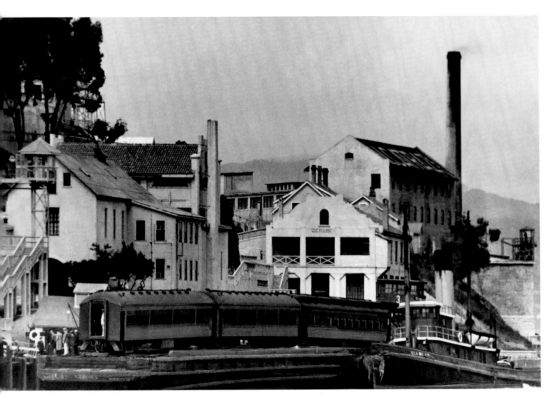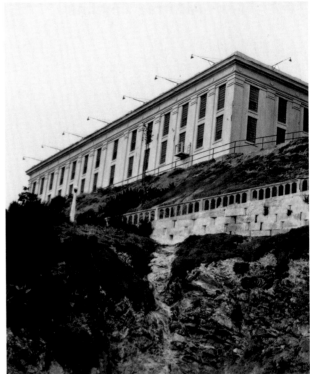

1912 The new Cellhouse (Alcatraz's fourth prison), built with convict labor, is completed and prisoners move in. At the time, the Alcatraz Cellhouse was the largest concrete structure in the world.

1915 Alcatraz is renamed "Pacific Branch, U.S. Disciplinary Barracks."

1933 Alcatraz is transferred to the Federal Bureau of Prisons; thirty-two "hard-case" military prisoners remain on the island as the former military detention center becomes America's first maximum-security civilian penitentiary. This "prison system's prison" was specifically designed to house the troublemakers that other federal prisons could not successfully detain.

1934 Alcatraz begins its era as the nation's toughest and most feared federal penitentiary, housing the "worst of the worst" American criminals, among them Al Capone, George "Machine Gun" Kelly, and Robert "The Birdman" Stroud. Prisoners arrived on Alcatraz in handcuffs and ankle shackles. Daily life on Alcatraz was harsh, and prisoners were given only four rights: medical attention, shelter, food, and clothing; recreational activities and family visits had to be earned through hard work. Punishments for bad behavior included hard labor, lock-downs in solitary confinement, and restriction to bread and water. A total of fourteen escape attempts were made by thirty-four prisoners during Alcatraz's twenty-nine years as a federal penitentiary.

above, left: Armored train cars carrying inmates, including Al Capone, arrive on August 22, 1934

above, right: Prison building, west side

opposite: View of Alcatraz, 1902

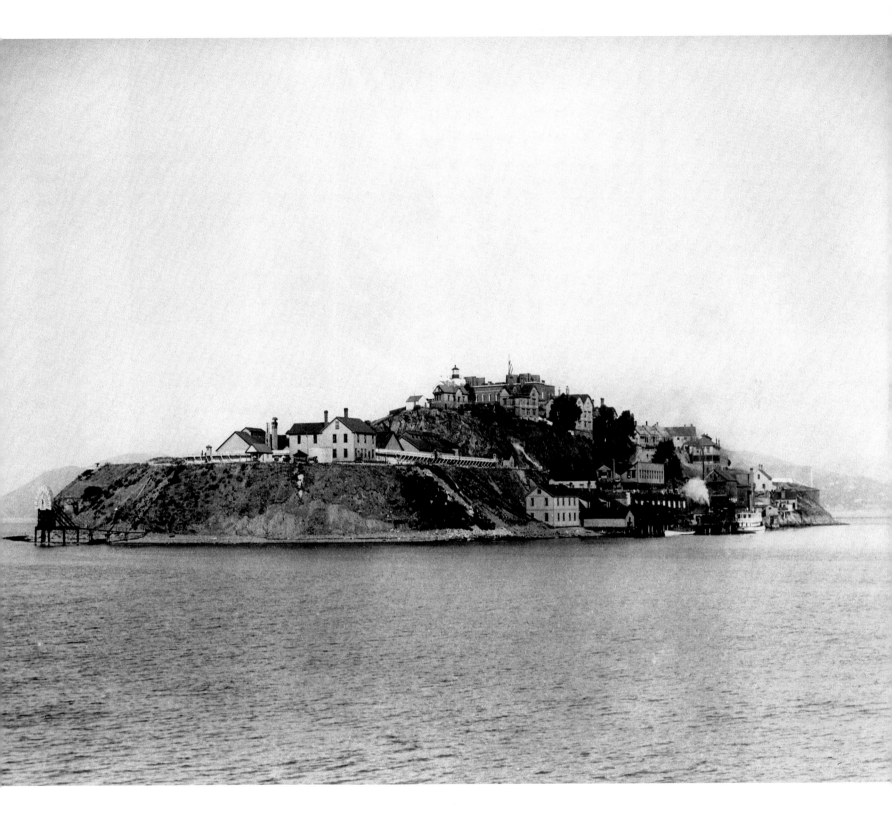

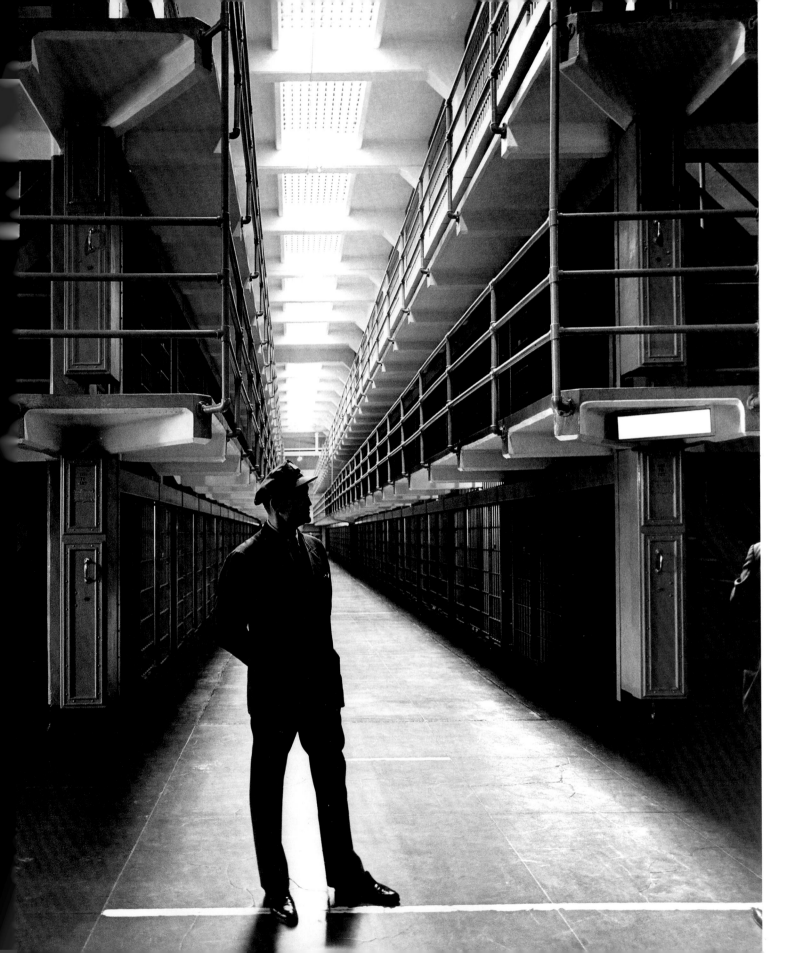

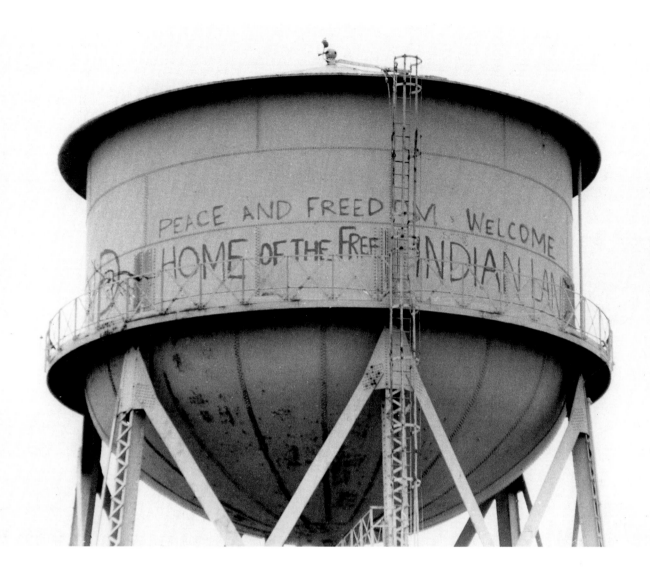

1963 Due to high operating costs and deteriorating infrastructure, Alcatraz is permanently closed by Attorney General Robert Kennedy and the remaining prisoners are transferred to other institutions, including the new maximum-security federal penitentiary in Marion, Illinois.

1969–1971 Mohawk activist Richard Oakes leads the occupation of Alcatraz by the "Indians of All Tribes," which at its height numbered more than 400 members. The group hoped to establish an American Indian cultural center on Alcatraz, but when Oakes left the island after the tragic death of his stepdaughter, public interest in the occupation waned and order among those remaining on the island began to deteriorate. After nineteen months, federal marshals moved in and forcibly removed the few remaining occupiers in June 1971. The Alcatraz occupation is recognized as a milestone in American Indian history, and each year Indians of All Tribes return to Alcatraz on Columbus Day and Thanksgiving to hold a Sunrise Ceremony for Indigenous Peoples and commemorate the longest Native American occupation in U.S. history.

opposite: Officer on the cellblock, March 1963

above: Water tower with graffiti from the Native American occupation, c. 1975

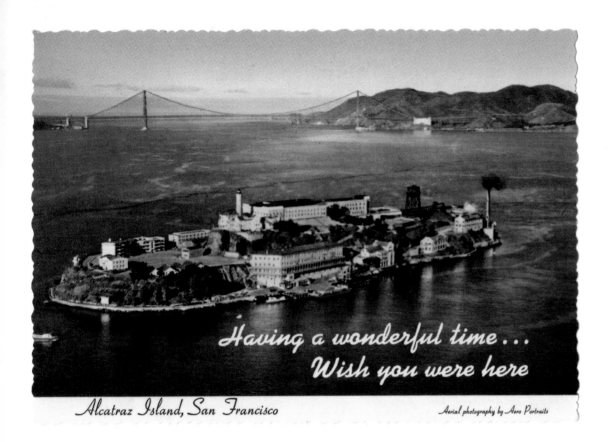

Having a wonderful time...
Wish you were here

Alcatraz Island, San Francisco *Aerial photography by Aero Portraits*

1972 Alcatraz becomes part of the new Golden Gate National Recreation Area under the management of the National Park Service. It opens as a national park site in the fall of 1973.

1976 Alcatraz is named to the National Register of Historic Places.

1986 Alcatraz receives designation as a National Historic Landmark.

2014 *@Large: Ai Weiwei on Alcatraz* premieres on the Rock.

top: Postcard of Alcatraz Island with view of the Golden Gate Bridge

above, left: National Park Service logo

opposite: Ai Weiwei, *Stay Tuned*, 2014 (detail); sound installation: custom-made furniture, audio files, speakers; part of *@Large: Ai Weiwei on Alcatraz*, Alcatraz Island, 2014–2015

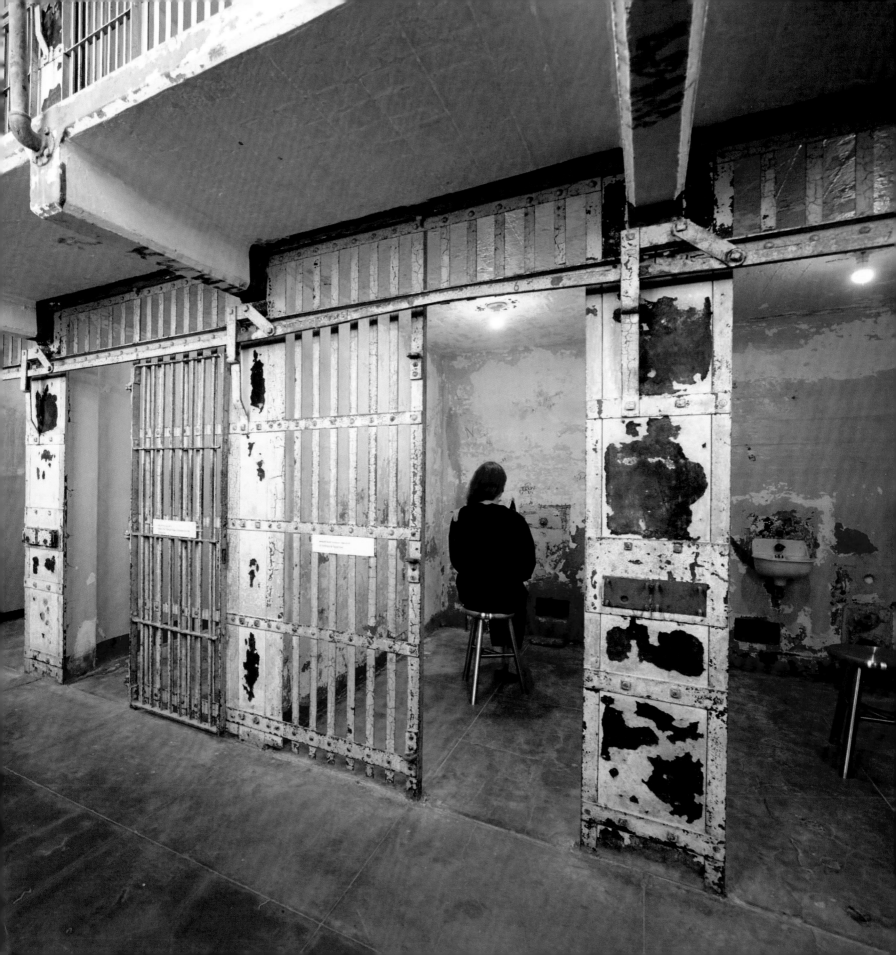

Ai Weiwei @Large on Alcatraz

Maya Kóvskaya, PhD

The truth is always terrible, unfit for presentation, unspeakable, and difficult for the people to handle; just speaking the truth would be "subversion of the state." [1]
—Ai Weiwei

An irreverent maverick with a cast-iron social conscience, Chinese artist/activist Ai Weiwei has been called many things. He's been called China's most famous living artist, while Western headlines have hinted that the defiant political critic just might be "China's most dangerous man"[2] and even claimed that the artist is an "enemy of the state."[3] Of course, in places where regimes monopolize historical "truth"—defending their claims to power by acting as gatekeepers of public culture—the union of art and political critique is a dangerous terrain. Yet through his art, Ai Weiwei fearlessly speaks his truth to power, and it is in this role of the public intellectual that Ai Weiwei's vocation finds its apotheosis.

Since his eighty-one-day police detention in China in 2011, global awareness of the political dimensions of Ai Weiwei's widely acclaimed artistic practice has grown. And although the artist remains in China, his passport confiscated, and unable to travel abroad, he has arrived in spirit—through his artworks—on Alcatraz, California's notorious island prison. It is hard to imagine a more appropriate setting for Ai Weiwei to create a site-specific intervention than Alcatraz. Now a flourishing national park and sanctuary for nesting birds, the San Francisco Bay island has a history of both unsettling and inspiring incarnations. Once a Civil War–era military fortress that held prisoners of war, from 1969 to 1971—after the infamous federal penitentiary was closed—the island was reoccupied as a site of Native American resistance. *@Large: Ai Weiwei on Alcatraz*, organized by the FOR-SITE Foundation and curated by its founder, Cheryl Haines, brings together a new body of works created to engage the historical legacies and significance of Alcatraz and explore the tenuous and tenacious aspects of freedom throughout the world.

What is so compelling about Ai Weiwei is not merely that his artwork is at once both beautiful and critical but also that it is as democratic in form as in message; it is an art intended for people everywhere. Ai Weiwei is a genuine public intellectual not only because he speaks for the public but because he speaks to the public. He is effective because he does so in an intelligent yet accessible visual language that anyone (with a little cultural and historical context) can come to understand. This essay shares key moments in the artist's development in order to offer such a context. Ai Weiwei's family background and youth set the stage for the blossoming of a great artist, audacious dissenter, and an exemplary public intellectual—that is, an artist with a commitment to participating critically in public life, even at enormous personal risk.

A Family Lineage of Conscientious Objection

Born in Beijing in 1957, by the time he was a year old Ai Weiwei was already learning about the vicissitudes of being a political dissenter when his father, the venerable revolutionary-era poet Ai Qing,[4] was sent, along with his family, to a series of labor camps for "re-education." The family arrived first in frigid Heilongjiang Province at the outset of the Great Leap Forward (1958–1961), an ill-conceived attempt at transforming China into a modern communist paradise that led to the starvation of an estimated 30 to 40 million people.

From 1959 onward, they were transferred to a series of camps in Xinjiang, China's westernmost Central Asian province, including one near Tian Shan, Xinjiang's "Heavenly Mountains."

For nearly two decades, Ai Qing and his family endured life in the camps and the political volatility of the Cultural Revolution (1966–1976). Ai Weiwei recalls the day in 1968 when his father "was dragged out across the desert to a labor camp far from the mountains" he loved. The poet was prohibited from writing, forced "to scrub communal toilets, and the Ai family was forced to live in an earthen pit covered with brush and mud."[5] They remained exiled in Xinjiang for sixteen years, only returning to Beijing after Chairman Mao died and the Cultural Revolution ended. Ai Qing was finally politically rehabilitated in 1978 after Deng Xiaoping came to power and initiated the reform and opening up of China's economy and society.

Years later in 2011, after Ai Weiwei was detained without formal charges for eighty-one days— sometimes hooded and always accompanied by two guards who stayed within close physical proximity, depriving him of even the most rudimentary privacy—he studied the walls of his own small, padded prison, memorizing the details that would later inform his artworks, and pondered the conscience that had helped keep his father's dignity intact in the camps. The poem "The Wall," which Ai Qing published in 1979, is uncannily prescient:

> A wall is like a knife
> It slices a city in half
> […]
> How tall is this wall?
> How thick is it?
> How long is it?
> […]
> It is only a vestige of history
> A nation's wound
> […]
> Even a thousand times taller
> Even a thousand times thicker
> Even a thousand times longer
> How could it block out
> The clouds, wind, rain, and sunshine of the heavens?
> […]
> And how could it block out
> A billion people
> Whose thoughts are freer than the wind?
> Whose will is more entrenched than the earth?
> Whose wishes are more infinite than time?[6]

Art & Activism, 1978–1981

Ai Weiwei was just entering his twenties as culture from the West began to flow into China for the first time since the pre-revolutionary era. While the Chinese state still controlled the public sphere, those early days

of Deng's leadership were marked with an enthusiasm for Western goods and culture by officialdom and society alike.

Rock 'n' roll, blue jeans, and avant-garde art were among the cultural currents that swirled around edgy young Chinese creatives during this early era of experimentation and renewed optimism. At the forefront were people like Ai Weiwei, who was a founding member of one of China's first avant-garde art collectives, the Stars.[7] When their experiments with Western artistic approaches were rejected by the official old guard that then ruled the art world, the Stars responded by staging an innovative, rebellious exhibition of their works on the streets outside the National Art Museum of China in 1979. When this exhibition was declared illegal by authorities, the Stars brazenly took to the streets, organizing a protest march on October 1, 1979, the thirtieth anniversary of the founding of the People's Republic of China. As exciting as this new era in China was, however, Ai Weiwei was a natural cosmopolitan. When the opportunity arose, he migrated to New York City in 1981, only returning to Beijing to be at his father's deathbed in 1993.

Picturing Dissent: The New York Photographs (1981–1993)

By 1983, Ai Weiwei had found his niche in New York's East Village. He studied for a time at Parsons School of Design but found the city itself to be a greater source of creative stimulation than the classroom. Ai Weiwei became close to luminaries such as Allen Ginsberg (the poet had met Ai Weiwei's father during a visit to China), and his place became a crash pad for visiting Chinese culturati. Camera in hand, Ai Weiwei, with his need to bear witness, was already finding expression in his earliest artworks—by the time he left New York, he had amassed 10,000 black-and-white photographic negatives, from which 230 prints were produced for a traveling exhibition that premiered at the Three Shadows Photography Arts Centre in Beijing in 2009.

The New York photographs map the young Ai Weiwei's social conscience during this formative time with portraits of close friends and images from iconic events that he witnessed and participated in, including major political, social, and cultural phenomena that still resonate today. Marginalization, self-determination, and glorious defiance can be seen in his portraits from New York's annual outdoor drag festival Wigstock, which capture an important moment in the LGBT rights movement. His documentation of the 1990 protests against George H. W. Bush's Gulf War, the social conflicts caused by gentrification, the scourge of homelessness in the world's wealthiest country, and police brutality at the 1988 riots in Tompkins Square Park all reveal the tenor of the times with startling insight. These photographs demonstrate that Ai Weiwei's work has always been about more than just China. Justice bleeds across geopolitical boundaries; struggles against the abuse of power have always been a concern of the artist.

above, left: Ai Weiwei, *AIDS Protest*, 1989, black-and-white photograph

above, right: Ai Weiwei, *Washington Square Park Protest*, 1988, black-and-white photograph

following: Ai Weiwei, *Names of the Student Earthquake Victims Found by the Citizens' Investigation*, 2008–2011 (detail), black-and-white print

序号	姓名	性别	出生日期	年龄	学校	班级	家长	家长	住址
828	黄琴	女	1990-	18岁	北川中学	高二八班	黄廷福	王官游	北川县曲山镇白果村一组
829	黄婷婷	女	1990/2/22	18岁	北川中学	高二八班	黄素珍		北川县通口镇通泉村六组
830	贾长春	男	1990/7/14	18岁	北川中学	高二八班	贾春平	巩艳	北川县通口镇罗明村一组
831	蹇蓉	女			北川中学	高二八班	蹇全丰	潘清秀	北川县坝底乡林地村一组
832	姜礼超	男	1990/9/9	18岁	北川中学	高二八班	姜信光	刘美琼	北川县擂鼓镇镇板村五组
833	金汉	男	1990/6/7	18岁	北川中学	高二八班	金永林	董觉明	北川县五星乡双流村一组
834	金玲	女			北川中学	高二八班	母志财	金仕琼	北川县香泉乡香保村四组
835	景科强	男	1994-	14岁	北川中学	高二八班	景连聪		
836	李加庆	男	1992/1/1	16岁	北川中学	高二八班	李发云	李菊华	北川县邓家乡岩羊村一组
837	李盼盼	女	1991/2/28	17岁	北川中学	高二八班	李明红	王和碧	北川县任家坪板房区1区601
838	李强	男	1990/11/28		北川中学	高二八班	李弟华	田龙凤	北川县片口乡保尔村二组
839	廖建	男			北川中学	高二八班	廖昌国	贺润碧	松潘县白什乡白村四组
840	刘俊	男			北川中学	高二八班	刘光富	陈开群	
841	刘小英	女	1990/2/4	18岁	北川中学	高二八班	刘小蓉	周昌友	北川县漩坪乡元安村四组
842	刘兴	男	1989/11/29	19岁	北川中学	高二八班	刘顺国	王光蓉	北川县擂鼓镇坪村建新二区71栋4
843	龙俊	男	1990/11/14	18岁	北川中学	高二八班	龙成彬	张义美	北川县漩坪乡瓦塘村一组
844	罗春梅	女			北川中学	高二八班	罗安军	王之秀	北川县白什乡白村二组
845	罗春燕	女	1990/12/7	18岁	北川中学	高二八班	罗成明	李朝会	北川县白什乡七星村联合组
846	马武虎	男		17岁	北川中学	高二八班	虎玉红	马军	北川县擂鼓镇新村一组
847	马玉红	女	1990/11/27		北川中学	高二八班	马建贵	王刚宏	北川县陈家坝乡西河村三6号
848	牟鑫	男		18岁	北川中学	高二八班	牟启顺	冯贵香	
849	母桂林	男	1990/6/2		北川中学	高二八班	母资泽	张其聪	北川县桂溪乡高峰村一组
850	母志兰	女			北川中学	高二八班	母贤龙	董仁会	北川县陈家坝乡老场村二组
851	彭函辉	女			北川中学	高二八班	彭胜富	邓开华	北川县曲山镇沙村二组
852	沈丽华	女	1990/10/12		北川中学	高二八班	沈仕祥	杜兴蓉	北川县桂溪乡金星村一组
853	唐军	男	1989/12/10		北川中学	高二八班	唐富富	吕顺会	北川县擂鼓镇胜利村一组
854	唐俊	男	1991/10/14	17岁	北川中学	高二八班	唐远弟	汪士蓉	安县秀水镇东风村一组
855	王芳	女	1990/11/13	18岁	北川中学	高二八班	王永清	刘忠堂	北川县漩坪乡永吉村四组
856	王磊	男	1989/2/22	19岁	北川中学	高二八班	王建华	李志秀	北川县贾乡岩林村三组
857	王培炮	男	1991/12/8		北川中学	高二八班	王兴开	文孝琼	北川县曲山镇任家坪村九组
858	王太平	男			北川中学	高二八班	王贵金		北川县白什乡村茶园
859	王燕	女			北川中学	高二八班	王天文	张进会	北川县白什乡河坪村茶园
860	魏昌军	男			北川中学	高二八班	魏永胜	蒲登帅	北川县白什乡河坪村茶园
861	熊涪	男	1991-	17岁	北川中学	高二八班	熊青成	朱桂碧	北川县白什乡河坪村茶园
862	熊文摇	女			北川中学	高二八班	唐荣富	唐明全	北川县白什乡河坪村茶园
863	杨刚	男			北川中学	高二八班	杨文全	漆桂芳	
864	杨莉	女	1990/8/6	18岁	北川中学	高二八班	杨文全	伍兴蓉	北川县白什乡河坪村茶园
865	杨欣	女	1991/10/1	17岁	北川中学	高二八班	罗绿秀	杨永红	北川县擂鼓镇笊沟村五组
866	杨正彪	男			北川中学	高二八班	杨德安	王永菊	北川县擂鼓镇笊沟村五组
867	叶小红	女			北川中学	高二八班	蹇绍全	叶述琼	北川县擂鼓镇木村五组
868	尹大菊	女	1990/12/26	18岁	北川中学	高二八班	尹全华	杨大秀	北川县擂鼓镇木村五组
869	曾婷	女			北川中学	高二八班	曾全华	李英	北川县擂鼓镇笊沟村五组
870	张波	男	1990/9/1	18岁	北川中学	高二八班	张兴跃	杜登蓉	北川县片口乡洞口村一组
871	张从林	男	1991/1/1		北川中学	高二八班	张增洪	杨明凤	北川县片口乡保尔村四组
872	张伟	男	1990/4/12	18岁	北川中学	高二八班	张元富	陈志容	北川县擂鼓镇笊沟村三组
873	朱鑫	男			北川中学	高二九班	朱福武	吴公会	北川县坝底乡民权村六组
874	邓星波	男	1990/9/21	18岁	北川中学	高二九班	邓锡金	王明会	北川县小坝乡民族村
875	黄玲	女			北川中学	高二九班	邓锡金	王明会	北川县小坝乡民主村
876	桂正波	男			北川中学	高二九班	桂怀清	徐昌会	北川县小坝乡新建村一组
877	何小美	女	1990/5/24	18岁	北川中学	高二九班	何兴亮	刘明秀	北川县擂鼓镇胜利村三组
878	蹇康荣	男			北川中学	高二九班	赖贵财	陈福芳	北川县擂鼓镇田坝村一组
879	刘远明	男			北川中学	高二九班	谢天全	刘清华	北川县小坝乡大包村四组
880	石艳	女			北川中学	高二九班	石朝军	黄会	北川县陈家坝乡双坎村三组
881	孙方丽	女	1990-	18岁	北川中学	高二九班	孙卫海	萍复玲	北川县禹里乡石纽村四组
882	唐艳	女			北川中学	高二九班	唐金清		北川县禹里乡石纽村五组
883	王冰	男	1990/12/15	17岁	北川中学	高二九班	王林	夏龙琼	北川县孝德镇
884	吴亚婷	女	1990/8/4	18岁	北川中学	高二九班	吴亚勤	赵义勤	北川县禹里乡石纽村五组
885	杨兰兰	女	1990/7/18	18岁	北川中学	高二九班	杨康甫	任先俊	北川县禹里乡石纽村五组
886	张强	男	1990/8/21	18岁	北川中学	高二九班	张义全	李友琼	北川县禹里乡石纽村五组
887	张馨月	女	1991/7/11	17岁	北川中学	高二九班	张宏	张成玉	北川县擂鼓镇
888	赵露	女	1990/9/24	18岁	北川中学	高二九班	赵云	李孝银	北川县桂溪乡桂溪村一组
889	陈娟	女	1990/1/20	18岁	北川中学	高二十班	陈贵山	成大琼	北川县擂鼓镇陈山村
890	顾阳	男	1991/8/17	17岁	北川中学	高二十班	顾安旭		北川县禹里乡慈竹村二组
891	李明金	男			北川中学	高二十班	李清全	赵均	
892	李艳春	女	1990-	18岁	北川中学	高二十班	廖秀成	刘华英	北川县小坝乡百花村一组
893	廖乾斌	男			北川中学	高二十班	廖光辉	刘炳蓉	北川县禹里乡慈竹村一组
894	刘方圆	男	1990/3/16	18岁	北川中学	高二十班	母贵	孙正蜀	北川县曲山镇云竹村二组
895	母爽	女			北川中学	高二十班	母贵顺	孙正蜀	北川县曲山镇云竹村二组
896	任丹丹	女	1990/9/1		北川中学	高二十班	任寿寿	赵淑华	北川县曲山镇禹龙中街
897	谭堂	男			北川中学	高二十班	张秀红		北川县曲山镇文武街十九号
898	席真丽	女			北川中学	高二十班	席成永	贾德华	
899	杨平	男			北川中学	高二十班	杨碧华	付秀美	北川县擂鼓镇河道村四组
900	张涛	男	1991-	17岁	北川中学	高二十班	张永华	何德秀	北川县坝底乡小岭村三社
901	张婵婵	女	1989/4/6		北川中学	高二十班	张永建	申国庆	北川县禹里乡三合村四组
902	王蓉	女	1989/4/6	19岁	北川中学	高三二班	王南平	余健	北川县曲山镇寨家街
903	李梦	男	1991-	17岁	北川中学	高三二班			
904	李政忠	男			北川中学				
905	廖梅	女	1990-1-		北川中学				北川县禹里乡润江村四组
906	杨军	男	1988/4/13	20岁	北川中学				北川县曲山镇
907	杨刚						杨仕林		
908	蒋友标	女	2002/10/16	6岁	草坝小学	学前班	蒋泽贵		彭州市小鱼洞镇草坝二组
909	李继玲	女	1996-	12岁	茶坪初中				安县茶坪乡德胜村十四组
910	刘欢	男	1994-	14岁	茶坪初中				安县茶坪乡德胜村十组
911	瑞刚	男	1994-	14岁	茶坪初中				安县茶坪乡青松村六组
912	严涛	男	1997-	11岁	茶坪初中				安县茶坪乡宝藏村二组
1076	余阳	女	1990-	18岁	东汽中学	高二二班	余廷云		绵竹市拱星镇3大6组
1077	张进	男	1990/6/27	18岁	东汽中学	高二二班	辛华		绵竹市孝德镇4大1
1078	张显	男	1989/10/1	19岁	东汽中学	高二二班	张清文		绵竹市齐福镇金陵村3组
1079	张蓄	男			东汽中学	高二二班	张军		绵竹市棚锻锻轮检查站
1080	张睿	男	1989/7/28	19岁	东汽中学	高二二班	赵付玲		绵竹市剑南道仿古社区5园委6组3
1081	张世凯	男	1990/7/3	18岁	东汽中学	高二二班	张永榮		绵竹市孝德镇万游村2组
1082	朱子木	男	1991/8/9	17岁	东汽中学	高二二班	朱家勋		东汽主机一分厂
1083	邹远强	男	1991/6/28	17岁	东汽中学	高二二班	邹显华	王兴智	绵竹市九龙镇玉玉村15组
1084	刘欢	女	1991/1/9	17岁	东汽中学	高二三班	刘良萍	周友发	绵竹市土门镇康角村4组
1085	肖超				东汽中学	高二三班	昌金华		绵竹市玉泉镇泉江村9组
1086	杨姐	女	1989/8/1	19岁	东汽中学	高二三班	温华容	杨富权	绵竹市孝德镇石桥1组
1087	叶敏	女	1991/1/25	17岁	东汽中学	高二三班	叶良福		绵竹市玉泉镇箐公村2组
1088	张静	女			东汽				
1089	陈竹	女			东汽中学	高二四班	陈龙富	唐竹清	绵竹市清平镇磷矿
1090	丁浩	男	1990/8/2	18岁	东汽中学	高二四班	苏世英	丁仁兴	绵竹市汉旺镇板房
1091	何莹	女			东汽中学	高二四班	何兴川		绵竹市孝德镇妙相村9组
1092	胡珊珊	女	1989/3/28	19岁	东汽中学	高二四班	杨杰木		绵竹市富新镇高庆村(寄住)
1093	黄伯建	男	1990/3/8		东汽中学	高二四班	黄孟成	曾德英	绵竹市板桥镇八一村4组
1094	蒋勇男	男			东汽中学	高二四班	蒋子文		绵竹市观鱼镇火石村1组
1095	蒋玉翠				东汽中学	高二四班	杨秀丽		绵竹市汉旺镇
1096	李东川	男			东汽中学	高二四班	李开胜		绵竹市东汽中学
1097	李静	女	1990/8/15	18岁	东汽中学	高二四班	李国富	刘洪荣	绵竹市土门镇罗云村18组
1098	李俊	男	1990/8/23	18岁	东汽中学	高二四班	李永武		绵竹市广济镇祁祥村8组
1099	李明				东汽中学	高二四班			
1100	林小森	男	1991/2/8	17岁	东汽中学	高二四班	林青	杨小红	东汽锻坯分厂246号
1101	刘凤娇	女			东汽中学	高二四班	刘体锐		绵竹市汉旺镇东林村1组
1102	刘开荣	男	1990-	18岁	东汽中学	高二四班	刘正国	马兴客	绵竹市汉旺镇安仁红村1组
1103	马壮	男	1991/7/23	17岁	东汽中学	高二四班	马清		绵竹市新市(龙聊)就业公司
1104	毛欢	女	1991/5/4	17岁	东汽中学	高二四班	毛世宇		绵竹市拱星镇白溪河村13组
1105	皮敏	女	1991/3/7	17岁	东汽中学	高二四班	皮福华	林忠友	绵竹市土门镇三合村22组
1106	邱澄澄	女			东汽中学	高二四班	朱长秀	邱先发	绵竹市西南镇安园村4组
1107	任含吉	男	1990/8/25	18岁	东汽中学	高二四班	任泽义		绵竹市兴隆镇木村10组
1108	王丹	女	1990/12/23	18岁	东汽中学	高二四班	王廷章		绵竹市兴隆镇华村14组
1109	王浩	男	1990-	18岁	东汽中学	高二四班	王德华	阙学历	绵竹市什地镇协和村1组
1110	王静	女	1990/3/14	18岁	东汽中学	高二四班	丁英琼		绵竹市汉旺镇郡村4组
1111	王琪	男	1990/3/7	18岁	东汽中学	高二四班	王文颖		绵竹市广济镇新村14组
1112	王晓云	女	1989/12/10	19岁	东汽中学	高二四班	王明全		绵竹市汉旺镇安4大7
1113	王心桐	女	1990/9/29	18岁	东汽中学	高二四班	王开富	曾德兰	绵竹市广济镇6大2组
1114	王兴丽	女	1991/2/24	17岁	东汽中学	高二四班	王力志	王宏富	绵竹市玉泉镇前进村
1115	肖杨	男	1990/11/1	18岁	东汽中学	高二四班	肖永刚	杨金容	绵竹市九龙镇龙村4组
1116	严海	男	1990/7/4	18岁	东汽中学	高二四班	李代偁		绵竹市土门镇
1117	杨克勤	男	1990/11/13	18岁	东汽中学	高二四班	杨光志		绵竹市兴隆镇川木村10组
1118	易志博	男	1990/9/26	18岁	东汽中学	高二四班	杨琳		绵竹市剑南镇
1119	余丹	女	1991/4/21	17岁	东汽中学	高二四班	余春玲		绵竹市汉旺镇伐木厂
1120	袁红梅	女	1991/7/18	17岁	东汽中学	高二四班	袁乐涛	牟启芝	绵竹市土门镇大宝村12组
1121	岳坤君	男	1991/6/21	17岁	东汽中学	高二四班	黄朝英		绵竹市齐福镇(孝德桐村10组)
1122	张光伟	男	1989/12/1	19岁	东汽中学	高二四班	张震		东汽运业
1123	张磊	男	1989/11/15	19岁	东汽中学	高二四班	张彦		绵竹市东北镇玉玉村2组
1124	张丽	女	1989/10/28	19岁	东汽中学	高二四班	张文富	黄良均	绵竹市玉泉镇圣得泉村2组
1125	张丽	女			东汽中学	高二四班	张兴一		绵竹市孝德镇石桥浦村1组
1126	周倩思	女	1990/10/19	18岁	东汽中学	高二四班	周德英	唐文士	绵竹市孝德镇泉村8组
1127	周庆	男	1989/11/28	18岁	东汽中学	高二四班	周光国	黄存君	绵竹市孝德镇苦葛村1组
1128	蔡文祥	男	1991/8/16	17岁	东汽中学	高二五班	蔡丛明	陈兰	绵竹市汉旺镇玉泉村新2组
1129	陈超	男	1990/3/22		东汽中学	高二五班	陈勇	徐小琴	绵竹市西南镇安园村居委4组
1130	陈寅	男	1990/11/10		东汽中学	高二五班	陈光海	张代蓉	绵竹市东北镇
1131	陈姝	女	1990/10/31		东汽中学	高二五班	陈福军	王和翠	绵竹市孝德镇福田村14组
1132	付程	男		18岁	东汽中学	高二五班	付兴能		绵竹市清平镇元保村1组
1133	付威	男	1990/5/23		东汽中学	高二五班	付利德	黎友兰	绵竹市西南镇清泉村4组
1134	巩镇	男	1990/7/3		东汽中学	高二五班	巩贵青	王开平	绵竹市九龙镇清泉村8组
1135	何川	男	1989/10/12		东汽中学	高二五班	何家虎	钟守军	绵竹市孝德镇茶谷子厂
1136	胡秋云	女	1990/9/20		东汽中学	高二五班	胡应桂		绵竹市板桥镇高村4组
1137	黄登峰	男	1990/5/11		东汽中学	高二五班	黄联合	刘德英	绵竹市富新镇富滩村4组
1138	江志冬	男	1991/1/3	17岁	东汽中学	高二五班	江怀青		绵竹市广济市村村组
1139	姜陈	男	1990/10/4	18岁	东汽中学	高二五班	姜仕云		兴绵竹市广济镇5大6组
1140	蒋英	女	1990/1/28	18岁	东汽中学	高二五班	蒋和林		绵竹市齐福镇洪祥村4组46村1
1141	廖雪	女	1990/12/5	18岁	东汽中学	高二五班	廖继连	赵英	绵竹市土门镇曙祥村6组
1142	刘东	男	1990/9/1	18岁	东汽中学	高二五班	刘军		绵竹市什地镇双兴村4组
1143	潘丽	女			东汽中学	高二五班	杨川梅		绵竹市清平镇伐木厂
1144	邱琴	女	1990/4/5		东汽中学	高二五班	邱记才	曹礼清	绵竹市土门镇罗云村15组
1145	汪兵	男	1989/11/26	19岁	东汽中学	高二五班	汪华清	马青春	绵竹市孝德镇文村组
1146	吴剑	男	1990/8/31	18岁	东汽中学	高二五班	吴生华		绵竹市拱星镇红旗村8组
1147	杨为维	男	1991/7/12	17岁	东汽中学	高二五班	杨荣	龙志波	东汽焊接
1148	杨镇宇	男	1990/12/14	18岁	东汽中学	高二五班	杨辉	游利	东汽协作处
1149	叶俊权	男	1991/3/4	17岁	东汽中学	高二五班	叶建军		绵竹市玉泉镇信用社
1150	尹琳	男	1990-	18岁	东汽中学	高二五班			
1151	尹泽阳	男	1990/5/12	18岁	东汽中学	高二五班	尹全述		绵竹市东北镇玉马村4组
1152	智永锐	男	1991/1/16	17岁	东汽中学	高二五班	智品禄	胡向花	绵竹市土门镇曙第4组
1153	赵凡	男	1989/7/14	19岁	东汽中学	高二五班	赵顺平		绵竹市齐天镇1大5组
1154	朱勇	男	1991/8/25	17岁	东汽中学	高二五班	朱永椿		绵竹市孝德镇洪祥村
1155	安知全	男	1989/10/25		东汽中学	高二六班	安国成	福正琼	绵竹市汉旺镇青岭村12大1组
1156	戴正顺	男	1990/6/15	18岁	东汽中学	高二六班	戴顺英	肖传	绵竹市九龙镇五大村1组
1157	邓敏	女	1991/7/2	17岁	东汽中学	高二六班	邓友顺		绵竹市玉泉镇桥楼村3组
1158	邓强	男	1990/6/2	18岁	东汽中学	高二六班	邓富云		绵竹市兴隆镇桥楼村3组
1159	何关香	女			东汽中学	高二六班	洪其玉		绵竹市拱星镇3大3
1160	黄云涛	男	1991/8/13	17岁	东汽中学	高二六班	杨远兰		绵竹市遵道镇棚兴村

序号	姓名	性别	出生	年龄	学校	年级班级			地址
324	吴凡	女	1996/3/30	12岁	富新二小	六年级一班	吴学明	范菊	绵竹市富新镇永丰村四组
325	杨丹	女	1995/7/3	13岁	富新二小	六年级一班	杨林	李艳	绵竹市富新镇永明村三组
326	杨贵云	男	1996	12岁	富新二小	六年级一组	朱永会	杨富亮	绵竹市富新镇杜林村四组
327	杨坤	男	1995/10/6	13岁	富新二小	六年级一班	杨建	范菊	绵竹市富新镇杜林村八组
328	张菊	女	1995/7/11	13岁	富新二小	六年级一班	张龙富	曹凤芝	绵竹市富新镇永丰村五组
329	张琪	男	1995/3/16	13岁	富新二小	六年级一班	曹培芬	张义俊	绵竹市富新镇永丰村四组
330	张怡	女	1995/9/9	13岁	富新二小	六年级一班	张卖明		绵竹市富新镇永丰村户组
331	陈龙	男	1995-	13岁	富新二小	六年级一组	陈钟建	张兴明	绵竹市富新镇永丰村四组
332	陈国润	男	1996	12岁	富新二小	六年级二班	陈天清		绵竹市
333	丁鹏	男	1996-	12岁	富新二小	六年级二班	刘兴玉	丁明	绵竹市富新镇友助村四组
334	丁云涛	男	1995-	13岁	富新二小	六年级二班	丁艳平	黄泽英	绵竹市富新镇花泉村二组
335	付锐	男	1996-	12岁	富新二小	六年级二班	付正群	王达群	绵竹市
336	郭玲	女	1995/3/26	13岁	富新二小	六年级二班	郭光荣	林德英	绵竹市富新镇常明村三组
337	郭霜	女	1995/6/27	13岁	富新二小	六年级二班	郭光洪	邱先红	绵竹市富新镇常明村四组
338	胡寿莲	女	1995/9/10	13岁	富新二小	六年级二班	胡长福	张修会	绵竹市富新镇普胜村五组
339	景明春	女	1996/1/14	12岁	富新二小	六年级二班	景正富	叶冬梅	绵竹市富新镇常明村四组
340	李玉冠	男	1996-	12岁	富新二小	六年级二班	李开贵		绵竹市什地镇
341	卢倩	女	1996-	12岁	富新二小	六年级二班	宋英蓉	卢廷发	绵竹市富新镇普胜村五组
342	吴涛	男	1995/8/26	13岁	富新二小	六年级二班	吴先国	邓永群	绵竹市富新镇友明村二组
343	曾小双	男	1995/9/21	12岁	富新二小	六年级二班	曾剑祥	张友兰	绵竹市富新镇常明村二组
344	张徽	男	1996/1/26	12岁	富新二小	六年级二班	张兴祥	张敏	绵竹市什地镇
345	张超	男	1995/8/23	13岁	富新二小	六年级二班	张永伟	张安碧	绵竹市富新镇普村村一组
346	张伟	男	1995/8/21	13岁	富新二小	六年级二班	张道林		绵竹市富新镇普胜村二组
347	张小双	男	1995/9/12	13岁	富新二小	六年级二班	张登建	刘红霞	绵竹市五四镇茅坝村一组
348	张义	男	1995-	13岁	富新二小	六年级二班	张龙华	桑敏	绵竹市富新镇杜林村三组
349	张雨薇	女	1996-	12岁	富新二小	六年级二班	张玉明	李喜玉	绵竹市富新镇杜林村六组
350	赵川	男	1995/10/24	13岁	富新二小	六年级二班	赵军	廖珀凤	绵竹市
351	朱爽	女	1995/7/5	13岁	富新二小	六年级二班	朱传兴	张治平	绵竹市富新镇友助村四组
352	徐彩云	女	1998/1/1	10岁	富新一小	四年级一班			绵竹市
353	刘瑶	女			富新职业初级中学	初三三班			
354	马苗	男			富新职业初级中学	初三三班			
355	付兰	男	2003-	5岁	甘露幼儿园		母小红		北川县陈家坝乡老场村一组
356	李瑞	男	2004-	4岁	甘露幼儿园		李成勇		北川县陈家坝乡小河村一组
357	母雪镇	男	2005-	3岁	甘露幼儿园		母帅峰		北川县陈家坝社区
358	张城	女	2005-	3岁	甘露幼儿园		陈礼翠		北川县陈家坝乡双地村三队
359	陈平	男	1992/6/8	16岁	高川乡英才学校	初三	陈金军	黄冠英	
360	穆雪梅	女	1993/12/25	15岁	高川乡英才学校	初二	杨率双	马银美	
361	白元超	男	1999-	9岁	高庙小学				陕西省咸阳市乾县城关镇北斗村
362	甘元超	男	1999-	9岁	高庙小学				陕西省咸阳市乾县城关镇新庄村
363	葛依新	男	2000-	8岁	高庙小学				陕西省咸阳市乾县大杨乡杨汉村
364	张新周	男	2000-	8岁	高庙小学				陕西省咸阳市乾县城关镇大市场
365	张磊	男	1997/7/15	11岁	拱星镇小学	四年级一班	陈芳		绵竹市拱星镇四大队
366	杜希鹏	男	1999-	9岁	关庄小学	三年级			青川县关庄镇街上
367	杨仪	女	1993-	15岁	关庄中学	初三			青川县关庄镇红光村
368	郑国富	男	1992-	16岁	关庄中学	初三			青川县苏河乡
369	廖陈程	男	2001/9/17		广济小学				
370	刘成峻	男	1997/3/22	11岁	广济小学				绵竹市天池乡
371	曹雪	女	1994-	14岁	广济中学				绵竹市东北镇
372	戴林	男	1993/7/14	15岁	广济中学				绵竹市兴隆镇
373	王保薇	女	1992/6/7	16岁	广济中学				绵竹市清平乡
374	曾晓庆	女	1992/2/1	16岁	广济中学				绵竹市汉旺镇
375	黄鑫	男	1997-	11岁	汉昌春蕾小学	四年级二班	黄道元	王秀荣	安昌东风村12队
376	陈星星	男	1996-	12岁	汉昌春蕾小学	五年级一班	陈国斌		安昌东风村
377	刘金龙	男	1996-	12岁	汉昌春蕾小学	五年级一班	刘金铭		安昌汉昌镇东风村12队
378	刘田甜	女	1996-	12岁	汉昌春蕾小学	五年级一班			安昌东风村
379	徐琴	女	1996-	12岁	汉昌春蕾小学	五年级一班	徐卫华		安昌东昌村
380	杨子娇	女	1997-	11岁	汉昌春蕾小学	五年级一班			安昌群益大队
381	钟小川	男	1997-	11岁	汉昌春蕾小学	五年级一班			安昌
382	李迎春	女	1997-	11岁	汉昌春蕾小学	五年级一班			安昌群益大队
383	王小亚	男	1998-	10岁	汉昌春蕾小学	五年级一班			安昌五星乡大队4组
384	杨丁洋	男	1997-	11岁	汉昌春蕾小学	五年级二班			
385	杨洋	男	1996/6/4	12岁	汉昌春蕾小学	五年级二班	杨正辉	杨燕	安昌汉昌镇东风村12队
386	钟丽	女	1998-	10岁	汉昌春蕾小学	五年级二班			
387	刘仁祝	男	1990/6/18	18岁	汉昌初级中学				
388	杨双	男	1992/1/24	15岁	汉昌初级中学	09级1班			绵竹市汉旺镇
389	袁倩倩	女	1990/2/7	18岁	汉昌初级中学				绵竹市汉旺镇
390	王珊	女	1986/7/13	22岁	汉昌镇职业学校				
391	刘东东	男	2001-	7岁	汉旺镇中心小学	一年级一班			
392	夏苗君	女	2001-	7岁	汉旺镇中心小学	一年级一班			
393	张雨龙	男	2001/8/31	7岁	汉旺镇中心小学	一年级一班	张志林	赵祥菊	
394	郑强	男	2001-	7岁	汉旺镇中心小学	一年级一班			
395	邱宇轩	男	2000/12/2	8岁	汉旺镇中心小学	一年级一班	邱波	谢书清	
396	李成智	男	1999-	9岁	汉旺镇中心小学	三年级三班			
397	刘雅	女	1996-	12岁	汉旺镇中心小学	三年级三班			
398	唐鑫	男	1995-	13岁	汉旺镇中心小学	三年级四班			
399	朱悦	女	1999-	9岁	汉旺镇中心小学	三年级四班	朱瑞强		
400	杨凤	女	1997-	11岁	汉旺镇中心小学	四年级三班			
401	夏仁杰	男	1998-	10岁	汉旺镇中心小学	四年级三班			
402	曹俊杰	男	1998-	10岁	汉旺镇中心小学	四年级三班			
403	陈瞿	女	1998/9/5	10岁	汉旺镇中心小学	四年级三班			
404	陈魏娇	女	1998/10/17	10岁	汉旺镇中心小学	四年级三班	陈彪	赵珊	
405	陈燦馨	女	1998/12/28	10岁	汉旺镇中心小学	四年级三班	陈显斌	蒲德翠	
406	杜峰	男	1998-	10岁	汉旺镇中心小学	四年级三班			
407	高月雯	女	1998/5/18	10岁	汉旺镇中心小学	四年级三班	谷勇志		绵竹市青义镇东街9户3号406
408	何志伟	男	1998-	10岁	汉旺镇中心小学	四年级三班			
			1997/4/14	11岁	汉旺镇中心小学	四年级三班	李怀富	罗育平	

序号	姓名	性别	出生	年龄	学校	年级班级			地址
1571	叶启红	女	1997/9/19	11岁	红白中心学校	四年级一班	叶福坤	贾兴芹	什邡市红白镇红白村4组
1572	张廷	男	1997-	10岁	红白中心学校	四年级一班	张辉才	周绿容	
1573	赵泓全	男	1997/8/30	11岁	红白中心学校	四年级一班	赵昌明	王瑶芳	什邡市红白镇松林村1组
1574	郑锋				红白中心学校	四年级二班			
1575	周黎	女	1998/1/20	10岁	红白中心学校	四年级二班	周厚涛	黎子芳	什邡市红白镇栋子坪村6组
1576	陈军	男	1996-	12岁	红白中心学校	五年级一班	冉兴金	陈旋群	
1577	陈美				红白中心学校	五年级一班	陈立万		
1578	陈庆				红白中心学校	五年级一班			
1579	陈英杰	男	1996/11/9	12岁	红白中心学校	五年级一班	陈颜红		
1580	冯丹				红白中心学校	五年级一班	冯成富	曾华香	
1581	梁思怡				红白中心学校	五年级一班			
1582	廖翠	女	1996-3	12岁	红白中心学校	五年级一班			
1583	肖航	男			红白中心学校	五年级一班	肖世德	梁海英	
1584	肖帅鑫	男	1997/1/10	11岁	红白中心学校	五年级一班	肖永龙		什邡市红白镇五桂坪村6组
1585	谢雨星	女			红白中心学校	五年级一班	谢雨荣	卞文芳	
1586	杨思健	男	1997/8/27	11岁	红白中心学校	五年级一班	杨达健		什邡市红白镇栋子坪村3组
1587	张思露	女	1996/7/11	12岁	红白中心学校	五年级一班	张云华	许华英	什邡市红白镇栋子坪村6组
1588	张梦明	女	1997/6/28	11岁	红白中心学校	五年级一班	张智诚		
1589	张帅	男			红白中心学校	五年级一班	张世财	马传容	
1590	赵莉	女	1997-	11岁	红白中心学校	五年级一班	赵忠云		
1591	赵陶	男			红白中心学校	五年级一班	赵建军	肖磊	
1592	赵毅	男	1996/8/20	12岁	红白中心学校	五年级二班	赵忠和	马具英	什邡市红白镇栋子坪村二组
1593	周涛	男	1996/12/10	12岁	红白中心学校	五年级二班	周绿贵	肖兴萍	什邡市红白镇二村4组
1594	陈镇	男	1996/1/9	12岁	红白中心学校	五年级二班	陈颜双	郭喜荣	
1595	陈依蓉	女	1996/1/9	12岁	红白中心学校	五年级二班	陈颜双	郭喜容	
1596	甘镇菲	男	1996/12/20	12岁	红白中心学校	五年级二班	甘尚兵	赖世莲	什邡市红白镇栋子坪村2组
1597	甘悦	女	1996/9/5	12岁	红白中心学校	五年级二班	甘尚平	孙富琴	什邡市红白镇栋子坪村3组
1598	黄诚国	男	1996/12/6	11岁	红白中心学校	五年级二班	黄润勇	郭长珍	什邡市红白镇木瓜坪村7组
1599	黄威国	男			红白中心学校	五年级二班			
1600	赖薛颖	女	1997/2/28	11岁	红白中心学校	五年级二班	田亨红		什邡市红白镇栋子坪村2组
1601	李倩	女	1997/8/14	11岁	红白中心学校	五年级二班	李廷春		什邡市红白镇栋子坪村4组
1602	李耀	男	1997/3/9	11岁	红白中心学校	五年级二班	李亭华		什邡市红白镇松林村4组
1603	唐沥陶	男	1996/5/27	12岁	红白中心学校	五年级二班	唐世华	赵晓蓉	绵竹市金花2大队3队
1604	唐章杰	男	1996/8/5	12岁	红白中心学校	五年级二班	唐文军	方帮媛	
1605	田开平	男	1995/8/16	13岁	红白中心学校	五年级二班			
1606	魏可儿	男	1997/2/19	11岁	红白中心学校	五年级二班	魏敏		
1607	谢宇	男			红白中心学校	五年级二班	谢远云	陈芳	
1608	严新月	女	1997/7/9	11岁	红白中心学校	五年级二班	严大成	黄凤英	什邡市红白镇栋子坪村四组
1609	余琴	女			红白中心学校	五年级二班	姜孝华	林兴兰	
1610	张宇	女	1997/5/25	11岁	红白中心学校	五年级二班	张德全	王芳	什邡市红白镇松林村2组
1611	赵丹	女	1996/10/8	12岁	红白中心学校	五年级二班	赵发祥	黄文玉	绵竹市金花镇三江村3组
1612	赵璐	女	1996-		红白中心学校	五年级二班			
1613	何佳	女	1994/11/20	14岁	红白中心学校	七年级一班	黄云生	徐忠芝	什邡市云华镇仁和村3组
1614	汤玲	女	1994/10/10	14岁	红白中心学校	七年级一班	汤组全	詹安菊	
1615	汪东一	男	1995/11/1	13岁	红白中心学校	七年级一班			
1616	王巍	男	1994-	14岁	红白中心学校	七年级二班	王帮兵	魏丽	
1617	曾月	女	1994-	14岁	红白中心学校	七年级二班	黄茂钟	曾秀华	
1618	卞小双	女	1994/8/24	14岁	红白中心学校	七年级二班	卞开文	李钰	
1619	陈帅	男			红白中心学校	七年级二班	陈无元	李昌红	
1620	陈颖	女			红白中心学校	七年级二班	陈尚斌	钟云香	
1621	甘宇	男	1994-	14岁	红白中心学校	七年级二班	甘尚乐	陈三东	
1622	雷涛	男			红白中心学校	七年级二班	雷洪成		
1623	雷贺坚	女	1993-	15岁	红白中心学校	七年级二班	雷贺富	郭不芳	
1624	廖欢	女			红白中心学校	七年级二班	廖昌文	尹光兰	
1625	刘兰	女	1994-	14岁	红白中心学校	七年级二班	杨梅		汶川县水磨镇郭家坝村
1626	唐晓霜	女	1994/7/16	14岁	红白中心学校	七年级二班	唐文富	叶仁芳	什邡市红白镇马口村2组
1627	王斌	男	1995/3/5	13岁	红白中心学校	七年级二班	王兴华	冯成玉	什邡市红白镇松林村3组
1628	杨玲	女			红白中心学校	七年级二班			
1629	钟红霞	女	1994-	14岁	红白中心学校	七年级二班	钟正江		
1630	钟思儿	女	1995/8/3	13岁	红白中心学校	七年级二班	钟刚兵		什邡市红白镇木瓜坪村4组
1631	朱玲	女	1994-	14岁	红白中心学校	七年级二班	冯福健	肖泽芝	
1632	祝星月	女			红白中心学校	七年级二班			
1633	刘红君	女	1993/12/23	15岁	红白中心学校	七年级三班	刘华万	晏孝莉	
1634	黄叶	女	1993-		红白中心学校	八年级一班	黄宣明		
1635	林伟	男	1993-		红白中心学校	八年级一班	林志强		
1636	宋玉强	男	1993/7/12	15岁	红白中心学校	八年级一班	宋玉太		什邡市红白镇栋子坪村4组
1637	魏其林	男	1993/8/24	15岁	红白中心学校	八年级一班	魏小明		什邡市红白镇五桂坪村6组
1638	谢彬	女	1993/7/17	15岁	红白中心学校	八年级一班	谢述	杨芬	绵竹市金花镇三江村4组
1639	张小阳	男	1993/5/7	15岁	红白中心学校	八年级一班	张文俊		
1640	冯佩佩	女	1993/6/28	15岁	红白中心学校	八年级二班	蜀传英	冯述友	
1641	赖小雪	女			红白中心学校	八年级二班	赖世红	陈秀花	
1642	李进明	男			红白中心学校	八年级二班			
1643	刘彩玲	女	1993/8/31	15岁	红白中心学校	八年级二班	刘德	冯福彬	什邡市红白镇红白村4组
1644	蒲晓燕	女	1994-		红白中心学校	八年级二班			
1645	王飞扬	男	1993/8/31	15岁	红白中心学校	八年级二班	王世云	杨全英	什邡市红白镇送林村2组
1646	魏丽君	女	1999/3/3	9岁	红白中心学校	八年级二班	魏守英		
1647	魏云涛	男			红白中心学校	八年级二班	魏守清		
1648	肖永	男			红白中心学校	八年级二班			
1649	杨静	女	1992-	16岁	红白中心学校	八年级二班	杨柳	马红	
1650	詹小琴	女	1993-		红白中心学校	八年级二班	詹小娇		
1651	詹晓	女	1993/3/27		红白中心学校	八年级二班	詹贺深	何代容	
1652	张毓杰	男	1993-	15岁	红白中心学校	八年级二班	张兴福		
1653	陈志	男	1993/2/24	15岁	红白中心学校	九年级一班	陈玉国		
1654	陈龙	男	1992-		红白中心学校	九年级一班	陈玉国		
1655	甘涛	男	1992/1/1	16岁	红白中心学校	九年级一班			
1656	李小雪	女	1993/1/1	15岁	红白中心学校	九年级一班	李德忠	徐友君	
1657	廖威	男	1992/5/1	16岁	红白中心学校	九年级一班	廖明全	姜吉贵	什邡市红白镇红白村4组

Beijing East Village, Community & Curation

When Ai Weiwei returned to Beijing in 1993 to be with his dying father, he was also returning to a changed China—post-1989 China, in which those who had criticized the nation's course had been forcefully reminded of the wisdom of silent complicity, and the last smatterings of a broken public intelligentsia were nursing their wounds in small underground communities. There was the Yuanmingyuan artist colony on the west side of Beijing, and the smaller, more experimental group of artists and musicians on the east side, which Ai Weiwei would christen the Beijing East Village. There he befriended post-punk musician Zuoxiao Zuzhou, photographer RongRong, performance artists Ma Liuming, Zhang Huan, Zhu Ming, Cang Xin, and many others.

Ai Weiwei mentored emerging artists doing provocative work during this era. After the arrests of artists and the crackdown that dispersed the Beijing East Villagein mid-1994, he continued to create space for critical art through his Samizdat-style publications of the *White, Gray,* and *Black Cover Books* (1994–1997), which introduced some of the most experimental and important art and aesthetic debates of that era, injecting innovation into the art scene at a time when such art was inaccessible within China's state-controlled media and museum systems.

Ai Weiwei's own artwork at the time was wry and down to earth. In his *Study of Perspective* series (1995–2003), we see the artist's hand in the classic gesture of defiance toward authority, giving the middle finger to symbols of state power such as Tiananmen and the White House. In the performance sequence *Dropping a Han Dynasty Urn* (1995), three photographs capture the irreverent smashing of an antique—or perhaps a simulacrum of an antique. For Ai, playing with questions of authenticity and authority, of who gets to say what is "real" and what is "fake," remains an enduring preoccupation. Over the next two and a half decades, as for all Chinese artists of that era, the conscience of the angry young man Ai Weiwei—bearing witness with his presence, his camera, and his attitude—would be tested and challenged by the changing world around him.

From the early 2000s, following Beijing's selection to host the 2008 Olympics, shifts in state cultural strategy and priorities allowed the emergence of a domestic contemporary art market and gallery scene. Chinese contemporary art had become molten hot on the international market, and many former "starving" artists who had once been critical of the Chinese government were now sporting what the Chinese call "success bellies," boasting record-breaking auction prices and toeing the party line in their Prada shoes and Range Rovers. But unlike his peers, Ai Weiwei, when presented with such seductions, refused that Faustian bargain—to simmer down and shut up, to refrain from making overtly critical art or commentary, all in exchange for the tidy little sphere of "freedom" in which to make money. His international career flourished, and surely it would have been easy to rationalize doing what so many others had done. But Ai Weiwei didn't. He refused to stop speaking out against corruption and absurd injustice; in short, he refused to stop being a public intellectual. In fact, he was only just getting revved up.

Social Media as Interventionist Art (2006–2014)

Although he could barely type, Ai Weiwei, recognizing social media's potential to reach a vast public, became a prolific blogger. From 2006 to 2009, he ruminated and ranted, passing scathing judgments on pathologies

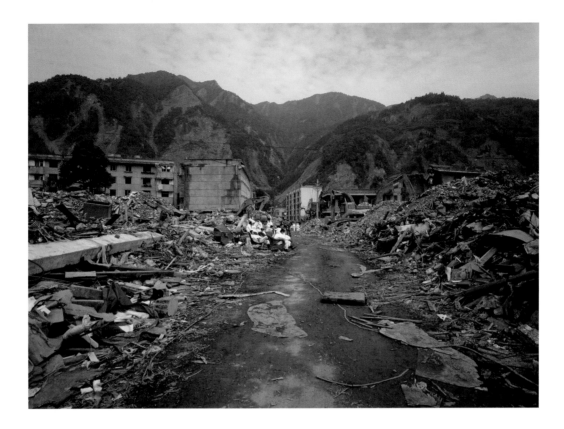

of the times and unleashing his wrath on rampant injustice. He wrote about art and architecture, his past, political and social events, government policies, and more. Then, on June 1, 2009, officialdom blocked his blog. After being silenced online in China, he leapt over the "Great Fire Wall" surrounding the heavily censored Chinese intranet and hopped onto Twitter.

Ai Weiwei's social media activities and his writings became as much a part of being an artist as they shaped his way of being a person. Alongside these writings came a flood of documentary photographs (now on Instagram). Some became memes, and many were virally shared. His YouTube channel[8] shares documentary videos related to the sociopolitical issues informing many of his recent works. After his arrest, in the face of constant surveillance, he again gave authority the finger and launched *WeiweiCam*, putting his entire life online live, until it was shut down by officialdom forty-six hours later.

Ai Weiwei's social conscience was not spawned overnight in the glow of the Olympics, but the 2008 games were perhaps the first in a series of critical junctures in his increasing unwillingness to be silenced. After working with Swiss architects Herzog & de Meuron to design the Beijing National Stadium (known as the Bird's Nest), he became an outspoken critic of theurban cleansing that had flushed the migrant laborers out of the city before the games like so much detritus—the people who had built the new Beijing and Olympic facilities. On the final day of the Olympics, Ai Weiwei posted the following message on his blog:

> For a moment, forget the struggle between tyranny and civil rights; forget the extravagant dreams of referendums or citizen votes. We should struggle for and protect those most basic, miniscule bits of power that we truly cannot cast aside: freedom of speech and rule of law. Return basic rights to the people, endow society with basic dignity, and only then can we have confidence and take responsibility, and thus face our collective difficulties. Only rule of law can make the game equal, and only when it is equal can people's participation possibly be extraordinary.[9]

Wenchuan Earthquake in Sichuan & Its Aftermath

On May 12, 2008, a 7.9 earthquake in Sichuan Province killed nearly 70,000 people and left almost 20,000 more missing. Millions lost their homes. A disproportionate number of schoolchildren died in the tragedy

above: Ai Weiwei, *Sichuan Earthquake Photo*, 2008, color photograph

when their classrooms collapsed, crushing them to death. While the government's rapid relief efforts were widely lauded, people wondered how so many schools could have crumbled unless substandard construction methods and materials had been used. Parents of the victims rallied for an investigation that never materialized, and some were intimidated or bribed into silence by local officials.

This tragedy was another critical juncture for Ai Weiwei and became one of the central themes in his art and activist interventions since 2008. He formed a team, including over one hundred volunteers, to carry out his "5.12 Citizens' Investigation" in order to compile a comprehensive names list commemorating the children killed in the quake, recording their ages, birthdates, places of residence, and places of death. One resulting artwork, *The Names of the Student Earthquake Victims Found by the Citizens' Investigation* (2008–2011), transforms this data into an enormous, neatly typed grid of names and personal data, bringing to mind Maya Lin's Vietnam Veterans Memorial wall in Washington, DC. Ai Weiwei's stark video *4851* (2009) is a tribute to those children his team had identified by September 2, 2009,[10] as is his film *Little Girl's Cheeks* (2012).[11] Later, these investigations confirmed the deaths of at least 5,192 children and led to confrontations

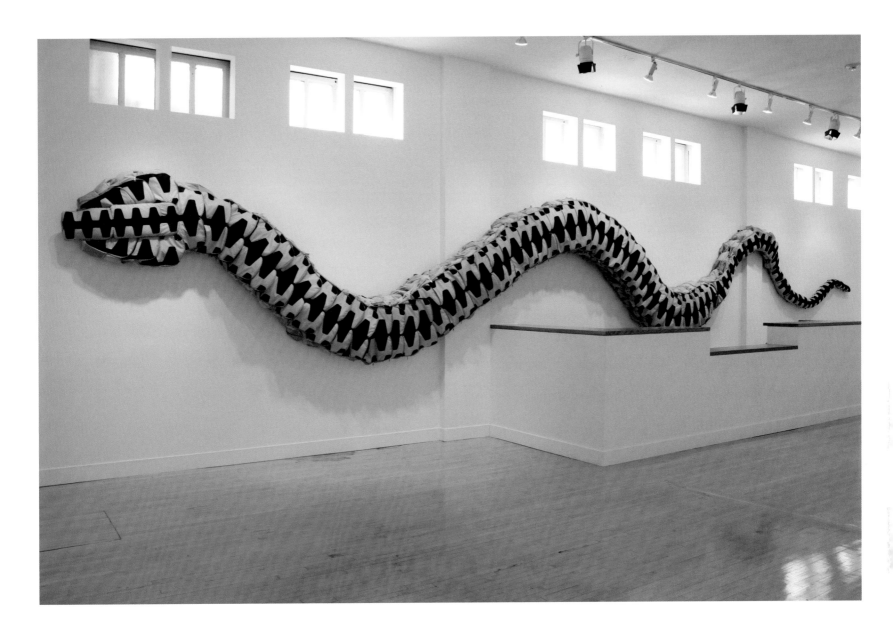

with the Chengdu police, which escalated when Ai Weiwei tried to appear as a witness at the trial of activist Tan Zuoren, who was subsequently sentenced to five years in prison.[12] After being beaten by police and prevented from attending the trial, Ai Weiwei suffered a cerebral hemorrhage. He had just flown to Munich for an exhibition and received emergency brain surgery there.[13] These events, and his related films *Disturbing the Peace* (2009) and *So Sorry* (2009), show the mounting tension between the artist and the state.[14]

In *So Sorry*, Ai Weiwei notes that his team and the officials refusing to cooperate during his citizens' investigation or provide information about schoolchildren killed in the quake are actually in the same predicament. According to the artist, the officials are "stuck in a system" and doing "their duty" from within that system, while he is doing his duty from within his own belief system. "Why does power exist as a necessity in virtually any society?" Ai Weiwei asks, before concluding that "every society must have the right to monitor and restrain power."[15]

opposite: From Ai Weiwei, *Sichuan Earthquake Photos*, 2008– ; series of 16 black-and-white photographs

above: Ai Weiwei, *Snake Bag*, 2008; 360 backpacks, 27.5 x 670 x 15.75 inches

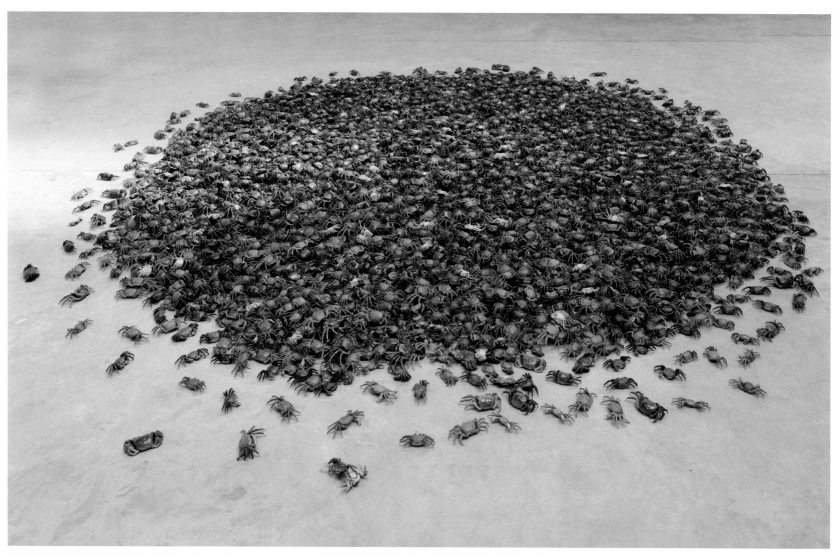

top: Ai Weiwei, *He Xie*, 2010– ; 3,000 porcelain crabs, dimensions variable

above, left: Ai Weiwei, *Shanghai Studio*, 2011 (before demolition); color photograph

above, right: Ai Weiwei, *Shanghai Studio*, 2011 (after demolition); color photograph

In response to the earthquake, Ai Weiwei has also created a number of visually wrenching pieces, including *Snake Ceiling* (2009), made from children's backpacks coiled along ceilings, and the audio work *Remembrance* (2010). He procured over two hundred tons of the steel rebar that was supposed to reinforce concrete buildings from out of the rubble of Beichuan Middle School, where so many children perished. From this found material he has created works such as the precisely carved *Rebar in Marble* (2012), a replica of a mangled steel rod; *Forge Bed* (2008–2012); and *Straight* (2008–2012), in which 150 tons of twisted rebar rods were restraightened and assembled to resemble a "fissure in the ground, and a gulf in values."[16]

The Claws of the River Crabs

On the Chinese intranet, where sites such as Facebook, YouTube, Twitter, and many others are blocked by the Great Fire Wall of China, legions of state employees are paid to police websites, identifying and deleting—a process euphemistically called "harmonizing"—content deemed inappropriate by state censors. Tech-savvy netizens find ways to scale the wall, using coded language to evade censors: usually innocuous homophones with meanings that are obviously incorrect given their context. The Chinese word for "harmonious," *he xie*, is one such homophone. The word, which gained currency following the Communist Party's 2004 self-proclaimed goal of creating a more "harmonious society," sounds similar to the Chinese word for "river crab"; thus the river crab has become a symbol through which Chinese netizens can slyly refer to censorship while avoiding the mechanisms of silence they are critiquing.

Before Ai Weiwei had become critical of the Olympics, in early 2008 officials in Shanghai had invited him to build a studio there, only to claim later that he had no permit and suddenly demolish the space in January 2011. The artist saved the brick and cement rubble for a later artwork, *Souvenir from Shanghai* (2012), but first he decided to hold a river crab feast at the studio in symbolic protest. After being placed under house arrest to prevent him from attending, the artist made a series of porcelain river crabs for the work *He Xie* (2011). These crabs appear again in his heavy metal video *Dumbass* (2013).

Eighty-One Days and Counting—Incarceration

As China scholar Geremie Barmé puts it, Ai Weiwei must have made a conscious decision to keep pushing, knowing where it would lead. He places Ai Weiwei in lineage with "a long line of modern Chinese thinkers and cultural figures whose moral outrage in the face of tyranny has taken the form of lambast, irony, or biting satire."[17]

On April 3, 2011, Ai Weiwei was taken into state custody and held without being charged until June 22, 2011. Over those eighty-one days, during which the world did not know where the artist was or if he would ever be seen again, cultural and political figures such as acclaimed writer and champion of free expression Salman Rushdie rallied to his defense, calling for his release.[18] Art world people organized events to draw attention to his missing status, and journalists wrote articles asking, "Where Is Ai Weiwei?"[19]

In 2012, after his release, Ai Weiwei was charged with a series of offenses, including tax evasion; online dissemination of pornography, based on an artwork featuring nudity; and bigamy, presumably due to having a son out of wedlock. His website contends that these charges were trumped-up "political retaliation for his outspoken criticism of the government."[20]

Many new works explore Ai Weiwei's experience of incarceration, such as his carved jade *Handcuffs* (2013), which references being cuffed during interrogation sessions. Some political dissidents in solitary confinement have preserved their sanity by memorizing the physical details of their cells. While Ai Weiwei was not allowed solitude during his confinement, the site of his interrogations is also imprinted on his memory and restaged as several artworks featuring his cell. The cell displayed at the 2014 exhibition *Ai Weiwei: Evidence,* at the Martin-Gropius-Bau in Berlin, is based wholly on Ai's memory:

> The outside of the door is labeled with the numbers 1135, making it resemble a hotel room. The room itself is quite large, at 26 square meters (269 square feet), the flooring is imitation parquet and there are two damask-patterned curtains. The window, however, is high, small and barred. The walls are also covered in foam plastic, which is covered with foil. It's a provisionary padded cell. A few openings in the coating enable a glimpse of the actual wall covering, flower-patterned wallpaper. There's a small bathroom in the corner.[21]

This theme also animates the six diorama works that compose the installation *S.A.C.R.E.D.* (2011–2013) that premiered in conjunction with the Venice Biennale in 2013. The acronym represents the subtitles of the six dioramas—*Supper, Accusers, Cleansing, Ritual, Entropy, and Doubt,* each one depicting harrowing experiences from his incarceration. He has also used one of the cellblocks of the historic Alcatraz penitentiary to house installations featuring the voices—reading poetry, singing, and speaking—of creatives of conscience imprisoned across the world during various periods, from contemporary Iran to apartheid-era South Africa.

Musical Self-Therapy

As a form of personal exorcism, Ai Weiwei released a heavy metal CD in 2013 with post-punk musican Zuoxiao Zuzhou. *The Divine Comedy* is accompanied by videos, including *Dumbass.*[22] It features scenes depicted in the *S.A.C.R.E.D.* dioramas, except here he uses the cathartic power of music to enact additional, alternate scenarios in his jail cell. Flanked by two guards as he showers, uses the toilet, eats, and sleeps, a defiant Weiwei also dances, singing roguishly as he showers, as if to taunt his captors that they can bind his wings but cannot keep his soul from flight. Ai Weiwei explains:

> During my detention, the conditions were very restrictive, but the guards would often secretly ask me to sing for them. . . . I felt deeply sorry that I couldn't do it, either I was not in the mood or I didn't think I can sing. The only songs I knew were the revolutionary ones. It is the same for many Chinese people; we had to memorize every Red song. Creating music is a way to break through that situation.[23]

Likewise, in his intervention in Alcatraz's psychiatric observation rooms, *Illumination*, the chants of Tibetans resisting colonial rule are paired with the singing of Hopi men, who were once imprisoned on the island for resisting colonial oppression. This work also pays tribute to the Native American Red Power occupation of Alcatraz from 1969 to 1971 and, more generally, to resistance to oppressive power everywhere.

Flowers for Freedom and Remembrance

Still under constant surveillance and no longer in possession of a valid passport, Ai Weiwei continues to live and make his work, defying attempts to intimidate him into docile silence. Using the language of art, he continues to struggle publicly for justice, making the world around him beautiful in his own sometimes small

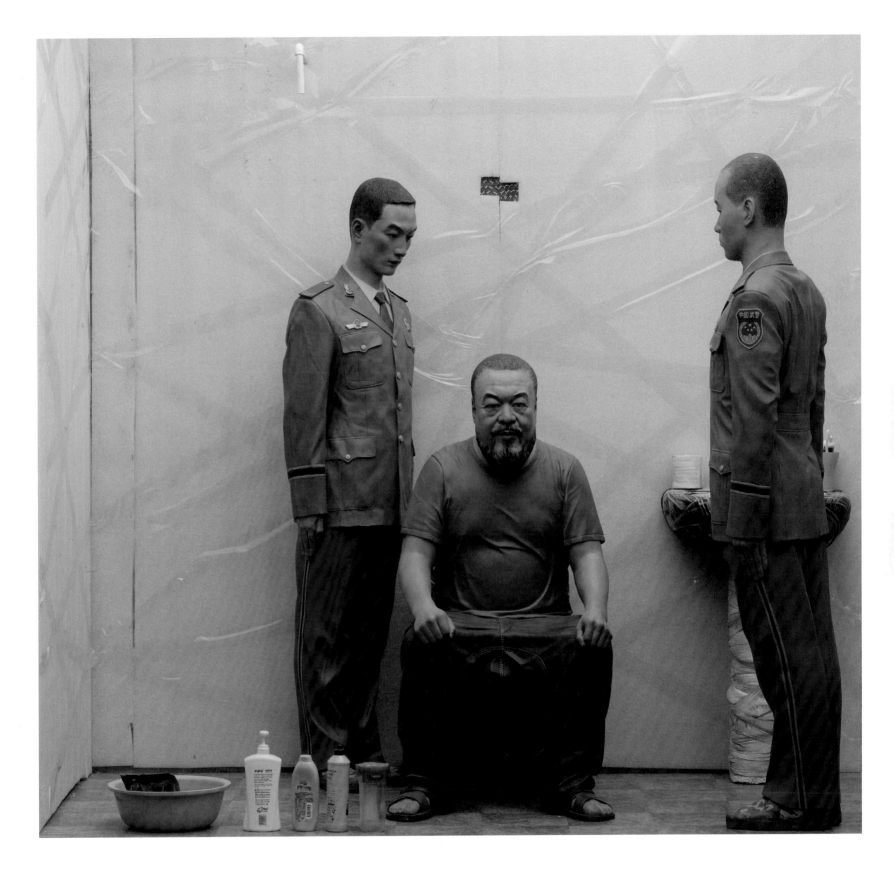

above: Ai Weiwei, *Accusers*, 2011–2013 (detail); fiberglass and iron,
148.5 x 78 x 60 inches; one of six dioramas from the work *S.A.C.R.E.D.*

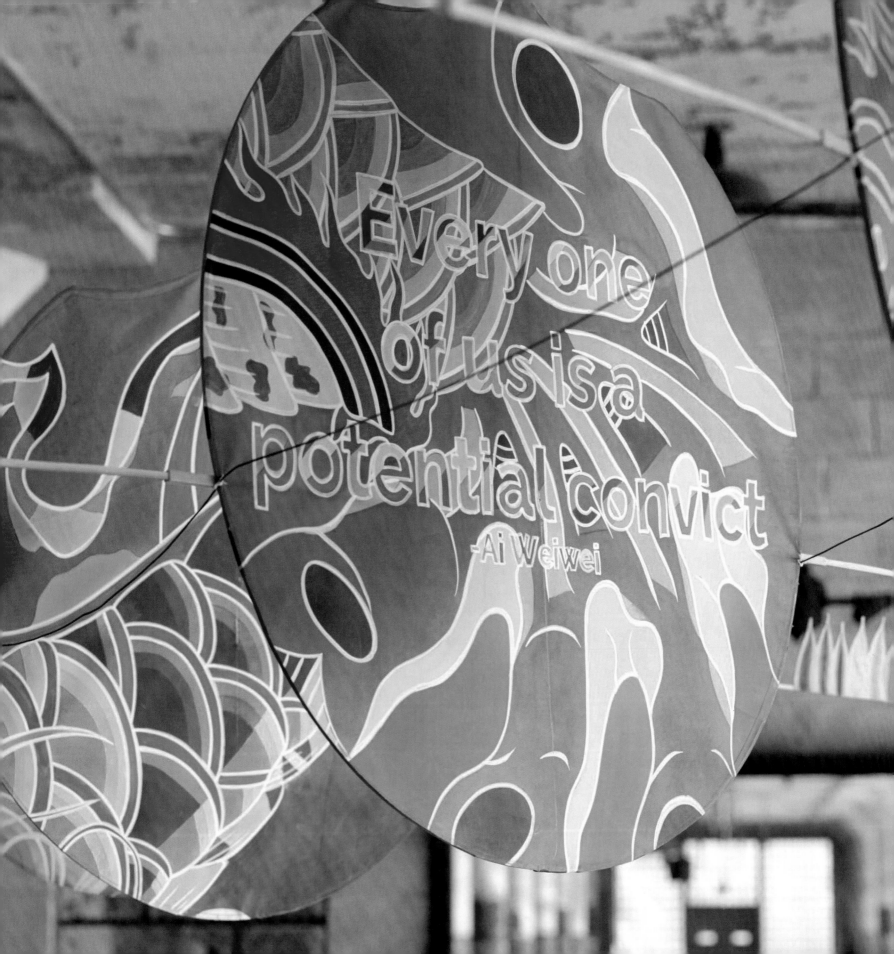

and sometimes momentous ways. For example, his #aiflowers Twitter hashtag invited people everywhere to make flowers memorializing the children killed in the earthquake.[24] Since late 2013, he has left a bouquet of fresh flowers in the basket of a bicycle outside his studio each morning, and plans to continue doing so until his right to travel freely is restored. The porcelain flowers making up his intervention project in Alcatraz's Hospital cells expands on this language, using flowers as a universal symbol for both freedom and remembrance.

Flying with Fettered Wings

Indeed, many of Ai Weiwei's Alcatraz interventions explore the meaning of freedom in conditions of constraint—not unlike the experience of flying with fettered wings. His imposing piece *Refraction* evokes this tension, as does his *With Wind* installation. Flying kites was a beloved pastime for the residents of old Beijing, but kite making is now a dying craft. As evidenced by his previous collaborations with the traditional porcelain craftspeople of Jingdezhen, Ai Weiwei has an abiding interest in giving dying crafts new wings by using traditional techniques and artisans to render contemporary artworks. Kites in a prison pose the paradoxical image of the caged flight. Yet the resilience of creative dissenters throughout history suggests that no power is great enough to pin down freedom itself. As Ai Weiwei puts it: "When you constrain freedom, freedom will take flight…." Perhaps these kites are another embodiment of Ai Weiwei's tenacious hope inherited from his poet father, Ai Qing, who writes in his 1979 poem "Hope":

> Dream's friend
> Illusion's sister
>
> Originally your shadow
> Yet always in front of you
> […]
> Like flying birds outside the window
> Like floating clouds in the sky
>
> Like butterflies by the river
> She is sly and lovely
> […]
> She is always with you
> To your dying breath.[25]

The Power of the Powerless

With great fame often comes a distorted sense of self-importance, but rather than being intoxicated by fame, Ai Weiwei is intrigued by what fame can leverage. His sees through the gimcrack glitz of celebrity and finds its rituals risible, yet understands that his high profile is partly what keeps him from disappearing into the bowels of a disgruntled state apparatus—a state impatient with his public provocations. Yet instead of convincing him to pack those contentious skeletons back into tidy closets, as so many of his peers have done in exchange for the right to make money, each effort to bully Ai Weiwei into self-censorship has only amplified his sense of outrage.

opposite: Ai Weiwei, *With Wind*, 2014 (detail); installation: handmade kites (paper, silk, and bamboo); part of *@Large: Ai Weiwei on Alcatraz*, Alcatraz Island, 2014–2015

Indeed, each attempt to show Ai Weiwei that he is puny and powerless before the mighty state has only crystallized the artist's understanding of the necessity of speaking out. As Edward Said suggested, a public intellectual is "someone whose place is to raise embarrassing questions, to confront orthodoxy and dogma, to be someone who cannot easily be co-opted by governments or corporations."[26] Being a public intellectual is neither parallel to nor separate from Ai Weiwei's practice as an artist but inextricably intertwined. For Ai Weiwei, being an artist is a way of being a person. And being a person he can face in the mirror has become synonymous with being a public intellectual.

A line from one of his father's poems, "Living Fossil," foreshadows the principled resistance that animates Ai Weiwei's life's work: ". . . any fool can see: / We cannot live unless we can move. / To live is to struggle, / to advance / We must expend our all / Before the advance of death."[27]

Perhaps more unambiguously than any exhibition of his work thus far, *@Large* transcends both the larger-than-life myth of Ai Weiwei as art world celebrity and the poignancy of his own predicament as a critic of one of the world's most powerful states. In doing so, this exhibition becomes something greater than simply a testament to individual will and a display of his personal struggles and achievements. Created in dialogue with the multiple histories of Alcatraz, the works in *@Large* are an embodiment of how Ai Weiwei's art can speak across nations and cultures to all of us, drawing us into a conversation about resistance and persistence and, in doing so, offering visitors to this prison island a humbling, uplifting vision of the potential power of the powerless.

Notes

1. Ai Weiwei, *Ai Weiwei's Blog: Writings, Interviews, and Digital Rants*, 2006–2009, ed. and trans. Lee Ambrozy (Cambridge, MA: MIT Press, 2011), 218. Original blog post, April 13, 2009.
2. Mark Stevens, "Is Ai Weiwei China's Most Dangerous Man?" *Smithsonian Magazine*, September 2012.
3. Ulrike Knöfel, "The Unrelenting Ai Weiwei: Show Evokes Danger and Urgency of Art," *Spiegel Online International*, April 2, 2014. http://www.spiegel.de/international/zeitgeist/ai-weiwei-exhibition -underscores-dangers-and-importance-of-art-a-961990.html
4. For some of Ai Weiwei's father's critically acclaimed poetry in English translation, see Ai Qing, *Selected Poems of Ai Qing*, trans. Eugene Chen Eoyang (Bloomington, IN: Indiana University Press, 1988).
5. Beige Wind, "Dispatches from Xinjiang: The Legacy of Ai Qing's Chinese Central Asian Poetics," *Beijing Cream*, November 21, 2013. http://beijingcream.com/2013/11/dfxj-the-legacy-of-ai-qings -chinese-central-asian-poetics and http://beigewind.wordpress.com/2013/07/08/a-smile-of-recognition -a-look-of-disdain-sharing-a-uyghur-frame
6. http://zocalopoets.com/category/poets-poetas/ai-qing
7. The Stars included Huang Rui, Ma Desheng, Wang Keping, and other major artists still noteworthy today.
8. https://www.youtube.com/user/diaocha
9. Ai Weiwei, *Ai Weiwei's Blog*. Original blog post, April 13, 2009.
10. http://aiweiwei.com/projects/5-12-citizens-investigation/name-list-investigation
11. Ibid.
12. Ibid.
13. http://aiweiwei.com/documentaries/so-sorry
14. Ibid.
15. Ibid.
16. http://www.brooklynmuseum.org/exhibitions/ai_weiwei/#!lb_uri=straight.php
17. Geremie Barmé, "A View on Ai Weiwei's Exit," *The China Beat*, April 27, 2011. http://www.thechinabeat.org/?p=3371
18. Salman Rushdie, "Dangerous Arts," *New York Times*, April 19, 2011. http://www.nytimes.com/2011/04/20/opinion/20Rushdie.html
19. Adrian Searle, "Where Is Ai Weiwei?" *The Guardian*, May 9, 2011. http://www.theguardian.com/artanddesign/2011/may/09/ai-weiwei-arrest-protest-exhibition
20. http://fakecase.com
21. Knöfel, "The Unrelenting Ai Weiwei," 2014.
22. http://aiweiwei.com/mixed-media/music-videos
23. http://aiweiwei.com. Posted May 22, 2013.
24. http://aiweiwei.com. Posted May 9, 2013.
25. http://zocalopoets.com/category/poets-poetas/ai-qing
26. Edward Said, *Representations of the Intellectual* (New York: Pantheon Books, 1994), 11.
27. Barmé, "A View on Ai Weiwei's Exit."

Universal Declaration of Human Rights

Drafted by the Commission on Human Rights
Adopted by the UN General Assembly on December 10, 1948

Preamble

Whereas recognition of the inherent dignity and of the equal and inalienable rights of all members of the human family is the foundation of freedom, justice and peace in the world,

Whereas disregard and contempt for human rights have resulted in barbarous acts which have outraged the conscience of mankind, and the advent of a world in which human beings shall enjoy freedom of speech and belief and freedom from fear and want has been proclaimed as the highest aspiration of the common people,

Whereas it is essential, if man is not to be compelled to have recourse, as a last resort, to rebellion against tyranny and oppression, that human rights should be protected by the rule of law,

Whereas it is essential to promote the development of friendly relations between nations,

Whereas the peoples of the United Nations have in the Charter reaffirmed their faith in fundamental human rights, in the dignity and worth of the human person and in the equal rights of men and women and have determined to promote social progress and better standards of life in larger freedom,

Whereas Member States have pledged themselves to achieve, in co-operation with the United Nations, the promotion of universal respect for and observance of human rights and fundamental freedoms,

Whereas a common understanding of these rights and freedoms is of the greatest importance for the full realization of this pledge,

Now, Therefore THE GENERAL ASSEMBLY proclaims THIS UNIVERSAL DECLARATION OF HUMAN RIGHTS as a common standard of achievement for all peoples and all nations, to the end that every individual and every organ of society, keeping this Declaration constantly in mind, shall strive by teaching and education to promote respect for these rights and freedoms and by progressive measures, national and international, to secure their universal and effective recognition and observance, both among the peoples of Member States themselves and among the peoples of territories under their jurisdiction.

Article 1

All human beings are born free and equal in dignity and rights. They are endowed with reason and conscience and should act towards one another in a spirit of brotherhood.

Article 2

Everyone is entitled to all the rights and freedoms set forth in this Declaration, without distinction of any kind, such as race, colour, sex, language, religion, political or other opinion, national or social origin, property, birth or other status. Furthermore, no distinction shall be made on the basis of the political, jurisdictional or international status of the country or territory to which a person belongs, whether it be independent, trust, non-self-governing or under any other limitation of sovereignty.

Article 3

Everyone has the right to life, liberty and security of person.

Article 4

No one shall be held in slavery or servitude; slavery and the slave trade shall be prohibited in all their forms.

Article 5

No one shall be subjected to torture or to cruel, inhuman or degrading treatment or punishment.

Article 6

Everyone has the right to recognition everywhere as a person before the law.

Article 7

All are equal before the law and are entitled without any discrimination to equal protection of the law. All are entitled to equal protection against any discrimination in violation of this Declaration and against any incitement to such discrimination.

Article 8

Everyone has the right to an effective remedy by the competent national tribunals for acts violating the fundamental rights granted him by the constitution or by law.

opposite, top row, left to right: Eleanor Roosevelt, United States; Dr. Peng-chun Chang, China; Hernán Santa Cruz, Chile
center row, left to right: René Cassin, France; William Hodgson, Australia; Alexandre Bogomolov, USSR
bottom row, left to right: Charles Dukes, United Kingdom; John P. Humphrey, Canada, Dr. Charles Malik, Lebanon

Article 9

No one shall be subjected to arbitrary arrest, detention or exile.

Article 10

Everyone is entitled in full equality to a fair and public hearing by an independent and impartial tribunal, in the determination of his rights and obligations and of any criminal charge against him.

Article 11

(1) Everyone charged with a penal offence has the right to be presumed innocent until proved guilty according to law in a public trial at which he has had all the guarantees necessary for his defence.
(2) No one shall be held guilty of any penal offence on account of any act or omission which did not constitute a penal offence, under national or international law, at the time when it was committed. Nor shall a heavier penalty be imposed than the one that was applicable at the time the penal offence was committed.

Article 12

No one shall be subjected to arbitrary interference with his privacy, family, home or correspondence, nor to attacks upon his honour and reputation. Everyone has the right to the protection of the law against such interference or attacks.

Article 13

(1) Everyone has the right to freedom of movement and residence within the borders of each state.
(2) Everyone has the right to leave any country, including his own, and to return to his country.

Article 14

(1) Everyone has the right to seek and to enjoy in other countries asylum from persecution.
(2) This right may not be invoked in the case of prosecutions genuinely arising from non-political crimes or from acts contrary to the purposes and principles of the United Nations.

Article 15

(1) Everyone has the right to a nationality.
(2) No one shall be arbitrarily deprived of his nationality nor denied the right to change his nationality.

Article 16

(1) Men and women of full age, without any limitation due to race, nationality or religion, have the right to marry and to found a family. They are entitled to equal rights as to marriage, during marriage and at its dissolution.
(2) Marriage shall be entered into only with the free and full consent of the intending spouses.
(3) The family is the natural and fundamental group unit of society and is entitled to protection by society and the State.

Article 17

(1) Everyone has the right to own property alone as well as in association with others.
(2) No one shall be arbitrarily deprived of his property.

Article 18

Everyone has the right to freedom of thought, conscience and religion; this right includes freedom to change his religion or belief, and freedom, either alone or in community with others and in public or private, to manifest his religion or belief in teaching, practice, worship and observance.

Article 19

Everyone has the right to freedom of opinion and expression; this right includes freedom to hold opinions without interference and to seek, receive and impart information and ideas through any media and regardless of frontiers.

Article 20

(1) Everyone has the right to freedom of peaceful assembly and association.
(2) No one may be compelled to belong to an association.

Article 21

(1) Everyone has the right to take part in the government of his country, directly or through freely chosen representatives.
(2) Everyone has the right of equal access to public service in his country.
(3) The will of the people shall be the basis of the authority of government; this will shall be expressed in periodic and genuine elections which shall be by universal and equal suffrage and shall be held by secret vote or by equivalent free voting procedures.

Article 22

Everyone, as a member of society, has the right to social security and is entitled to realization, through national effort and international co-operation and in accordance with the organization and resources of each State, of the economic, social and cultural rights indispensable for his dignity and the free development of his personality.

Article 23

(1) Everyone has the right to work, to free choice of employment, to just and favourable conditions of work and to protection against unemployment.

(2) Everyone, without any discrimination, has the right to equal pay for equal work.

(3) Everyone who works has the right to just and favourable remuneration ensuring for himself and his family an existence worthy of human dignity, and supplemented, if necessary, by other means of social protection.

(4) Everyone has the right to form and to join trade unions for the protection of his interests.

Article 24

Everyone has the right to rest and leisure, including reasonable limitation of working hours and periodic holidays with pay.

Article 25

(1) Everyone has the right to a standard of living adequate for the health and well-being of himself and of his family, including food, clothing, housing and medical care and necessary social services, and the right to security in the event of unemployment, sickness, disability, widowhood, old age or other lack of livelihood in circumstances beyond his control.

(2) Motherhood and childhood are entitled to special care and assistance. All children, whether born in or out of wedlock, shall enjoy the same social protection.

Article 26

(1) Everyone has the right to education. Education shall be free, at least in the elementary and fundamental stages. Elementary education shall be compulsory. Technical and professional education shall be made generally available and higher education shall be equally accessible to all on the basis of merit.

(2) Education shall be directed to the full development of the human personality and to the strengthening of respect for human rights and fundamental freedoms. It shall promote understanding, tolerance and friendship among all nations, racial or religious groups, and shall further the activities of the United Nations for the maintenance of peace.

(3) Parents have a prior right to choose the kind of education that shall be given to their children.

Article 27

(1) Everyone has the right freely to participate in the cultural life of the community, to enjoy the arts and to share in scientific advancement and its benefits.

(2) Everyone has the right to the protection of the moral and material interests resulting from any scientific, literary or artistic production of which he is the author.

Article 28

Everyone is entitled to a social and international order in which the rights and freedoms set forth in this Declaration can be fully realized.

Article 29

(1) Everyone has duties to the community in which alone the free and full development of his personality is possible.

(2) In the exercise of his rights and freedoms, everyone shall be subject only to such limitations as are determined by law solely for the purpose of securing due recognition and respect for the rights and freedoms of others and of meeting the just requirements of morality, public order and the general welfare in a democratic society.

(3) These rights and freedoms may in no case be exercised contrary to the purposes and principles of the United Nations.

Article 30

Nothing in this Declaration may be interpreted as implying for any State, group or person any right to engage in any activity or to perform any act aimed at the destruction of any of the rights and freedoms set forth herein.

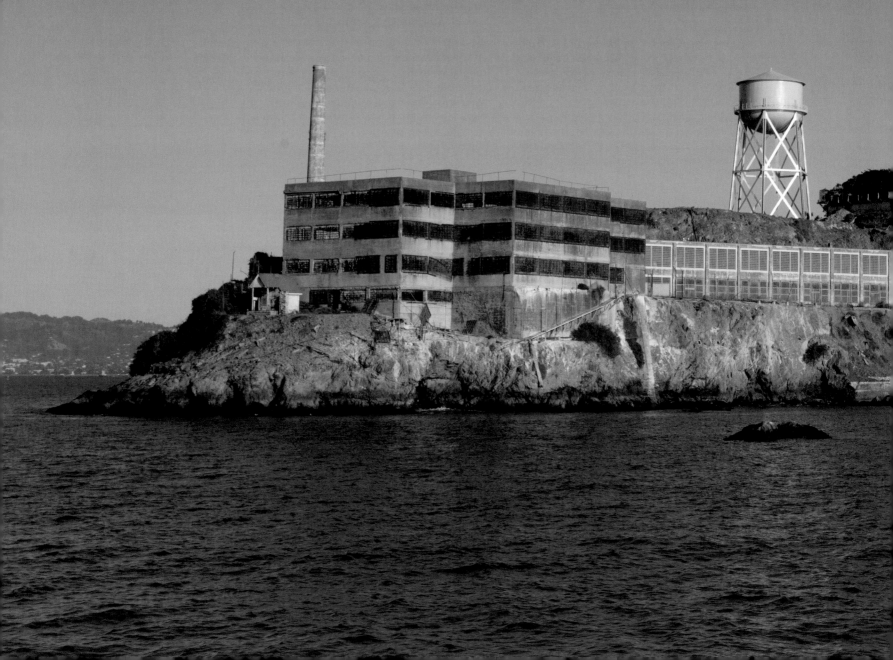

Artworks

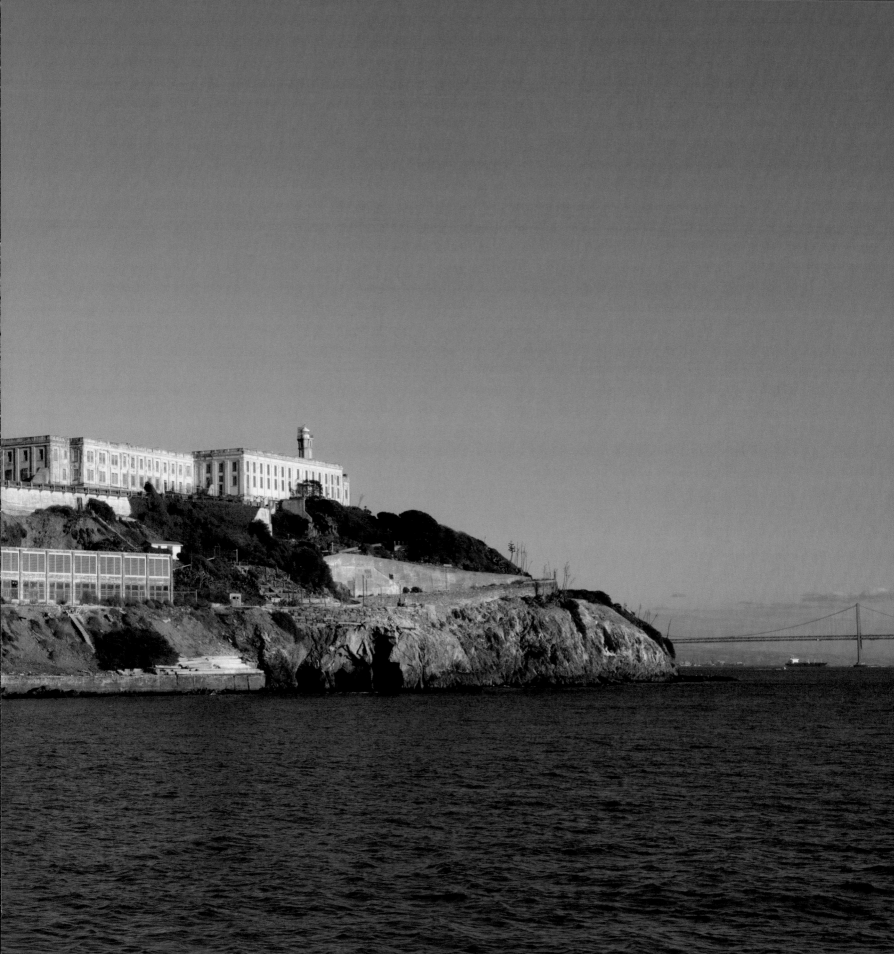

New Industries
Building:

With Wind

Trace

Refraction

New Industries Building In the federal penitentiary on Alcatraz Island, work was considered a privilege. One of the rewards for good behavior was a job, and for many inmates during the last two decades of the prison's existence, that job was in the New Industries Building. Built between 1939 and 1941, this two-story laundry and manufacturing facility was designed to replace the Model Industries Building nearby, which had been the site of several escape attempts.

Working in "the Industries" offered its own kinds of escape: from boredom and physical inactivity, from social isolation, and even from a full prison term. In exchange for his labor, an inmate could earn a shortened sentence—an average of two days' "good time" for a month's work—as well as a little money to send to family or save for the future. (In the prison's early days, the wage was five to twelve cents per hour.) Work could be a relief from the tedium of hours spent alone in a cell, and the daily walk down from the cellhouse to the New Industries Building offered panoramic views of San Francisco and the Golden Gate.

For some prisoners, though, the sight of the city was a tormenting reminder of how far they really were from freedom, and work, rather than a respite, was just another dreary routine. Former inmate Jim Quillen remembered his job in the New Industries brush shop as "the most frustrating and boring, not to mention aggravating, work I have ever done—before, during, or after my release from prison." Although workers had slightly more freedom to move about and communicate at work than in the cellhouse, they were still under constant control: unarmed guards patrolled the floor, carrying whistles to signal to armed guards in the gun gallery overhead in case of trouble.

opposite: New Industries tailor shop, c. 1950s

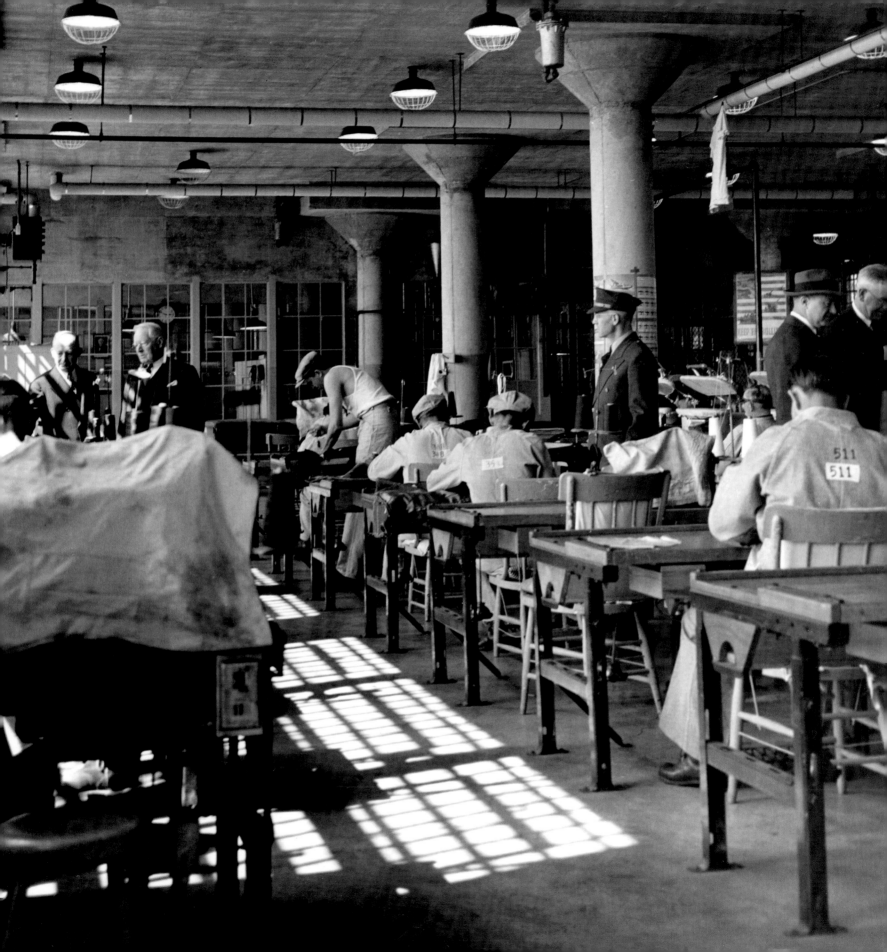

above: Inmates sewing in the New Industries Building, c. 1939–1962

opposite: Construction of laundry shop, c. 1930–1940

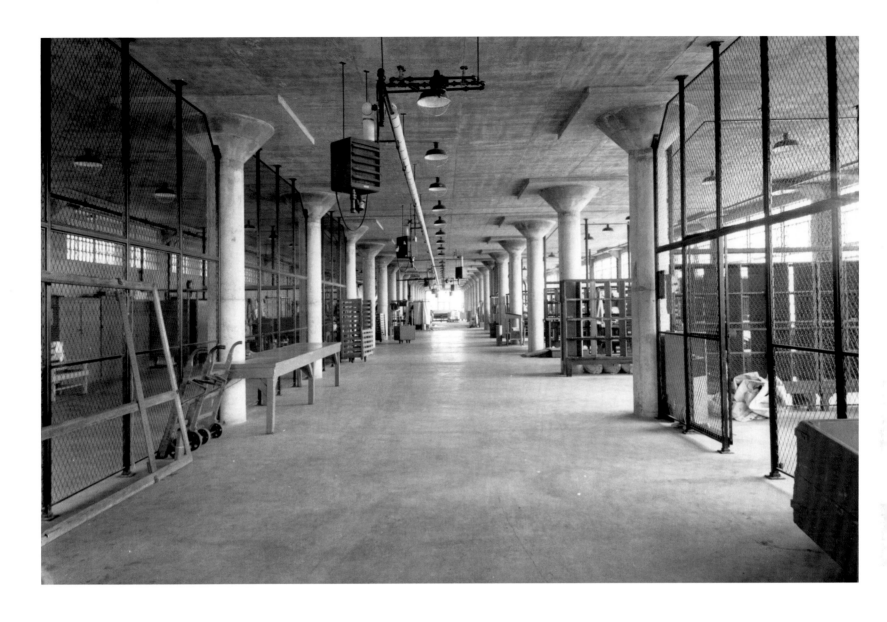

Former guard Jim Albright described the New Industries Building as "filled with the assorted sounds of clothes washers and dryers, band saws, grinders, hammers, and sewing machines.... The combined scents of laundry detergent, cleaning fluids, and other chemicals once filled the air." Workers here did laundry for military bases all over the Bay Area— initially, the entire upper floor was a laundry facility, the largest in San Francisco at the time—and manufactured clothing, gloves, shoes, brushes, and furniture for government use. During World War II, prisoners were also called upon to help the war effort: workers made tens of thousands of cargo nets for the U.S. Navy and repaired the large buoys that secured the submarine net across the Golden Gate.

The official employer of workers on Alcatraz was not the penitentiary itself but rather Federal Prison Industries, a government corporation launched in 1934 to create "factories with fences" in federal prisons. This corporation still exists today; operating under the name UNICOR, it has expanded to provide not only manual labor for government industry but also business services, such as prisoner-staffed call centers, for private companies. Currently, the United States is home to one of the world's largest prison labor forces, while forced labor remains a horrific reality for prisoners of conscience in many parts of the world.

The workshops in the New Industries Building started shutting down in October 1962, before the entire prison closed in 1963. Today, visitors to the national park can still see the views that were so tantalizing for the men who worked here, and observe the numerous birds that now use the cliffs outside New Industries as a nesting ground.

opposite: Gun gallery, New Industries Building

With Wind

Installation, 2014
Handmade kites made of
paper, silk, and bamboo

Both delicate and fearsome, the traditional Chinese dragon kite embodies a mythical symbol of power. Ai Weiwei unfurls a spectacular contemporary version of this age-old art form inside the New Industries Building: a sculptural installation with an enormous dragon's head and a body made up of smaller kites, some of which carry quotations from activists who have been imprisoned or exiled, including Nelson Mandela, Edward Snowden, and Ai himself. The swallow-shaped and hexagonal kites scattered throughout the room feature stylized renderings of birds and flowers—natural forms that allude to a stark human reality: many are symbols of nations with serious records of restricting their citizens' human rights and civil liberties.

Ai's studio collaborated with Chinese artisans to produce the handmade kites, reviving a craft with a diminishing presence in China. By confining the work inside a building once used for prison labor, the artist suggests powerful contradictions between freedom and restriction, creativity and repression, cultural pride and national shame. He also offers a poetic response to the multilayered nature of Alcatraz as a former penitentiary that is now an important bird habitat and a site of thriving gardens.

Individual prisoners of conscience from many of the countries referenced here are also represented in other artworks in the exhibition, including *Trace* in the adjacent room and *Yours Truly* in the Dining Hall. In addition to viewing the kite from floor level, visitors can observe it from above by entering the upper gun gallery that runs the length of the New Industries Building.

opposite and following: Ai Weiwei, *With Wind*, 2014 (detail);
installation: handmade kites (paper, silk, and bamboo); part of
@Large: Ai Weiwei on Alcatraz, Alcatraz Island, 2014–2015

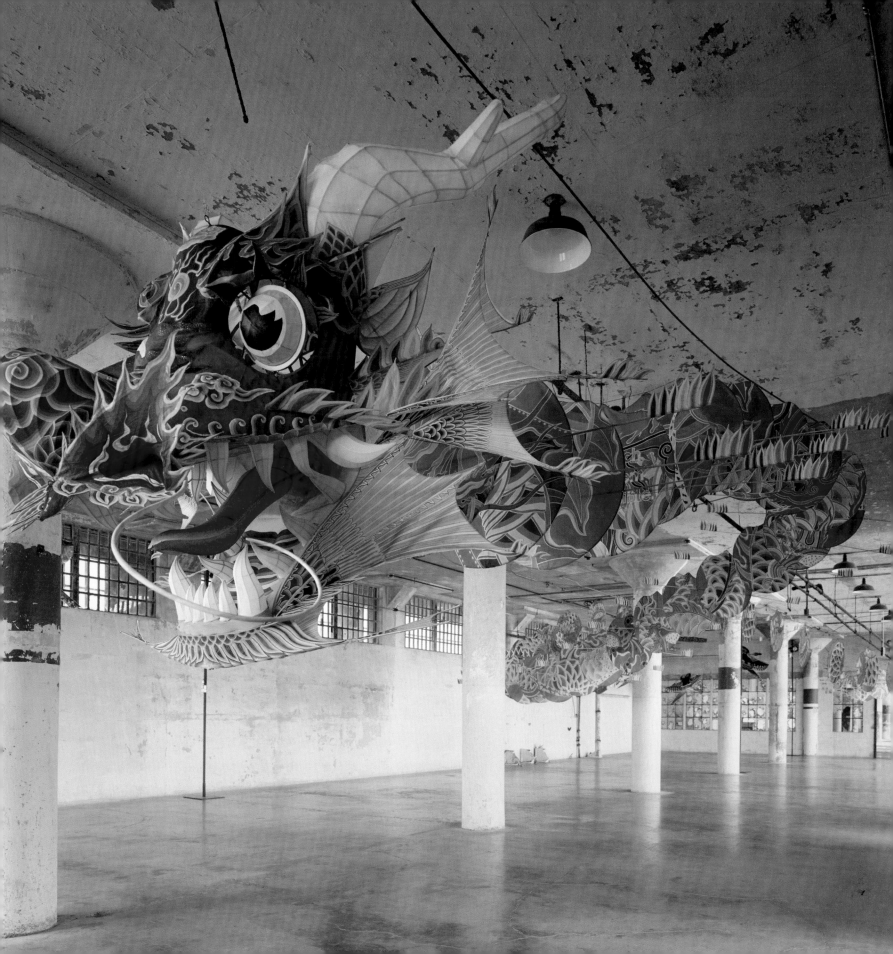

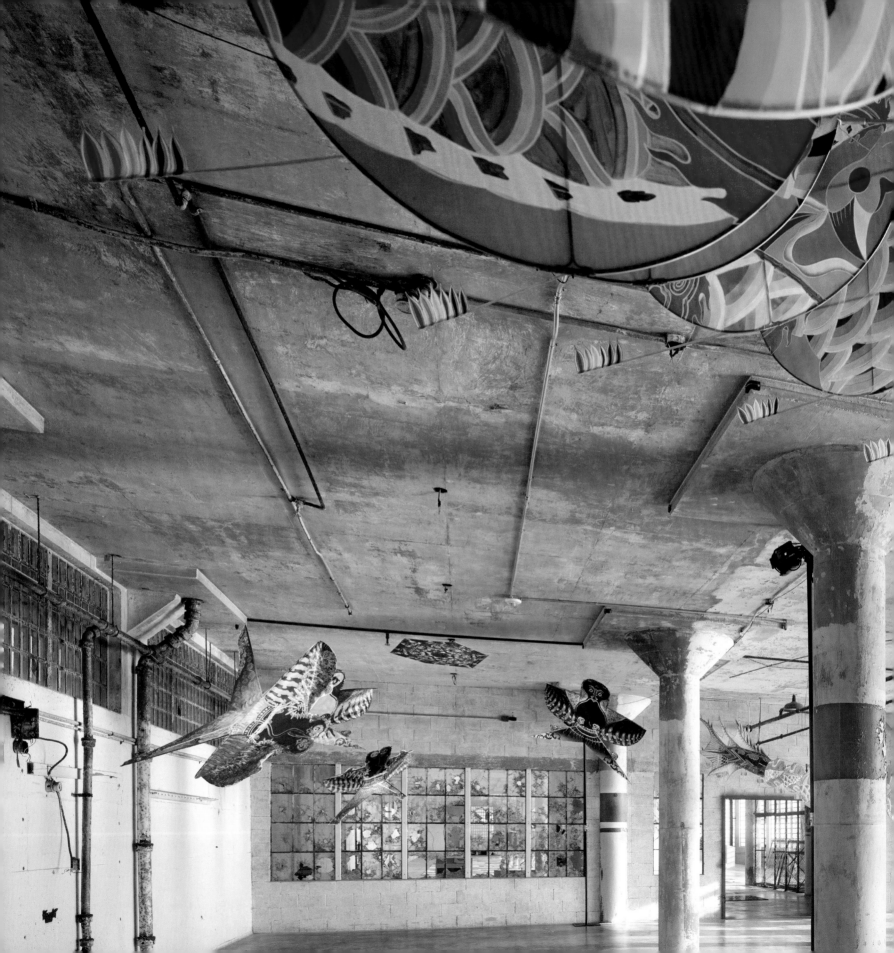

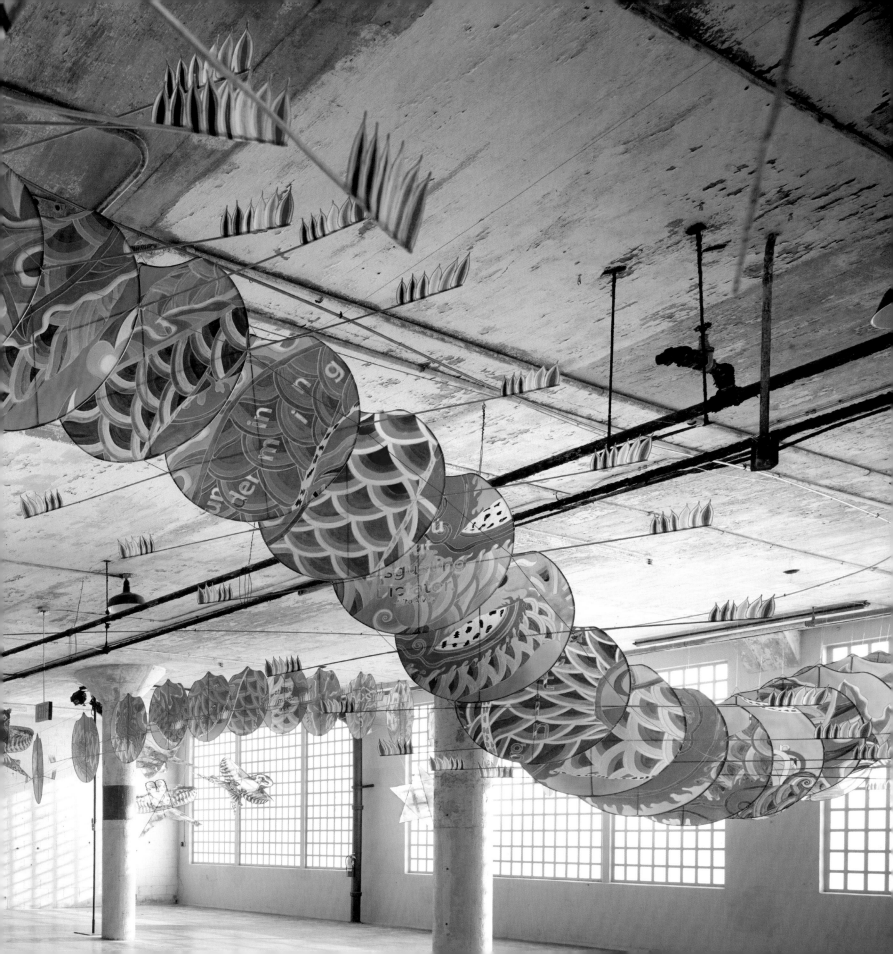

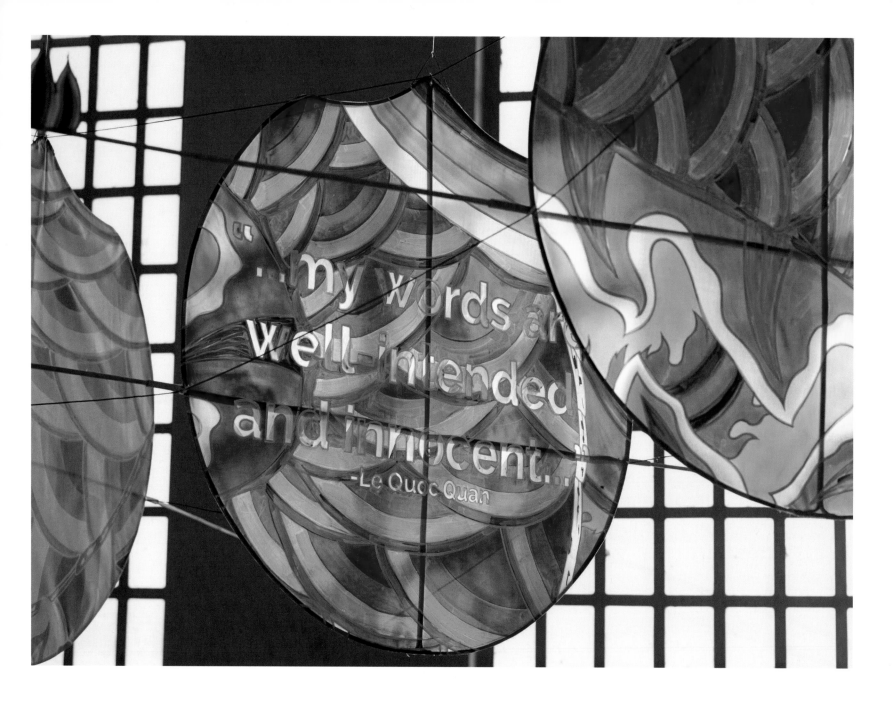

"...my words are
well intended
and innocent..."
—Le Quoc Quan

above, opposite, and following: Ai Weiwei, *With Wind*, 2014 (detail);
installation: handmade kites (paper, silk, and bamboo); part of *@Large:
Ai Weiwei on Alcatraz*, Alcatraz Island, 2014–2015

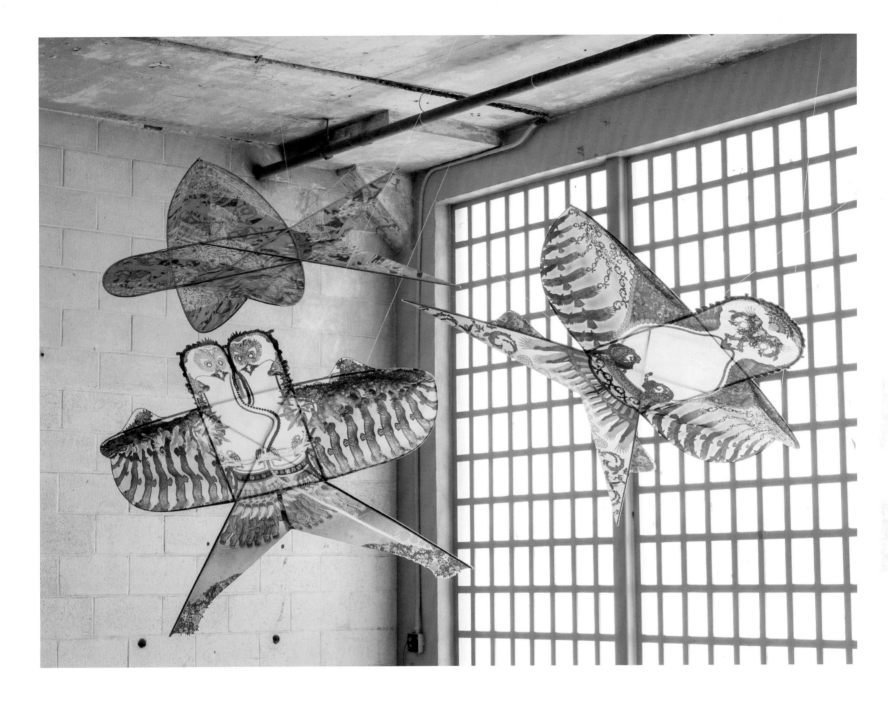

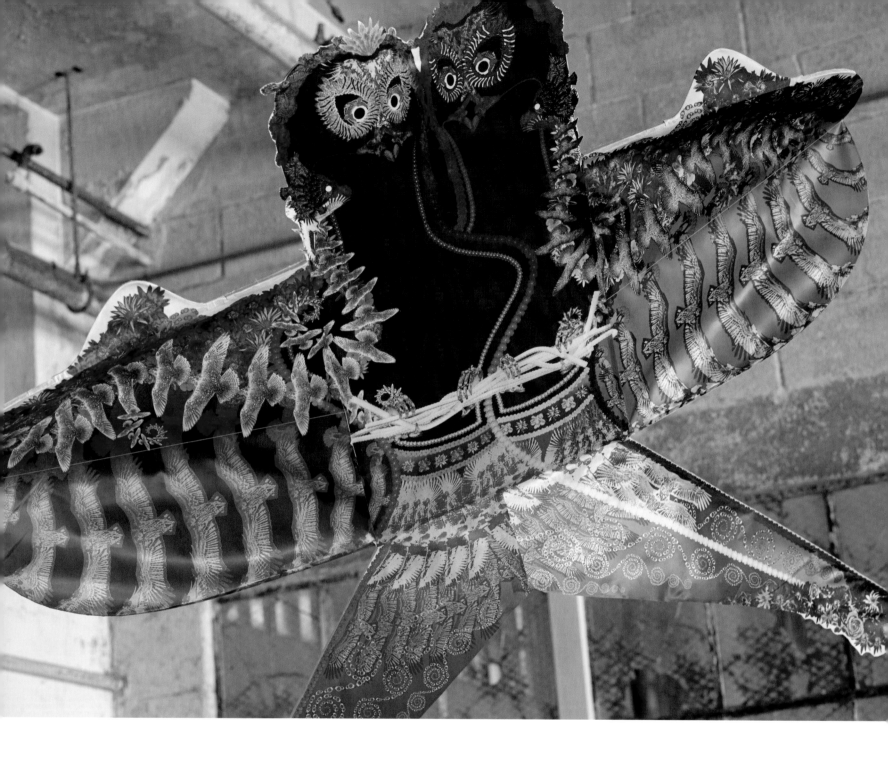

@Large: Ai Weiwei on Alcatraz

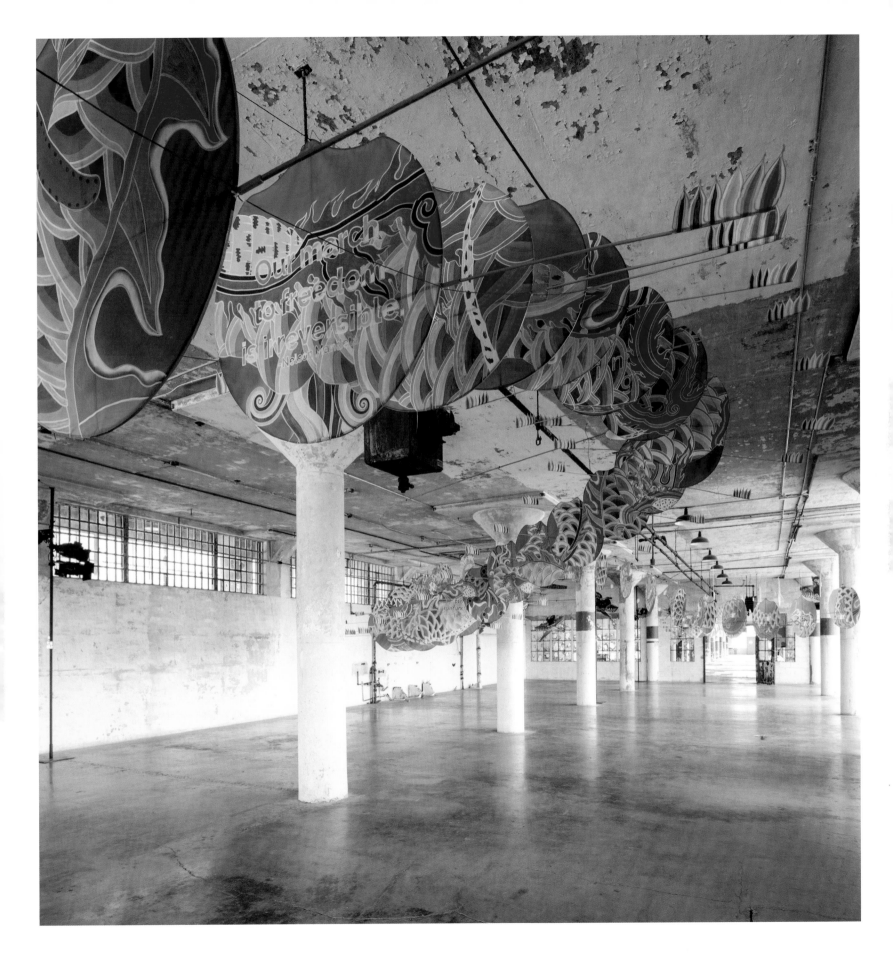

Trace

Installation, 2014
LEGO plastic bricks

While *With Wind* uses natural and mythical imagery to reference the global reality of political detainment, *Trace*, an installation at the rear of the New Industries Building, gives that reality a human face—or, rather, many individual faces. The viewer is confronted with a field of colorful images laid out flat across the expansive floor: portraits of over 170 people from around the world who have been imprisoned or exiled due to their beliefs or affiliations, most of whom were still incarcerated as of June 2014.

If the sheer number of individuals represented is overwhelming, the impression is compounded by the intricacy of the work's construction: each image was built by hand from LEGO bricks. The images of Chinese and Tibetan prisoners were assembled in the artist's studio, while others were fabricated in San Francisco to the artist's specifications. Assembling a multitude of small parts into a vast and complex whole, the work may bring to mind the relationship between the individual and the collective, a central dynamic in any society and a particularly charged one in contemporary China.

Like *With Wind*, this artwork may be viewed from the upper gun gallery as well as at floor level.

opposite and following: Ai Weiwei, *Trace*, 2014 (detail); installation: LEGO plastic bricks; part of *@Large: Ai Weiwei on Alcatraz*, Alcatraz Island, 2014–2015

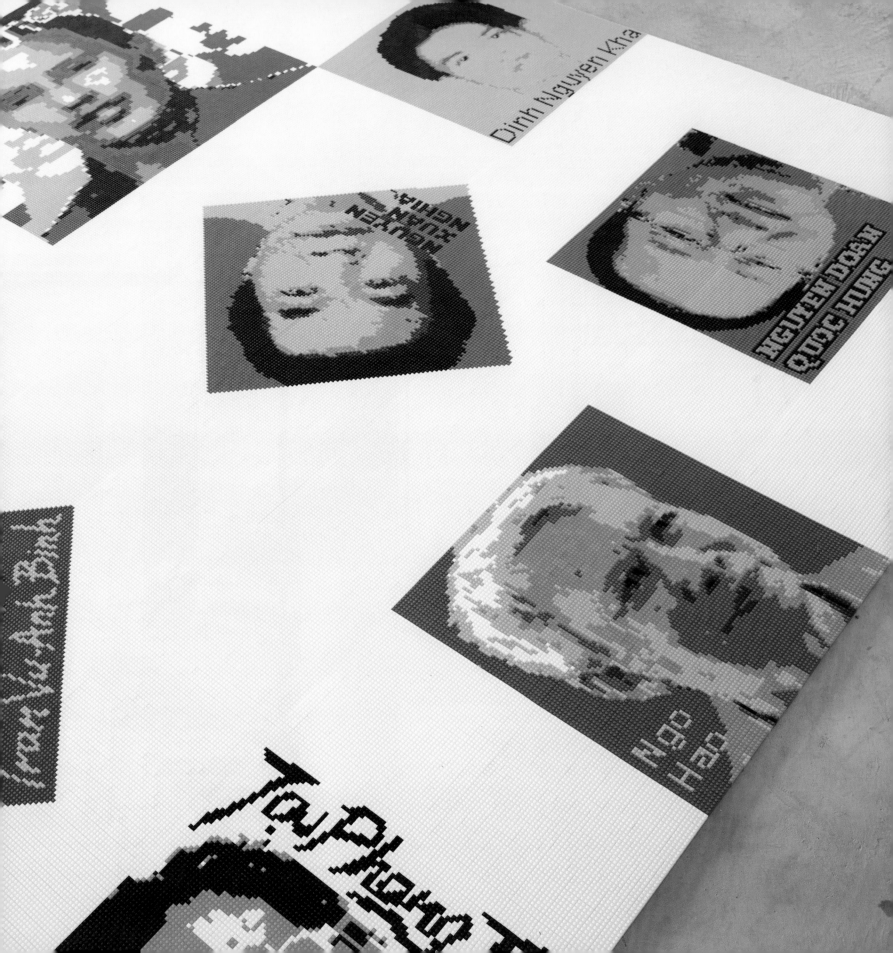

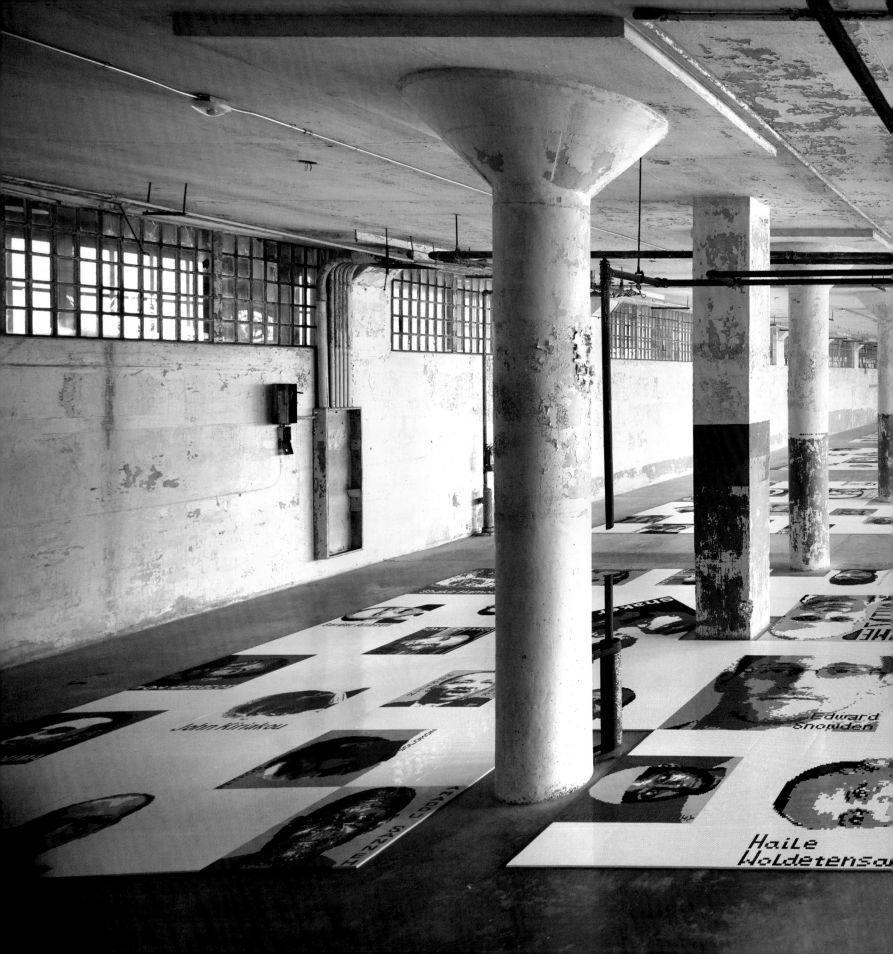

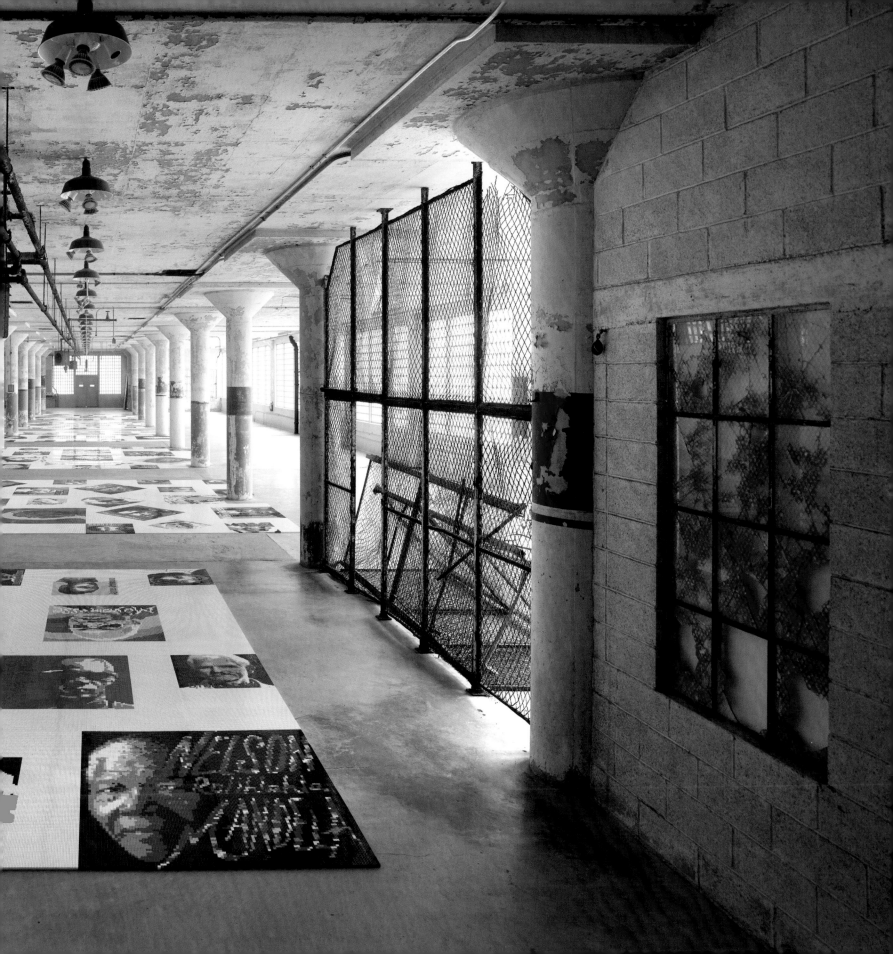

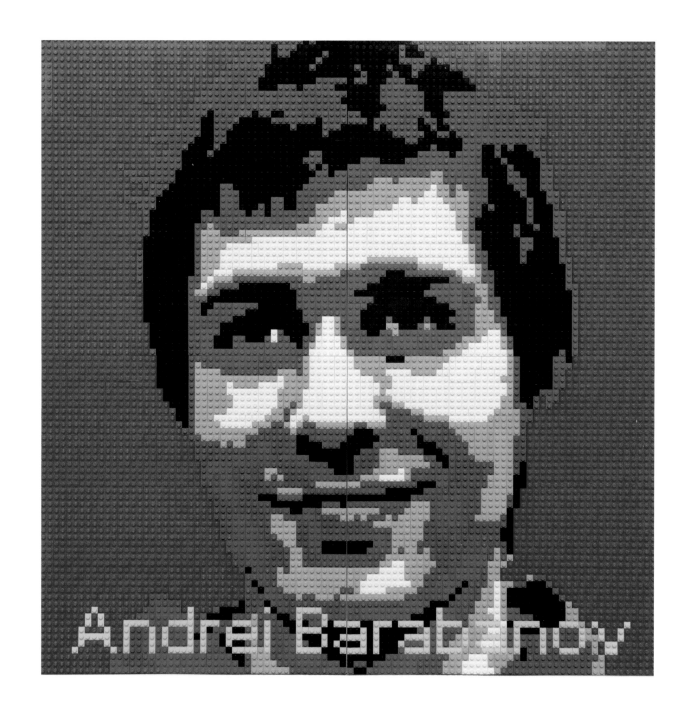

Andrei Barabanov

Russia

Convicted of attacking police and inciting mass riots, Barabanov is a graduate of the Moscow Mathematics College and an artist. He was involved in the March of the Millions demonstration in Moscow's Bolotnaya Square on May 6, 2012, when thousands of people held a protest on the eve of Vladimir Putin's presidential inauguration. At some point a small group of demonstrators tried to stage a sit-down strike and police began to try to force them out of the square. Other protesters resisted the police action, and the demonstration quickly degenerated into a street riot. In February 2014 Barabanov was sentenced to three years and seven months in prison.

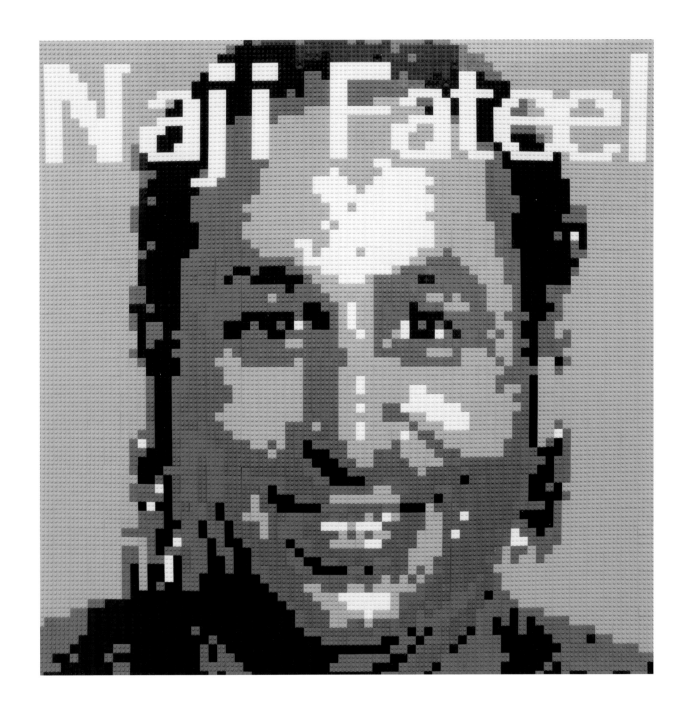

Naji Fateel
Bahrain

Charged by the Bahrain authorities with "setting up a terrorist group which aims to suspend the constitution and harm national unity," Fateel is a Bahraini human rights activist and member of the board of directors of the NGO Bahrain Youth Society for Human Rights (BYSHR). He was initially arrested following his participation in peaceful protests calling for democratic and human rights reforms in 2012. He has been imprisoned multiple times since 2007, has testified to being tortured, and has been the target of death threats. In 2013, he was sentenced to fifteen years in prison.

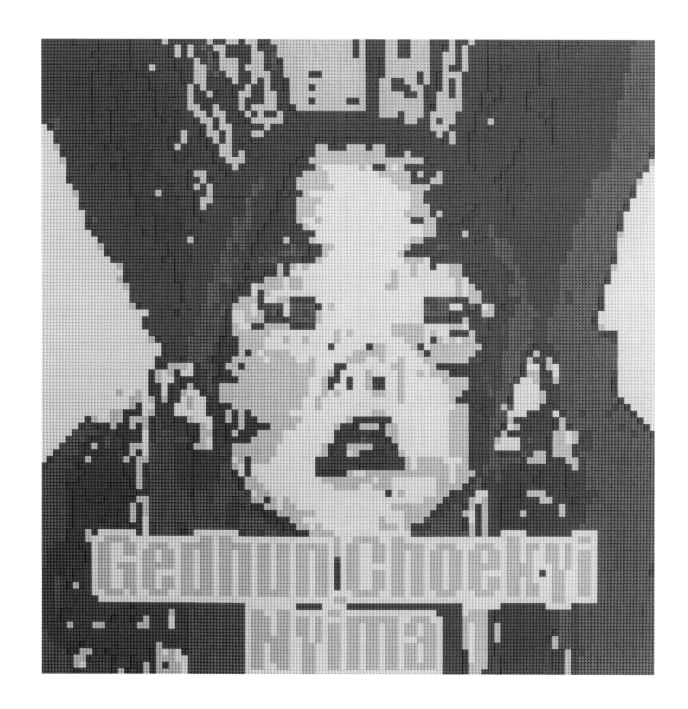

Gedhun Choekyi Nyima
China

On May 14, 1995, at age six, Nyima was named the 11th Panchen Lama by the 14th Dalai Lama. After his selection as the Dalai Lama's successor, Nyima was detained by authorities of the People's Republic of China (PRC). Another child, Gyaincain Norbu, was later named as Panchen Lama by the PRC, a choice that exiles claim is rejected by most Tibetan Buddhists. Nyima has not been seen in public since May 17, 1995; his current whereabouts are unknown.

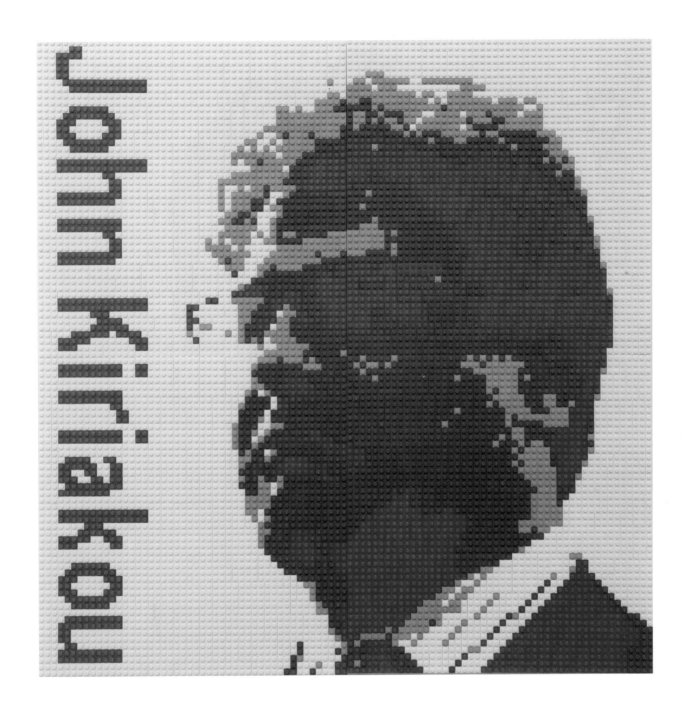

John Kiriakou
United States

On October 22, 2012, Kiriakou pleaded guilty to one charge of violating the Intelligence Identities Protection Act by disclosing to a reporter the name of an agency officer who had been involved in the CIA's program to hold and interrogate detainees. Kiriakou is a former CIA officer who worked as an agency analyst and counterterrorism official from 1990 to 2004. In December 2007 he publicly discussed the suffocation technique used in interrogations known as "waterboarding" and stated that this technique was approved by the Justice Department and National Security Council in 2002. He was also quoted as saying that waterboarding "was a policy decision that came down from the White House." Supporters say he is being unfairly targeted for having been the first CIA official to publicly confirm and detail the Bush administration's use of waterboarding. In 2012 he was awarded the Joe A. Callaway Award for Civic Courage. In January 2013 he was sentenced to thirty months in prison.

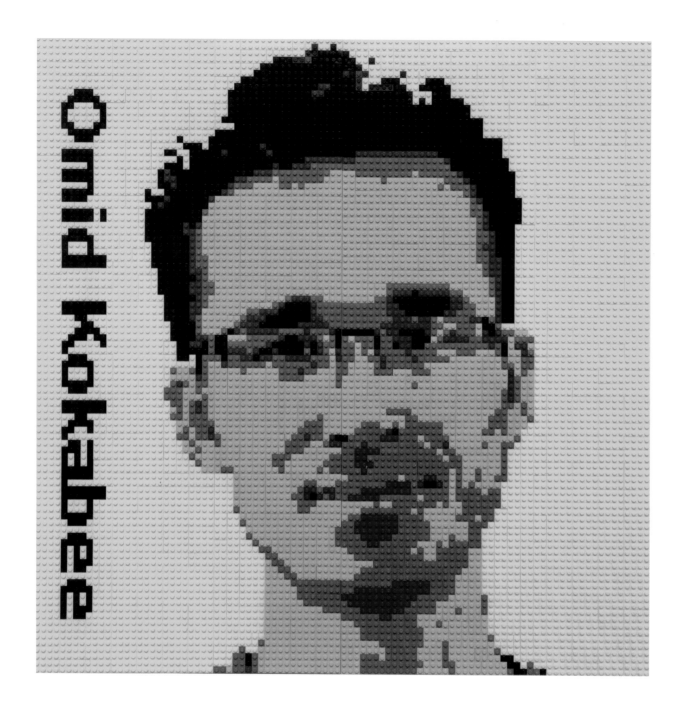

Omid Kokabee

Iran

Sentenced for "communicating with a hostile government [the U.S.]" and "illegitimate/illegal earnings," Kokabee was an experimental laser physicist at the University of Texas at Austin who in January 2011 was arrested in Iran after returning from the United States for a family visit. In an open letter, he claimed that the Iranian authorities were trying to force him to assist in the country's nuclear program by threatening him and his family. He is the co-recipient of the American Physical Society's 2014 Andrei Sakharov Prize for "his courage in refusing to use his physics knowledge to work on projects that he deemed harmful to humanity in the face of extreme physical and psychological pressure." He is currently serving a ten-year prison sentence.

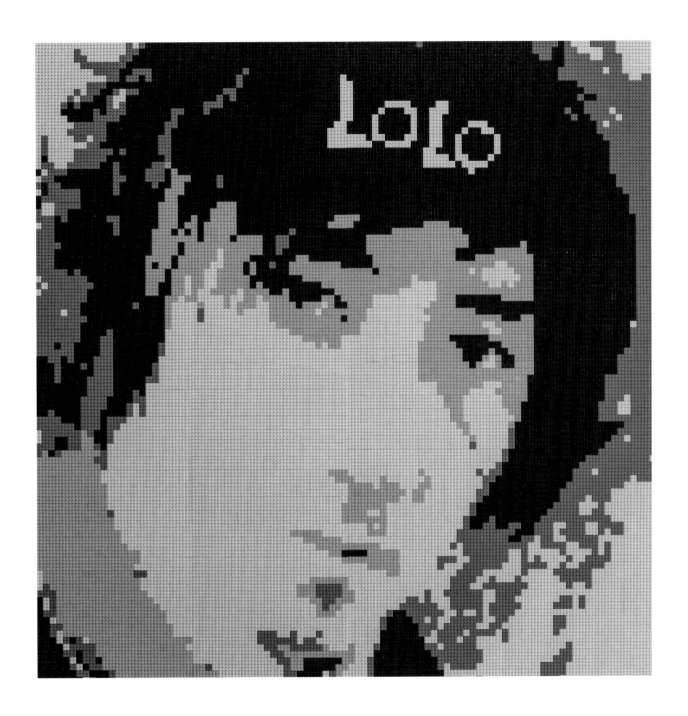

Lolo
China

Tibetan singer Lolo was arrested on April 19, 2012, in the Tibetan Autonomous Prefecture and eventually sentenced to six years in prison. His crime was recording an album of fourteen songs that called for Tibet's independence, unity of the Tibetan people, and the return to Tibet of the Dalai Lama. Soon after the album's release in 2012, the thirty-year-old was arrested in eastern Tibet. He had no known links to protests or other activism. It is likely that he was charged with a catchall offense that allows the Chinese authorities to punish ethnic minorities defending their rights—and which carries penalties up to and including execution.

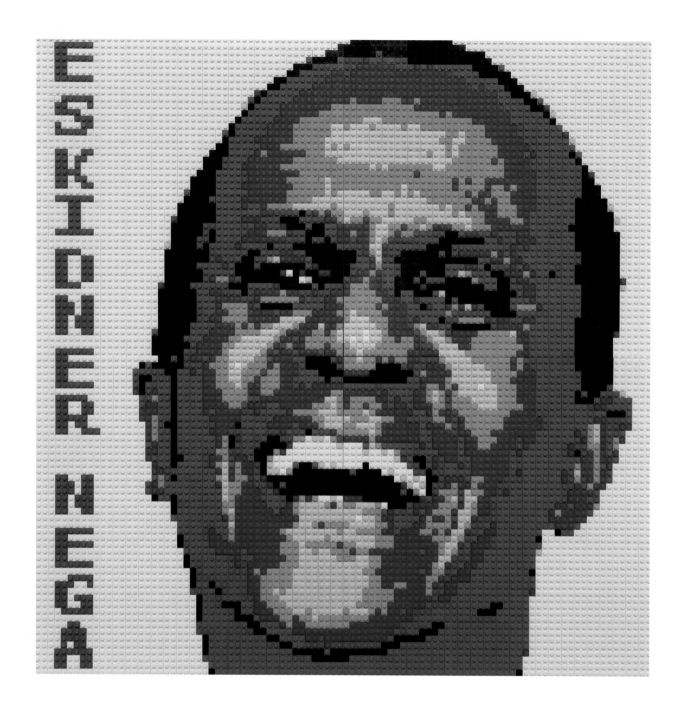

Eskinder Nega

Ethiopia

Convicted of treason, "outrages against the Constitution," and "incitement to armed conspiracy," Nega published an online column critical of the use of an anti-terrorism law to silence dissent and calling for the Ethiopian government to respect freedom of expression and end torture in the country's prisons. His sentence was upheld in May 2013. In 2014 he was awarded the Golden Pen of Freedom, the annual press freedom prize of the World Association of Newspapers and News Publishers (WAN-IFRA).

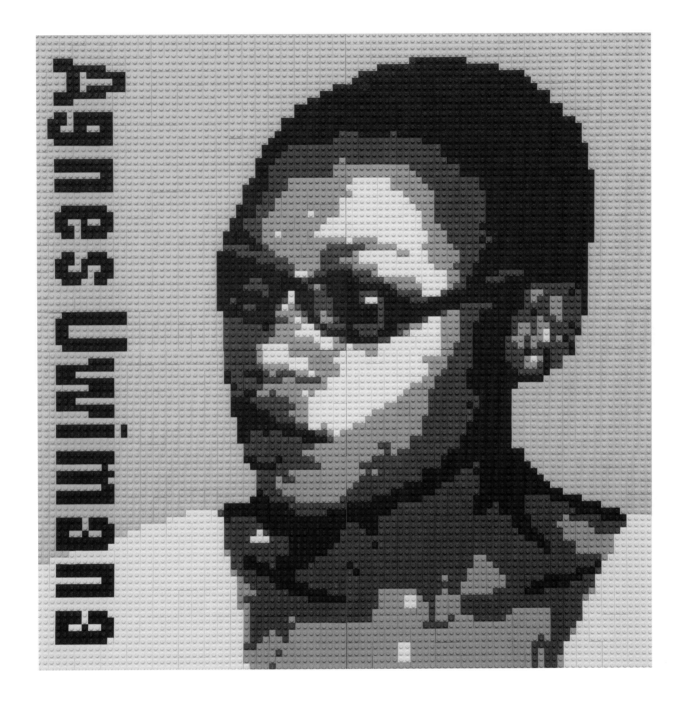

Agnes Uwimana Nkusi
Rwanda

Sentenced for defamation and threatening national security, Nkusi was the editor of the independent Kinyarwanda-language newspaper *Umurabyo*. Government authorities arrested her after she published opinion pieces criticizing government policies and alleging corruption in the run-up to the 2010 presidential elections. Previously, she was arrested and imprisoned after publishing an anonymous letter criticizing the government. Since April 2013 she has been serving a four-year prison sentence.

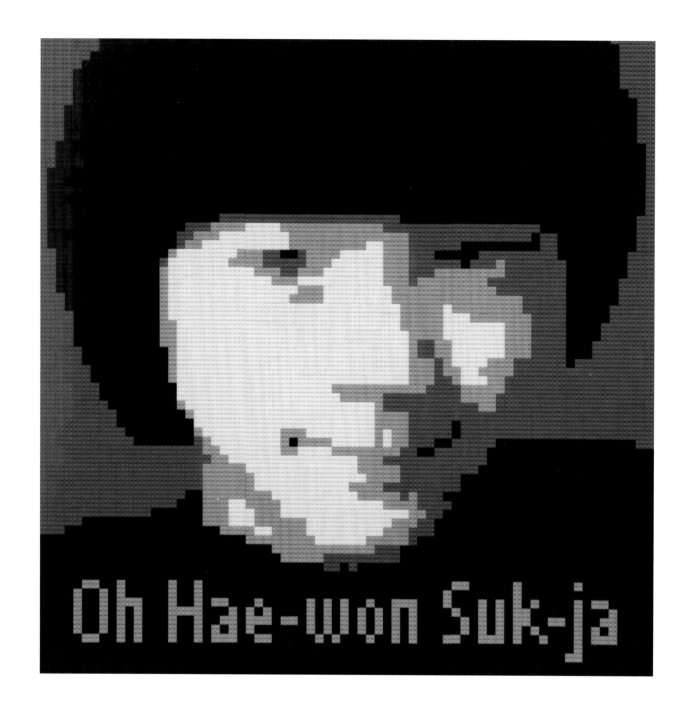

Oh Hae-won Suk-ja
South Korea

On December 8, 1995, Suk-ja's father, Oh Kil-nam, moved his family to Pyongyang, North Korea, to work as an economist and so that his wife, Shin Suk-ja, could receive treatment for hepatitis. He requested political asylum in Denmark on his way to Germany. The following year Suk-ja, her mother, and her sister were imprisoned indefinitely, apparently because her father did not return to North Korea. Suk-ja is presumed to be alive and was last known to be incarcerated in Yodok Concentration Camp, northeast of Pyongyang.

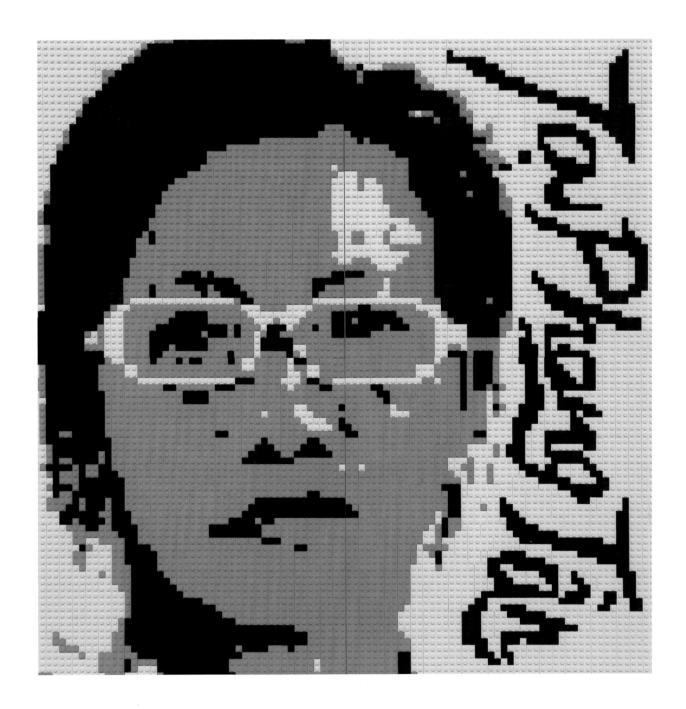

Tạ Phong Tần
Vietnam

Charged with writing anti-state propaganda and "seriously affecting national security and the image of the country in the global arena," Tạ is a Vietnamese dissident blogger. A former policewoman, she was arrested for her blog posts alleging government corruption. Due to these online posts and her criticism on the Web about the policies of the Communist Party of Vietnam, she was expelled from the party and lost her job in 2006. In July 2012 her mother, Dang Thi Kim Lieng, self-immolated outside the Bac Lieu People's Committee headquarters in protest of her daughter's detention. In October 2012 Tạ was sentenced to ten years in prison. The sentence was upheld on appeal in December 2012.

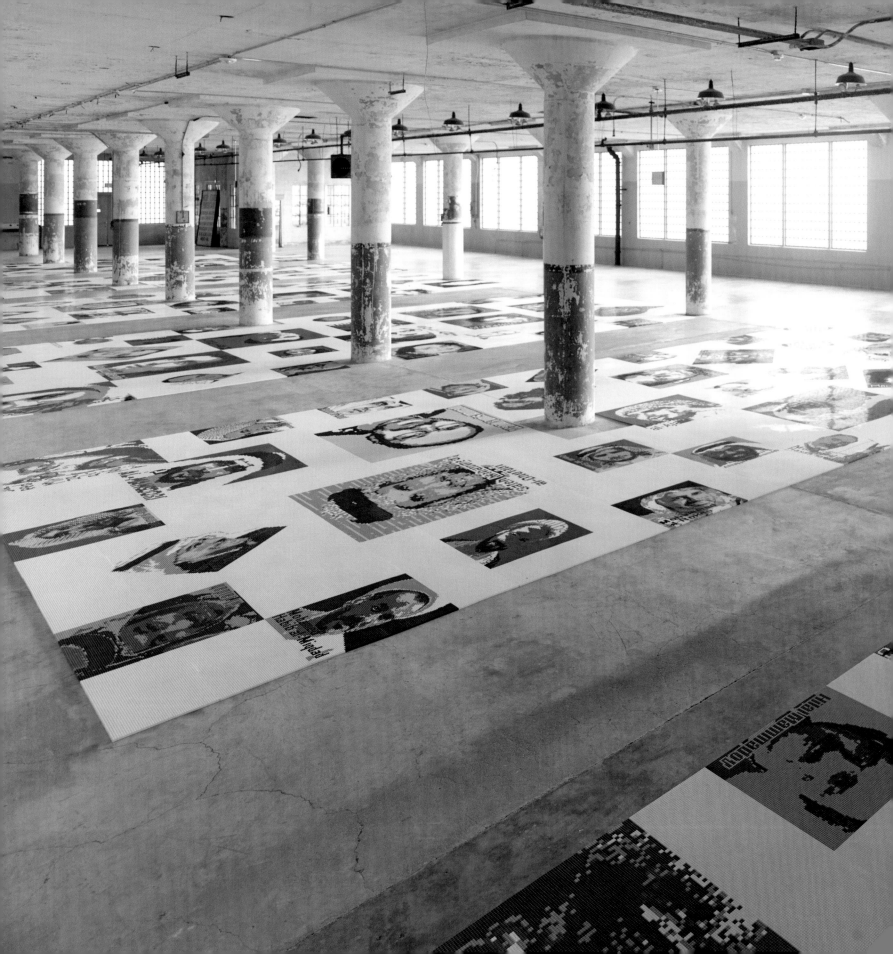

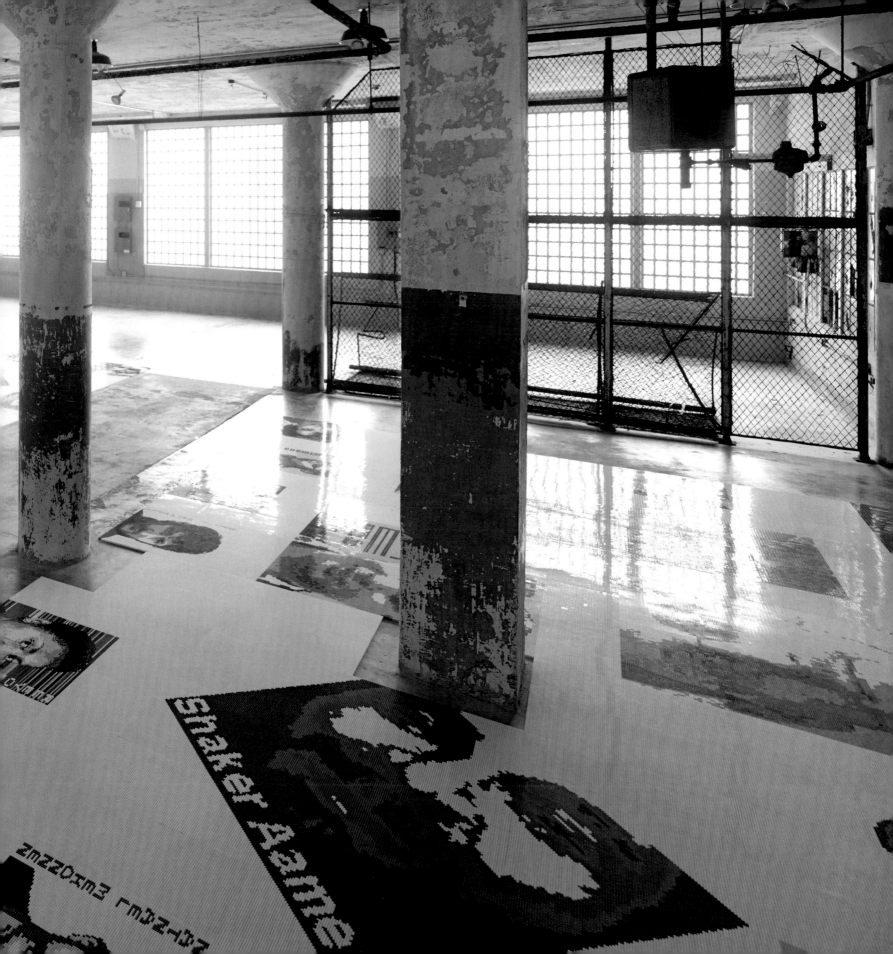

Refraction

Installation, 2014
Tibetan solar panels, steel

From the New Industries Building's lower gun gallery, where armed guards once monitored prisoners at work, visitors peer through cracked and rusted windows to glimpse an enormous, multifaceted metal wing on the floor below. Its design is based on close observation of the structure of real bird's wings, but in place of feathers, the artwork bristles with reflective metal panels originally used on Tibetan solar cookers.

Like *With Wind* on the floor above, *Refraction* uses imagery of flight to evoke the tension between freedom—be it physical, political, or creative—and confinement. The sculpture's enormous bulk (weighing more than five tons) and position on the lower floor keep it earthbound, but one might imagine its array of solar panels silently mustering energy, preparing for takeoff.

By requiring visitors to view the work from the gun gallery, the installation implicates them in a complex structure of power and control. Following in the footsteps of prison guards, visitors are placed in a position of authority, and yet the narrowness of the space creates a visceral feeling of physical restriction.

opposite and following: Ai Weiwei, *Refraction*, 2014 (detail); installation: Tibetan solar panels, steel; part of *@Large: Ai Weiwei on Alcatraz*, Alcatraz Island, 2014–2015

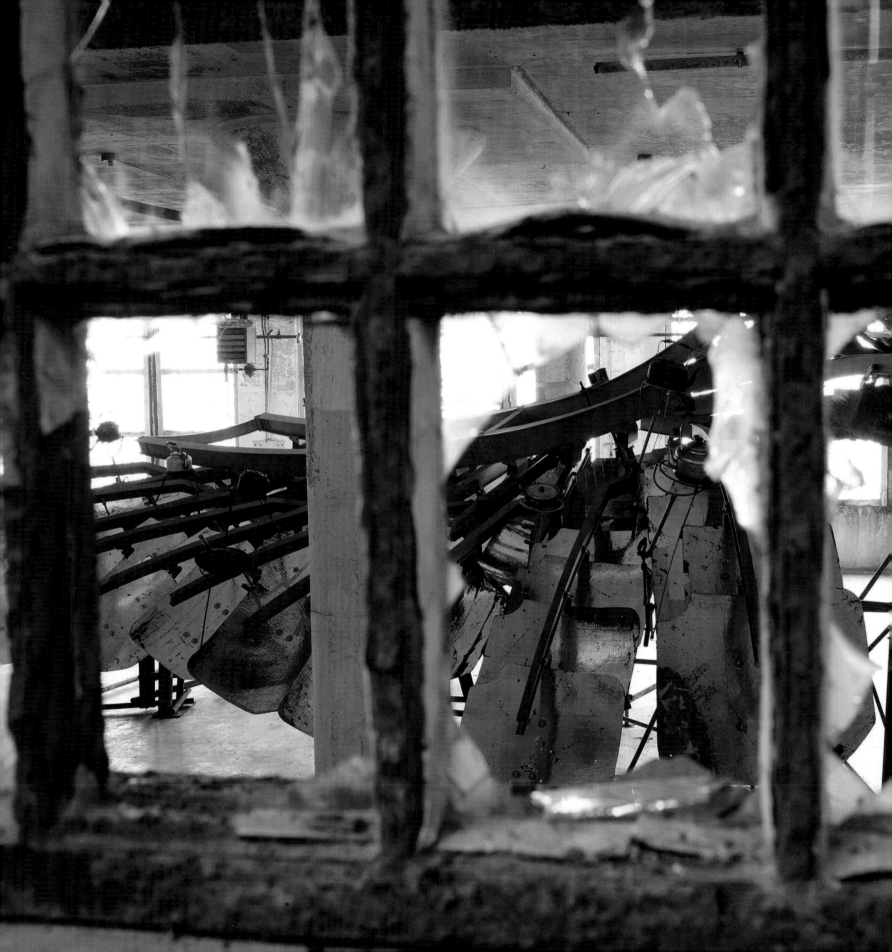

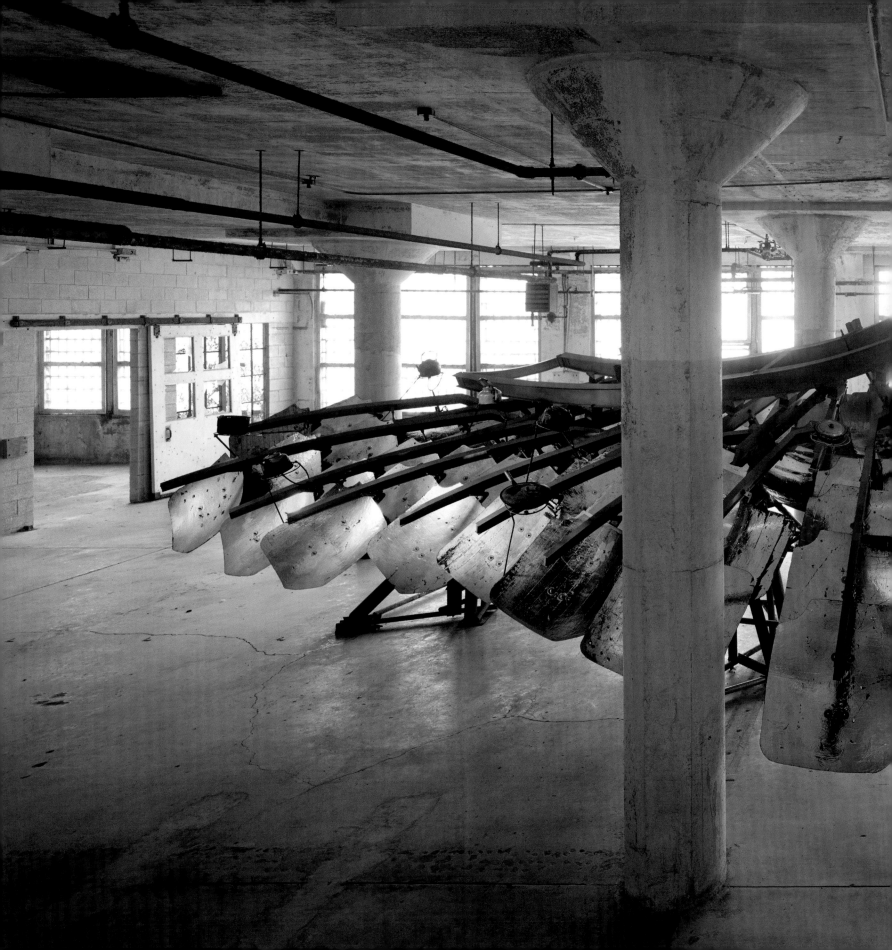

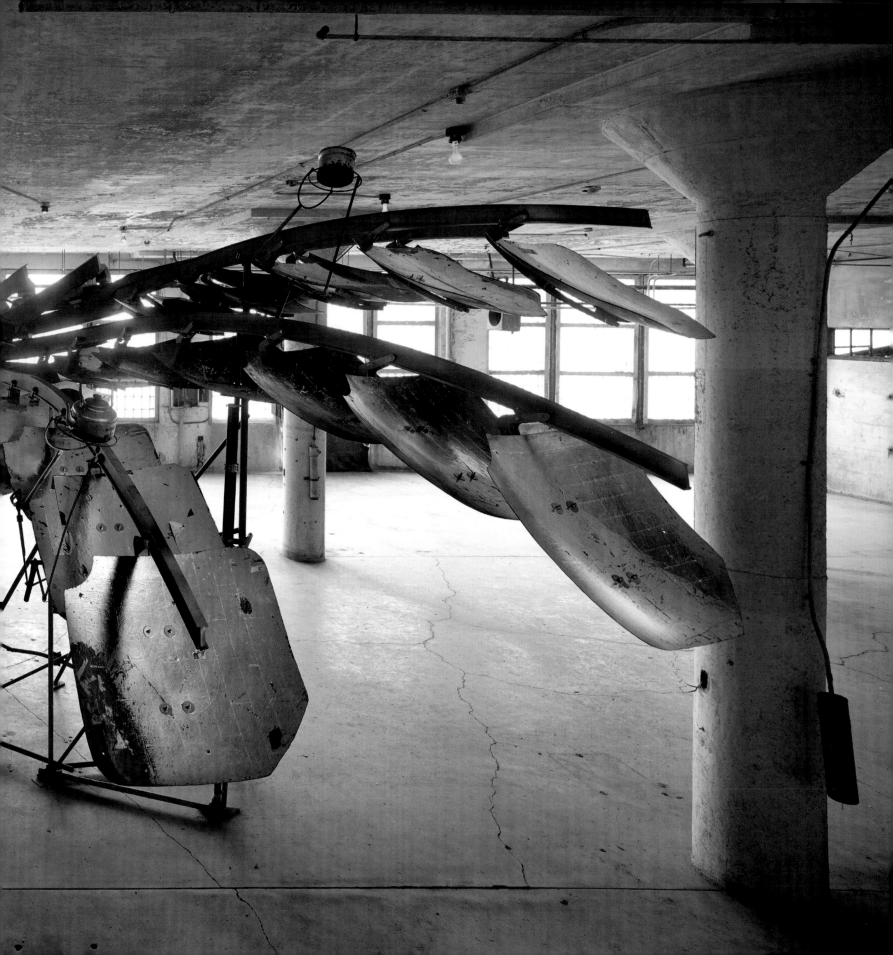

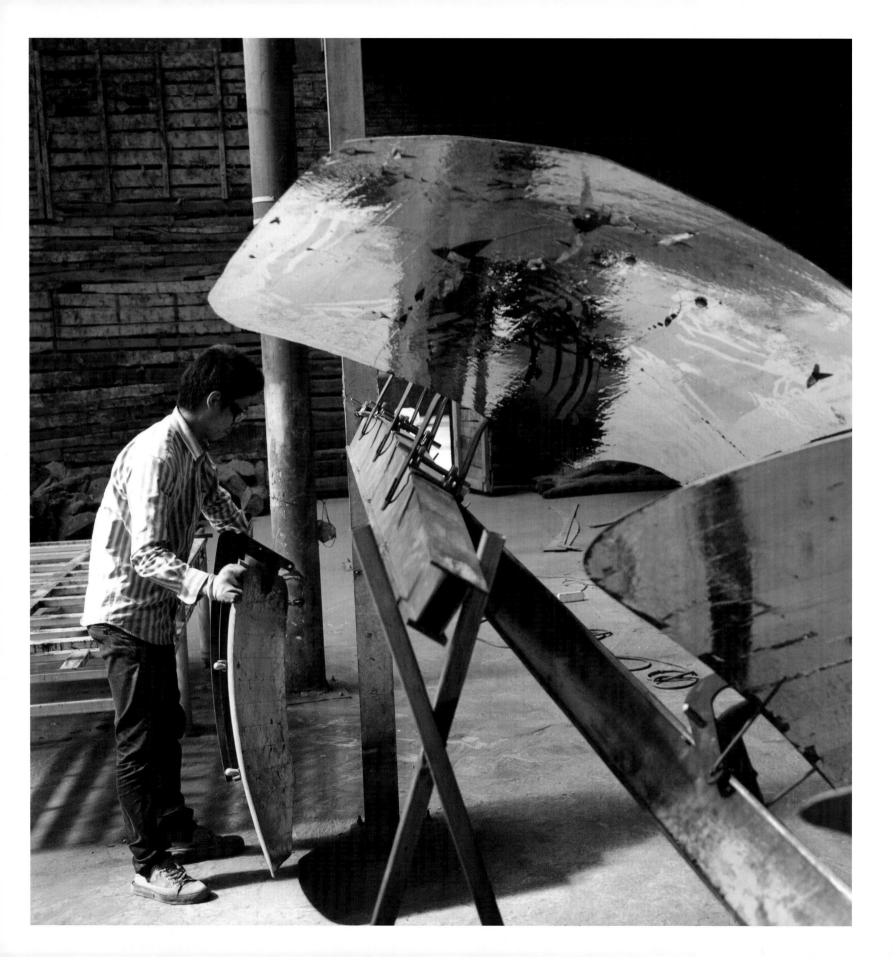

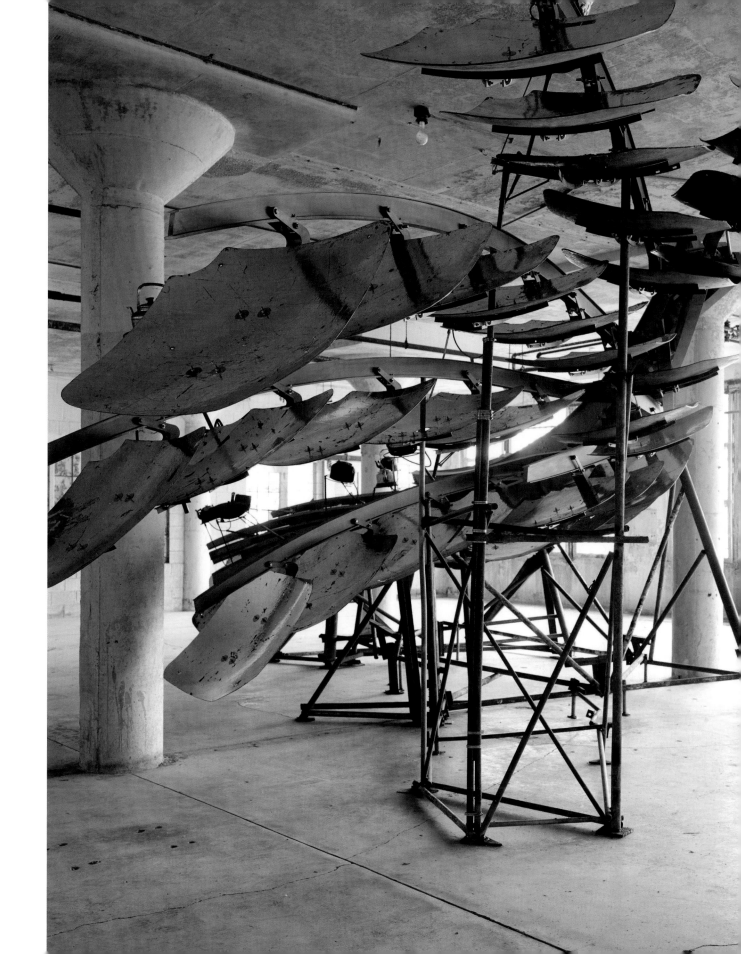

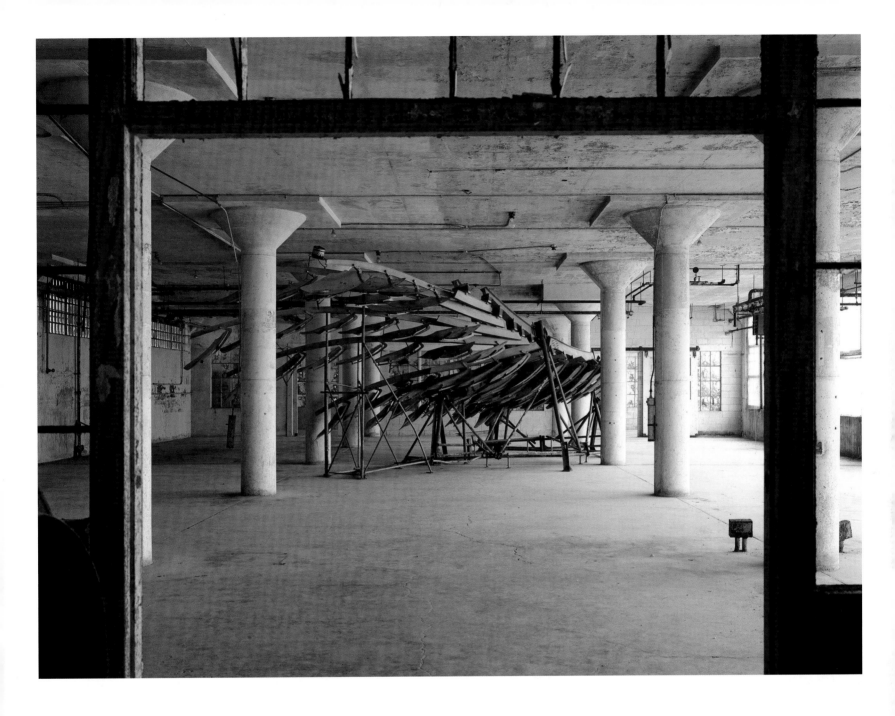

previous, left: A worker prepares to attach a Tibetan solar panel
to *Refraction*

previous, right; opposite and above: Ai Weiwei, *Refraction*, 2014 (detail);
installation: Tibetan solar panels, steel; part of *@Large: Ai Weiwei on Alcatraz*,
Alcatraz Island, 2014–2015

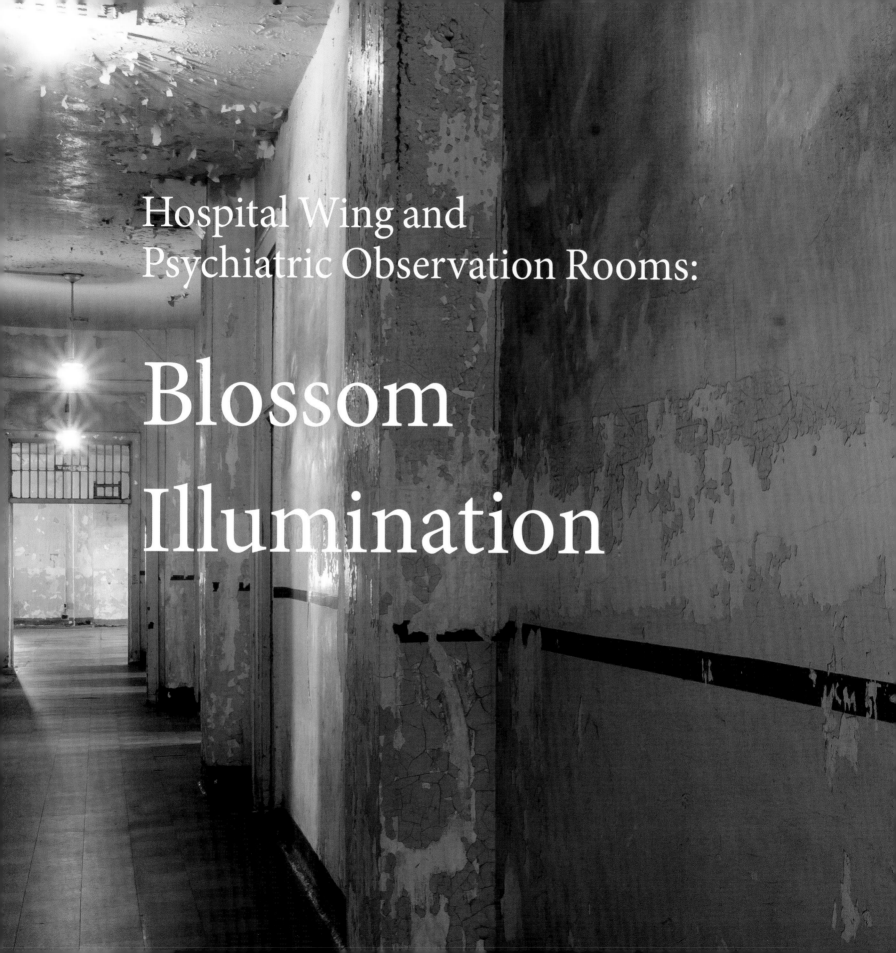

Hospital Wing and
Psychiatric Observation Rooms:

Blossom
Illumination

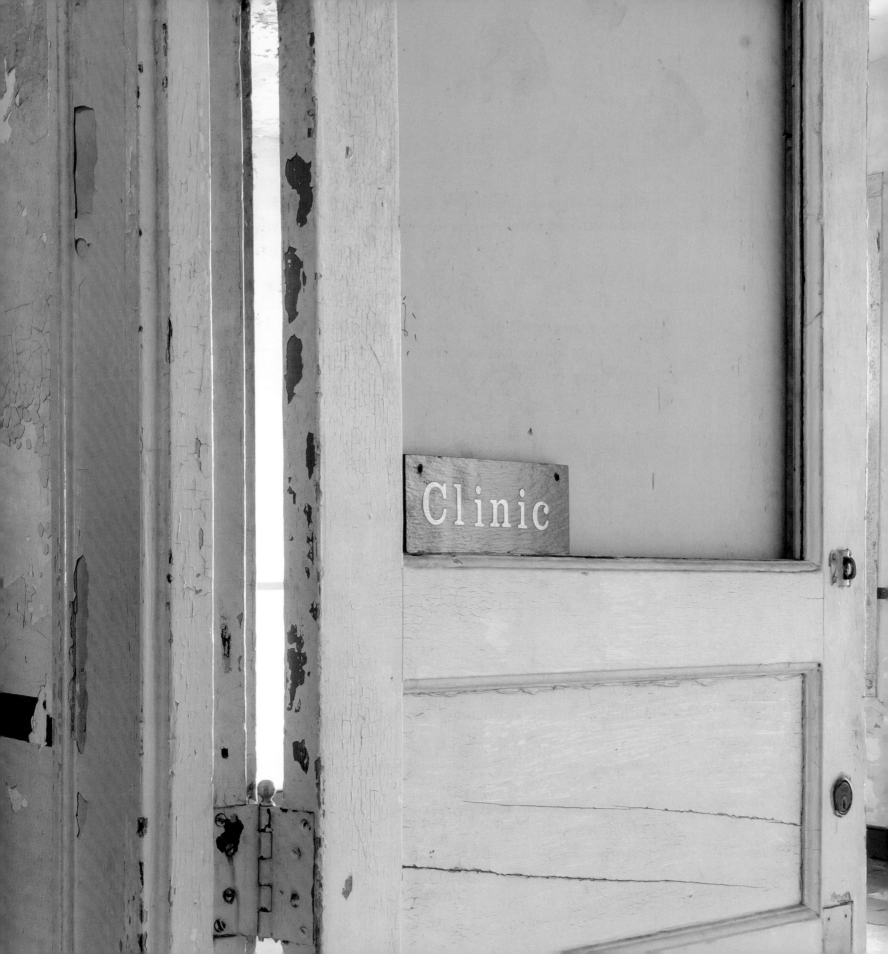

Hospital Wing and Psychiatric Observation Rooms

Medical care was one of only four basic rights granted to prisoners in the Alcatraz penitentiary, along with food, clothing, and shelter. Inmates exercised their right at sick call: every day after lunch, prisoners could line up to ask to be taken to the Hospital, upstairs from the Dining Hall. One former officer claimed that as many as 10 percent of inmates would appear in the sick line on a given day, either suffering from genuine illness or hoping for an escape from regular life in the cellblock.

A fully functioning hospital was maintained on Alcatraz throughout the military and federal prison years. Instead of sending sick or injured inmates to San Francisco, where they might have a chance to escape, Alcatraz administrators brought the doctors to the prisoners. A Bureau of Prisons bulletin boasted:

> The Alcatraz Hospital, adjacent to the main cellhouse, is equipped with modern X-ray and physical therapy apparatus, operating theater, laboratories, and dental unit, and contains wards and individual rooms for the treatment and convalescence of inmate patients. It has been certified by the American College of Surgeons and compares favorably with the up-to-date hospitals and clinics in the free community.

The Hospital was staffed by a general practitioner who lived on the island, while specialists, surgeons, and psychiatrists from the San Francisco Public Health Service and the Presidio military base visited when needed. Female nurses or assistants sometimes accompanied the surgeons—the only time women were ever allowed inside the cellhouse.

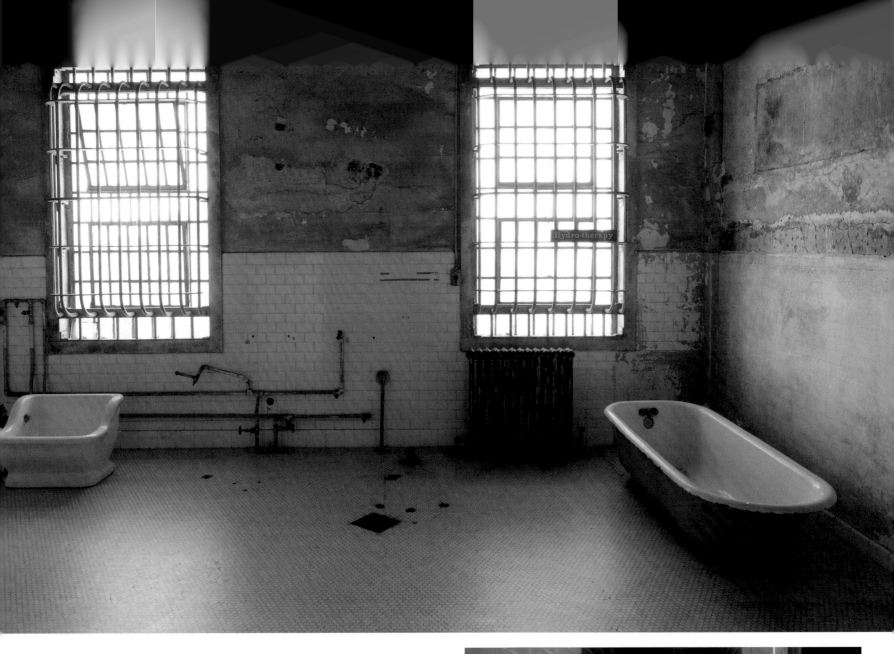

previous: Doors to treatment, examination, and other special-use rooms open off the Hospital corridor

above: One of the Hospital's ward cells. Though designed to house multiple patients, for safety reasons a ward cell was usually occupied by a single inmate.

right: Entrance to the psychiatric observation rooms

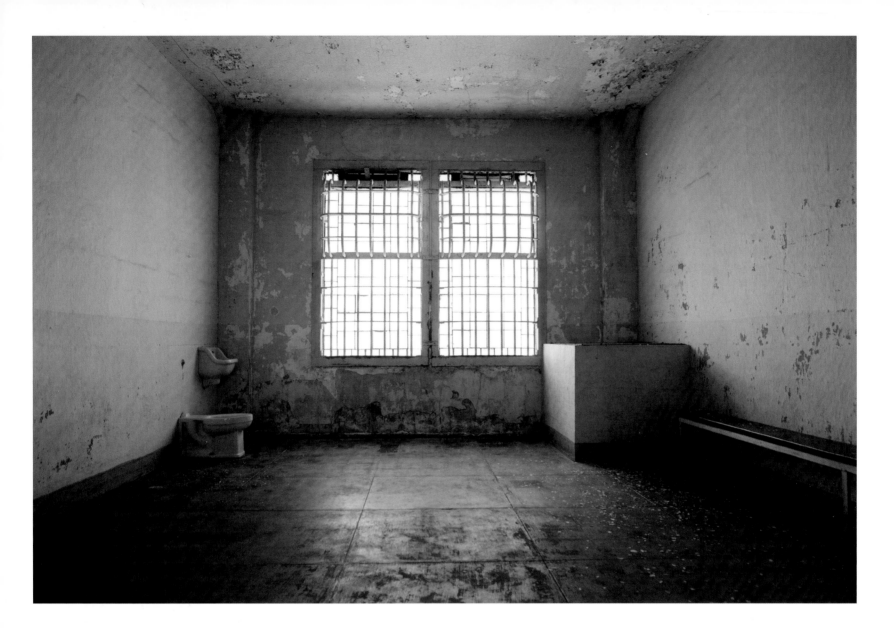

above: Hospital ward cell

Each cell in the Hospital could hold as many as six men, but inmates were usually kept separate for safety reasons. Among the prisoners who spent time in these cells were Al Capone, confined to the Hospital in 1938 after being diagnosed with syphilis, and Robert "The Birdman" Stroud, who lived in the infirmary for eleven years. A hypochondriac as well as an extremely disruptive inmate who had incited a riot in D Block, Stroud was permanently moved to the Hospital in 1948 to keep him out of the general population.

Set apart from the regular cells were two psychiatric observation cells, called "bug rooms" or "bug cages" by inmates. The number of prisoners who became mentally ill during their time on Alcatraz is hard to pin down: the official estimate of Warden James A. Johnston was 2 percent, but former inmate Jim Quillen said it happened "a lot more than that—all the time." Many aspects of life on Alcatraz could drive inmates over the edge: the monotony, the lack of privacy, the threat of violence, even the knowledge that San Francisco and freedom were so close but impossible to reach. However, some prisoners tried to fake insanity, hoping for a chance to be transferred to another institution—anywhere other than Alcatraz.

Blossom

Installation, 2014
Porcelain, hospital fixtures
(sinks, toilets, bathtubs)

In this work, Ai transforms the utilitarian fixtures in several Hospital ward cells and medical offices into fantastical and fragile porcelain bouquets. The artist has designed intricately detailed encrustations of ceramic flowers to fill the sinks, toilets, and tubs that were once used by hospitalized prisoners.

Like *With Wind* in the New Industries Building, *Blossom* draws on and transforms natural imagery as well as traditional Chinese arts. Rather than referring to national iconography, however, the flowers here carry other associations. The work could be seen as symbolically offering comfort to the imprisoned, as one would send a bouquet to a hospitalized patient. The profusion of flowers rendered in cool, brittle porcelain could also be an ironic reference to China's famous Hundred Flowers Campaign of 1956, a brief period of government tolerance for free expression that was quickly shattered by a severe crackdown against dissent.

opposite and following: Ai Weiwei, *Blossom*, 2014 (detail); installation: porcelain, hospital fixtures (sinks, toilets, bathtubs); part of *@Large: Ai Weiwei on Alcatraz*, Alcatraz Island, 2014–2015

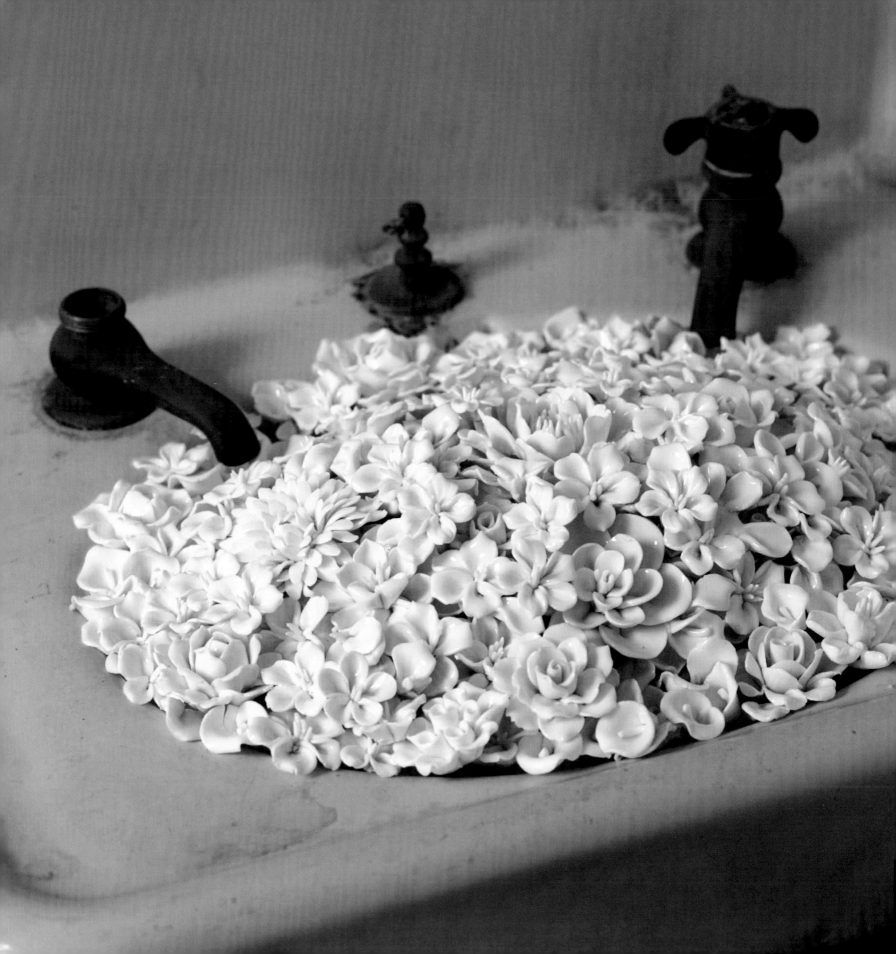

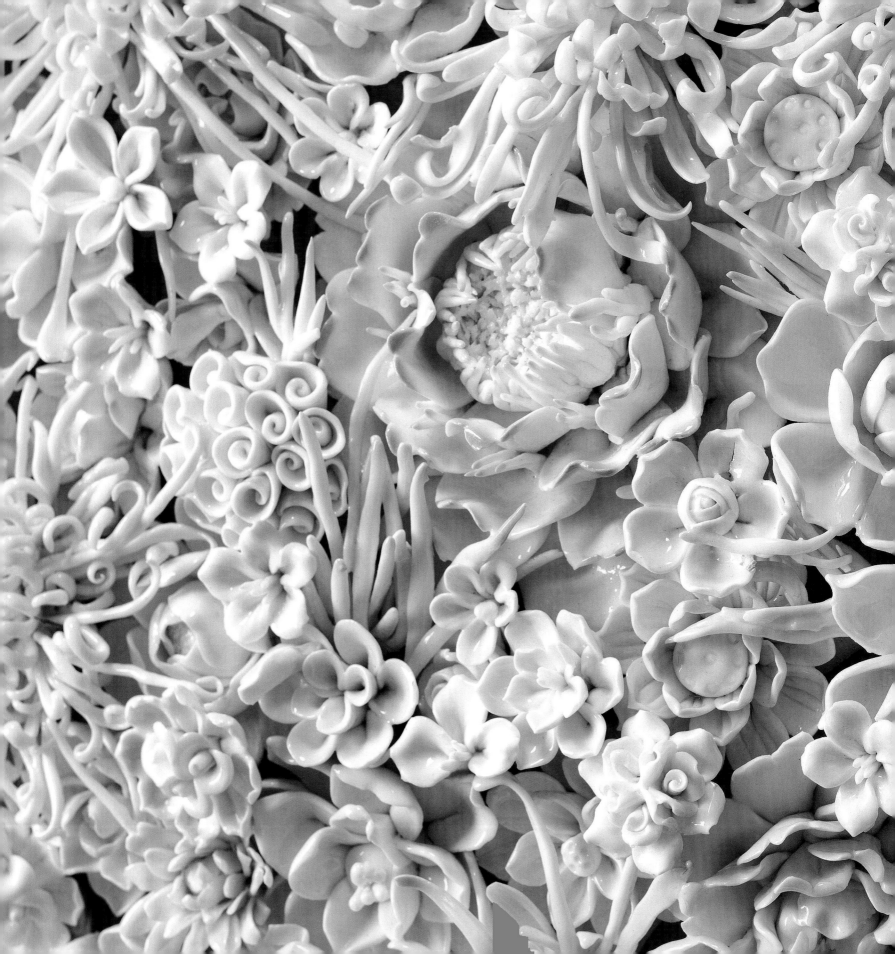

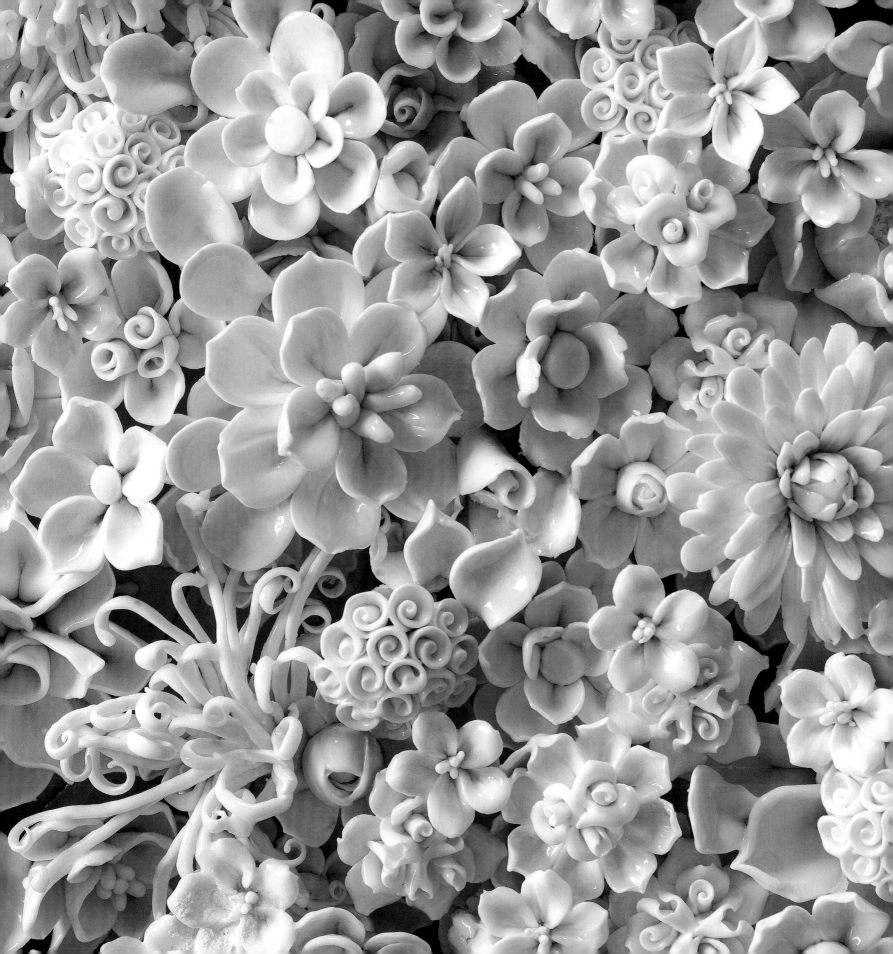

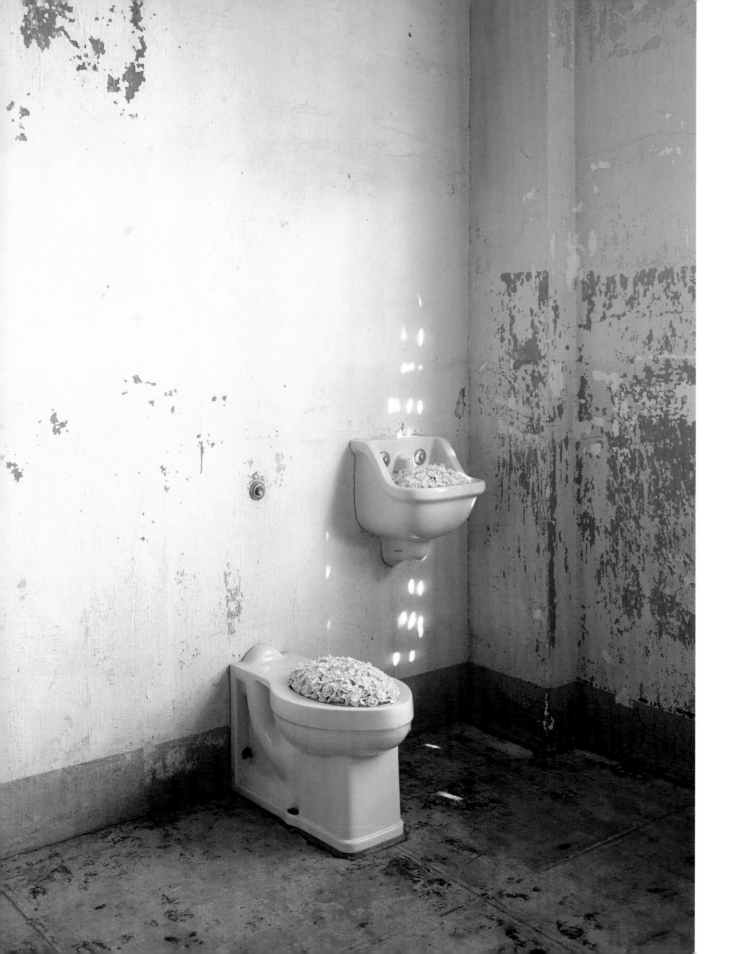

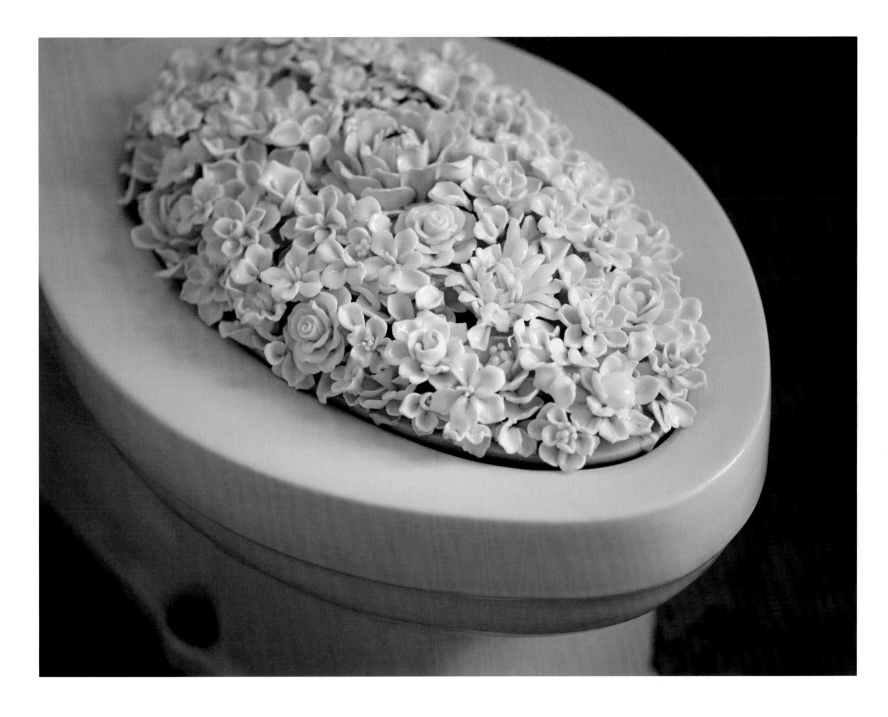

opposite, above, and following: Ai Weiwei, *Blossom*, 2014 (detail); installation: porcelain, hospital fixtures (sinks, toilets, bathtubs); part of *@Large: Ai Weiwei on Alcatraz*, Alcatraz Island, 2014–2015

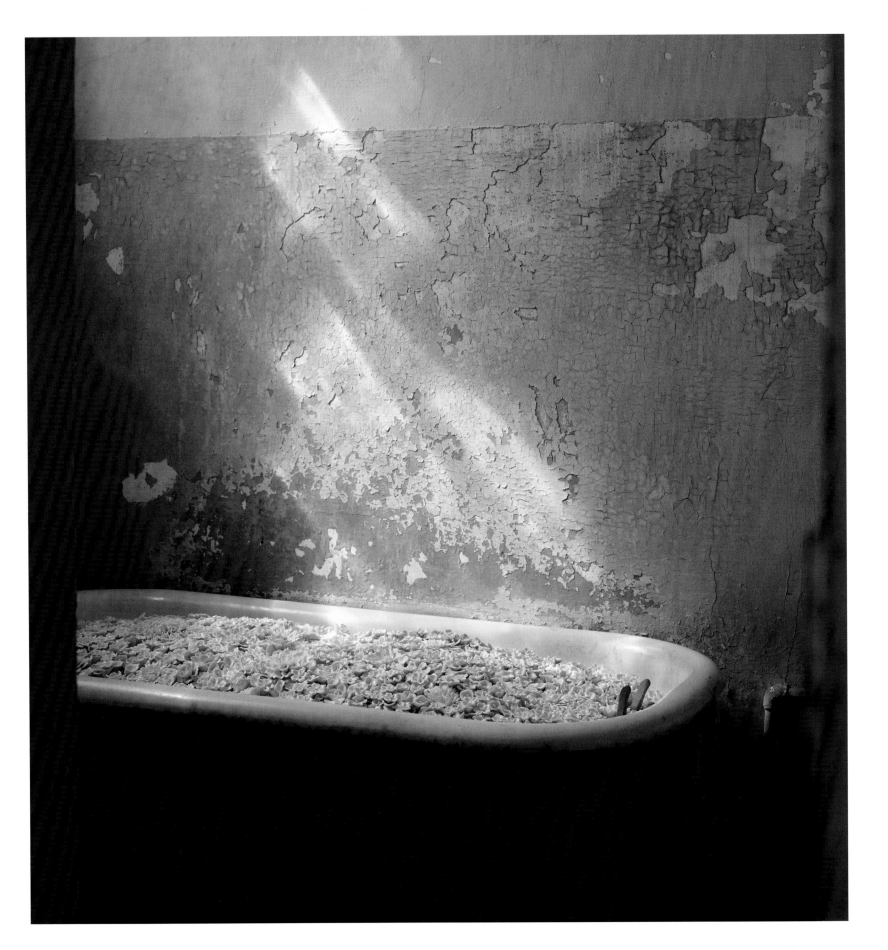

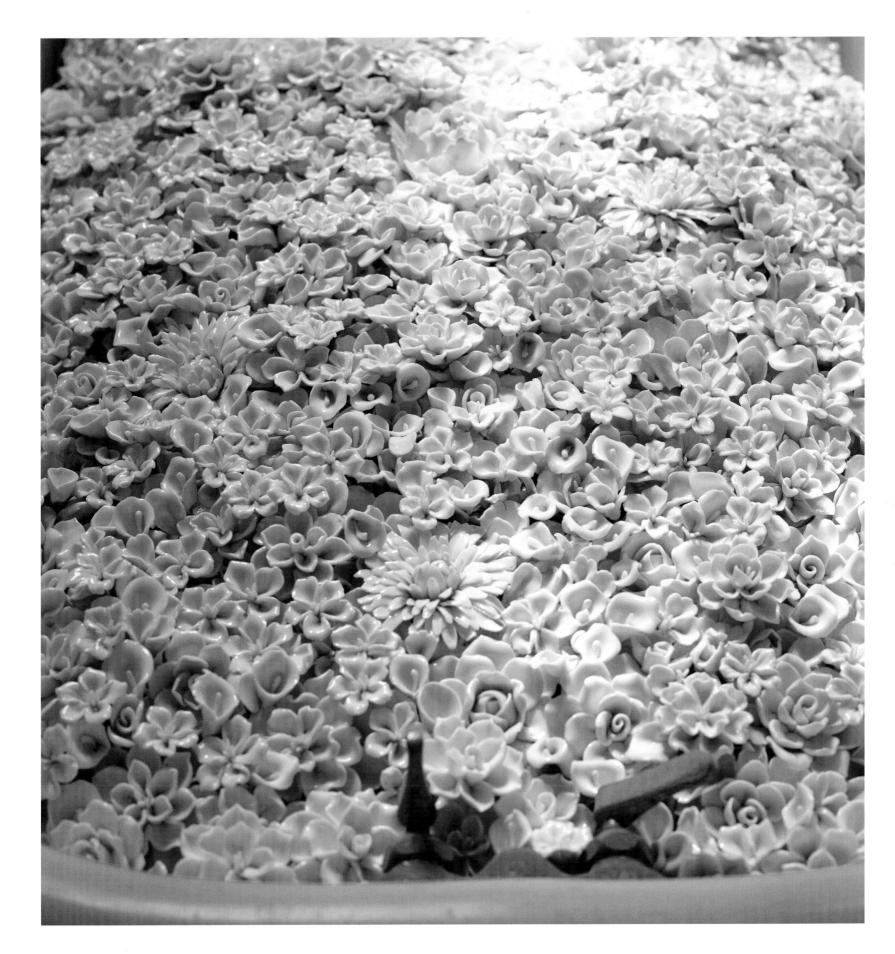

Illumination

Sound installation, 2014
Audio files, speakers

One of the most haunting spaces in the prison—a pair of tiled chambers that were once used for the isolation and observation of mentally ill inmates—resonates with the sound of Tibetan and Native American chants in this austere and moving installation. The work features chanting recorded at Namgyal Monastery, a Buddhist monastery in Dharamshala, India, as well as traditional Hopi song. Hopi men were among the first prisoners of conscience on Alcatraz, held for refusing to send their children to government boarding schools in the late nineteenth century.

Drawing pointed parallels between China and the United States, the work pays homage to people who have resisted cultural and political repression—whether Tibetan monks, Hopi prisoners, or the Indians of All Tribes who occupied Alcatraz from 1969 to 1971. The placement of the chants in the psychiatric observation rooms suggests an unexpected analogy: like subjugated peoples, those who have been classified as mentally ill have often been dismissed, deprived of rights, confined, and observed. Under the severe circumstances of incarceration, chanting could serve as a source of emotional comfort, spiritual strength, and cultural identity.

opposite: Ai Weiwei, *Illumination*, 2014 (detail); sound installation: audio files, speakers; part of *@Large: Ai Weiwei on Alcatraz*, Alcatraz Island, 2014–2015

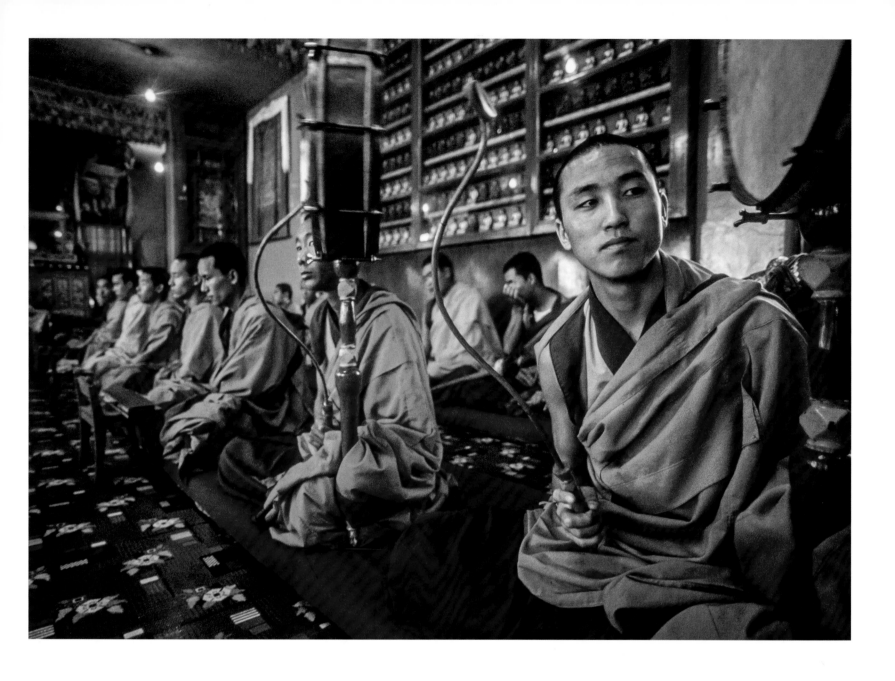

above: Monks playing traditional music at Namgyal Monastery in Dharamshala, India. Namgyal Monastery was founded by the 3rd Dalai Lama in the late sixteenth century and has served the Dalai Lamas since that time.

opposite: A Native American drummer and dancers from the Hopi Reservation in Arizona, performing in Santa Fe, New Mexico, 2012

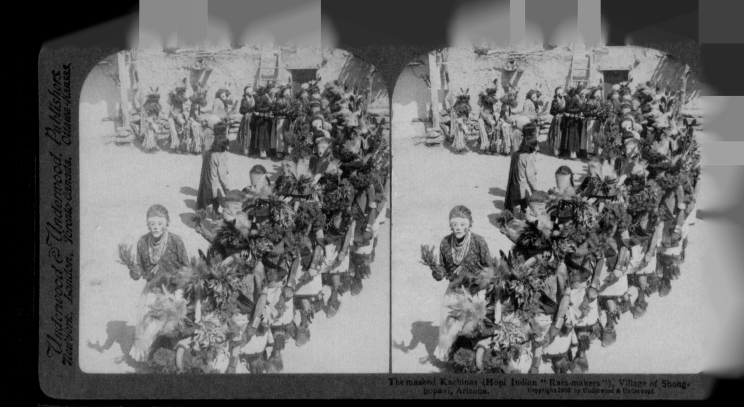

The masked Kachinas (Hopi Indian "Rain-makers"), Village of Shong-
hopavi, Arizona. Copyright 1903 by Underwood & Underwood

Eagle Dance
Hopi Indian Chant

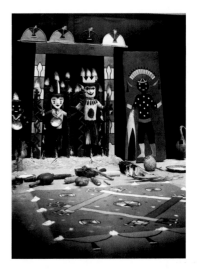

Two young men stand side by side, and as the eagle rides the air, so do these two dancers rise and fall on their toes. Around and around they circle, swooping with inconceivable grace. With arms extended, like the wings of the great bird, the dancers move their painted yellow bodies from side to side as they crouch and swoop and imitate the eagle's sweeping gestures with their wing-like arms. The Hopi believe the eagle is always strong and therefore can "cure anything." This dance, imitating the bird with its power, is part of a healing ceremony that is supposed to cure any disease. Since the eagle is considered a connecting link between earth and heaven, it is believed to have great powers, and its plumes are the prayer bearers.

The dance itself, which may be held at any time, is preceded by a four-day fast during which the sick are treated before an altar in the ceremonial chamber. Later, the dance is held for all to see and two men are selected to send medicine prayers heavenwards on the plumes of the mighty eagle as the old men chant and drum.

The eagle rises,
The wings swoop upward.
High toward the sky
The great bird moves.
His plumes are filled with prayers.
Earth and heaven are one.
The eagle rises.

From the Smithsonian Folkways Archive

opposite: The masked kachinas (Hopi Indian rainmakers), Hopi Pueblo, Shongopavi, Arizona, stereo cards, c. 1870–1900

above: Hopi Indian altar with three kachinas, 1906

following: Ai Weiwei, *Illumination*, 2014 (detail); sound installation: audio files, speakers; part of *@Large: Ai Weiwei on Alcatraz*, Alcatraz Island, 2014–2015

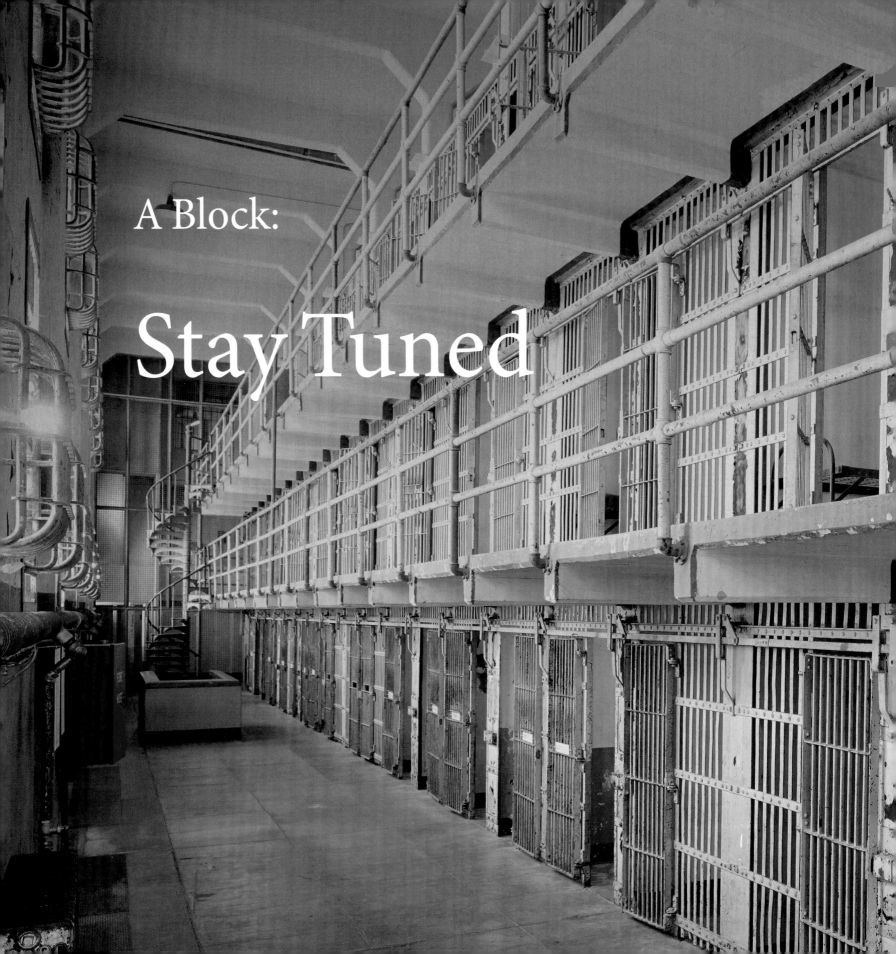

A Block:

Stay Tuned

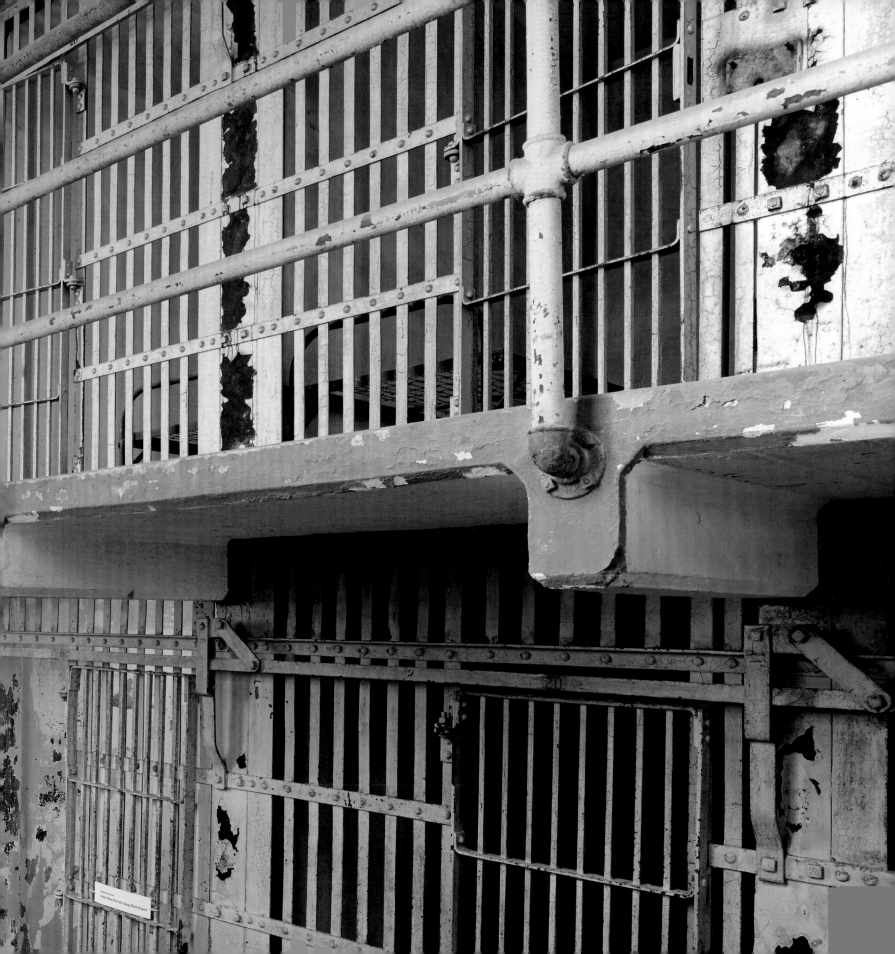

A Block

The massive concrete Alcatraz Cellhouse, completed in 1912, was originally designed to house military prisoners. When the prison became a federal penitentiary in 1934, two of the four cellblocks were renovated with tool-proof steel bars, remotely operated doors, and other maximum-security technologies. A Block, however, was not remodeled; more than any other part of the cellhouse, it retains the traces of Alcatraz's military past.

With its flat "strap iron" bars and keyed doors, A Block and the rest of the old military prison may have been less secure than the modern federal penitentiary, but the original "Disciplinary Barracks" were a no less forbidding environment. Six cells on the top tier of A Block were used for solitary confinement; outfitted with solid doors punctured by a few ventilation holes, they were precursors to the infamous isolation cells of D Block. Down below, steps led from the ground floor of A Block to the basement of the Citadel, the remnants of the original defensive barracks built in the 1850s. In the military prison period and in the early years of the federal penitentiary, parts of the basement were used for isolation; these dank, dark spaces earned the nickname "the Dungeon."

Among the inmates who became all too familiar with the military prison's lower depths was Philip Grosser, an anarchist and World War I conscientious objector, and one of a number of men who were imprisoned on Alcatraz for refusing to serve in the military on political or religious grounds. Grosser spent eighteen months on Alcatraz, including long

opposite: A Block, cell 146

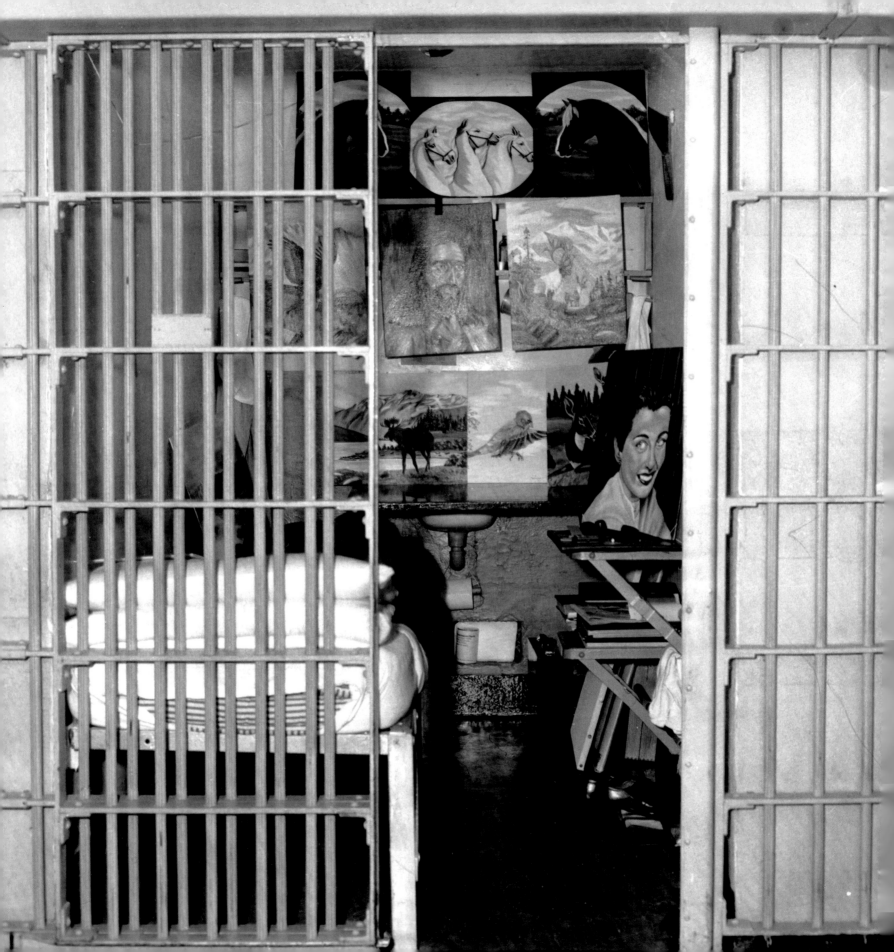

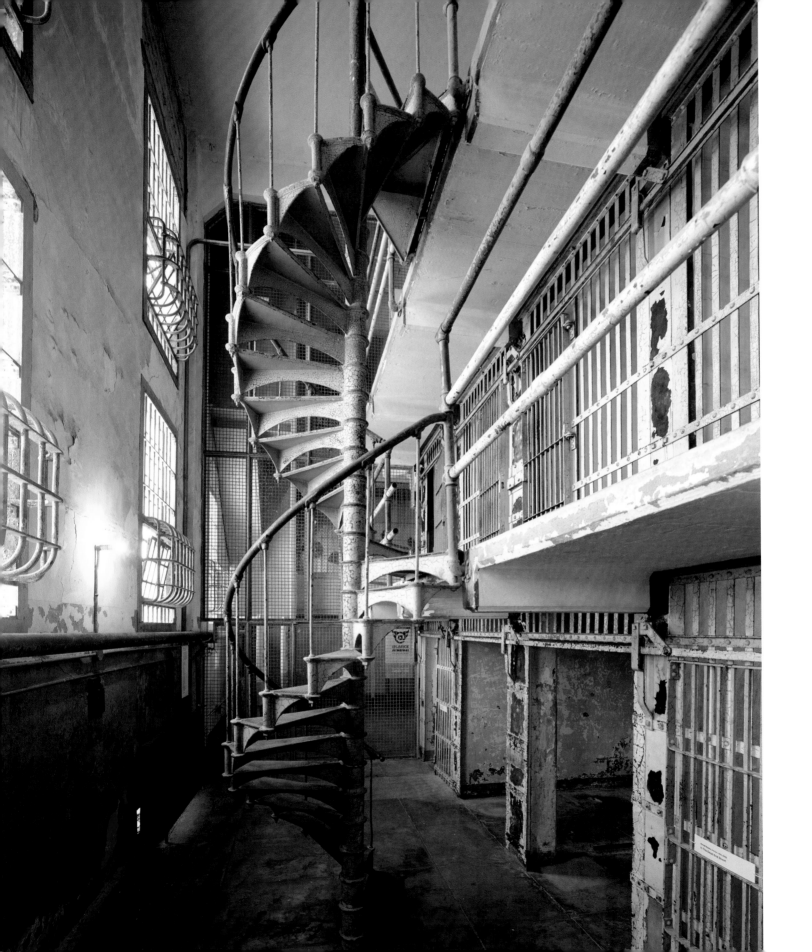

stretches in solitary confinement, and later wrote a scathing report on prison conditions. He vividly described his experiences in the Dungeon and in the vestibule doors, where cages, only twelve inches deep and twenty-three inches wide, were attached to the regular cell doors. Forced to stand in one of these "coffin cages" for eight hours a day, Grosser called the device a "veritable iron straight jacket."* The vestibule door cages were removed after 1920, but the hinges that are believed to have held them are still attached to some cell doors in A Block.

After Alcatraz became a federal prison, A Block was rarely used to confine inmates, except on rare occasions when prisoners needed to be completely separated from the general population; instead, the space was used for offices and storage. At least some of the federal prisoners who saw the inside of A Block came there voluntarily: cells equipped with typewriters and legal reference books gave prisoners a place to work on their legal cases or type correspondence, keeping some connection to life on the outside.

*For excerpts from Philip Grosser's firsthand account, *Uncle Sam's Devil's Island,* see p. 157.

Stay Tuned

Installation, 2014
Custom-made furniture,
speakers, audio files

Stay Tuned, an intimate and evocative sound installation, occupies a series of twelve cells in A Block. Inside each cell, visitors are invited to sit and listen to spoken words, poetry, and music by people who have been detained for the creative expression of their beliefs, as well as works created under conditions of incarceration. Each cell features a different recording. The diverse selection includes the Tibetan singer Lolo, who has called for his people's independence from China; the Russian feminist punk band Pussy Riot, opponents of Vladimir Putin's government; and the Robben Island Singers, activists imprisoned during South Africa's apartheid era.

Ai has described the texture of the human voice as a particularly potent vehicle for human connection and communication. Heard inside a cell, speech and singing create a powerful contrast to the isolation and enforced silence of imprisonment. The work encourages visitors to ponder not only what they hear and see but also their own personal values, responsibilities, and roles in the world.

opposite and following: Ai Weiwei, *Stay Tuned*, 2014 (detail); sound installation: custom-made furniture, audio files, speakers; part of *@Large: Ai Weiwei on Alcatraz*, Alcatraz Island, 2014–2015

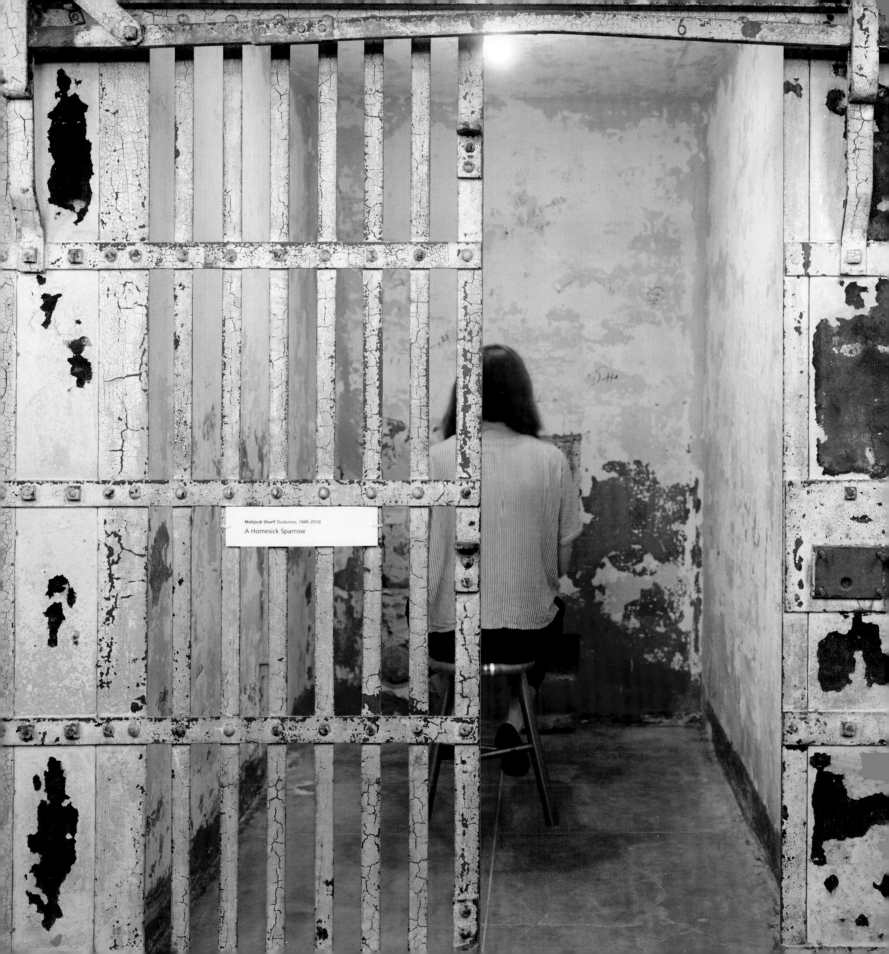

Mahjoub Sharif *(Sudanese, 1948–2014)*
A Homesick Sparrow

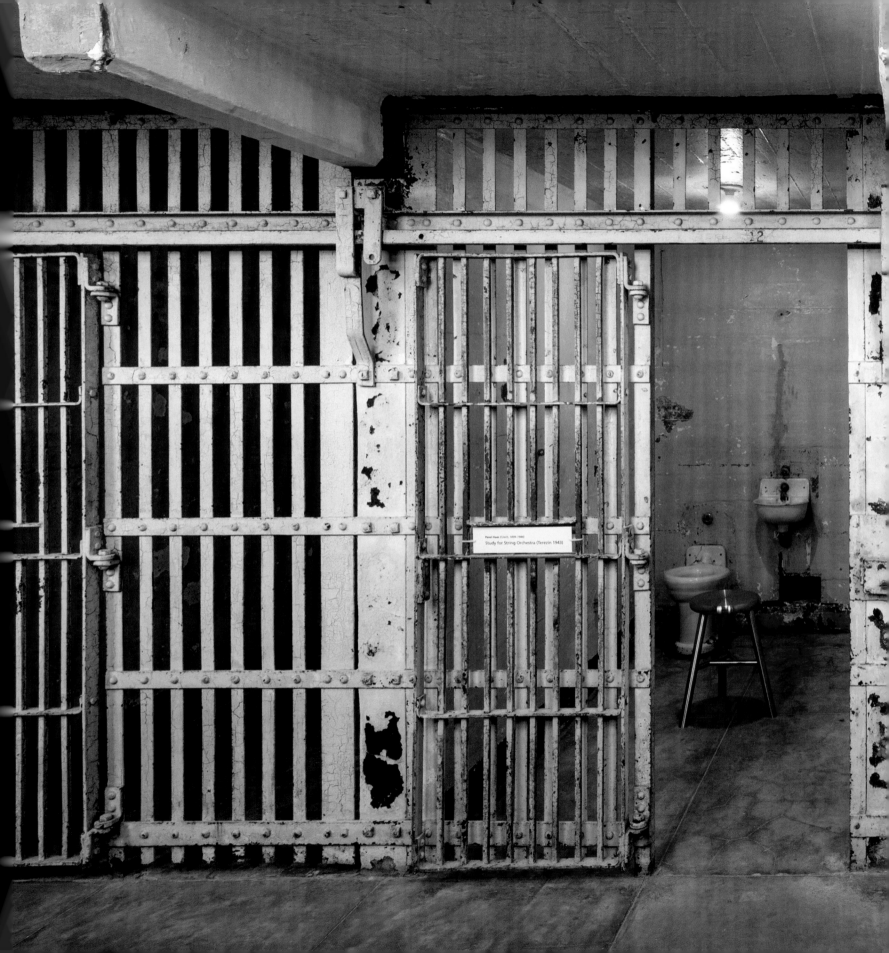

Pavel Haas (Czech, 1899–1944)
Study for String Orchestra (Terezín 1943)

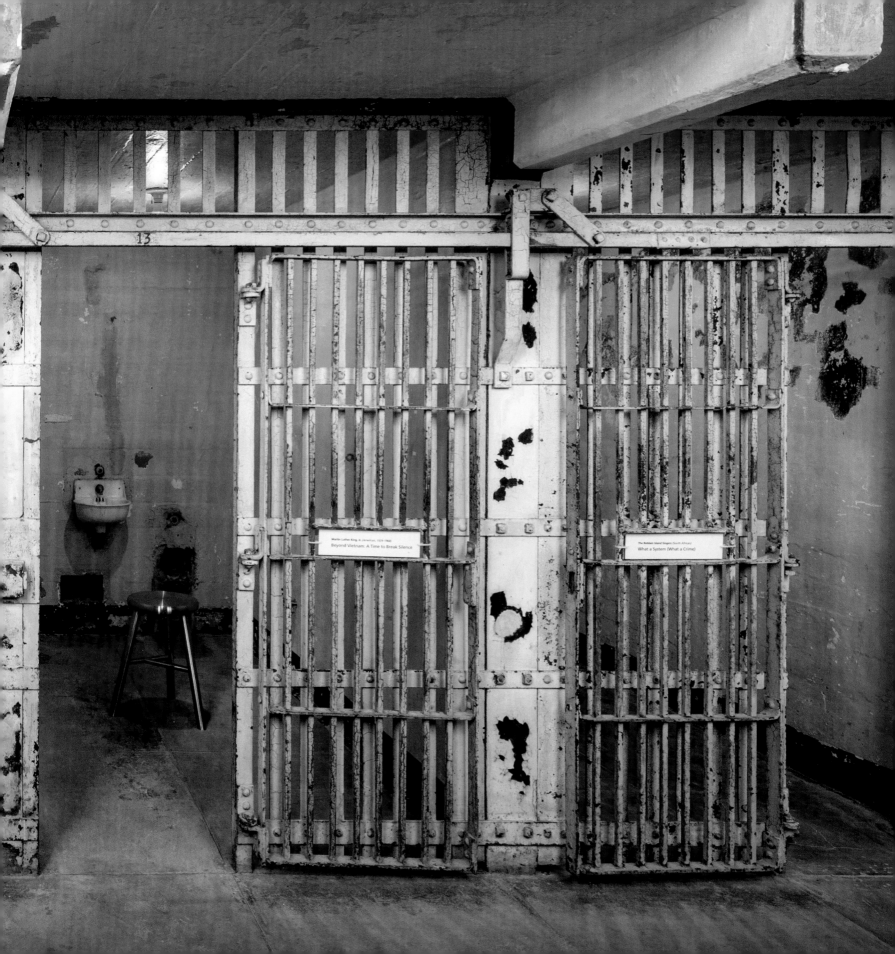

Pussy Riot

Russia

On February 21, 2012, a few weeks before Russia's national parliamentary election, five members of the performance punk rock group Pussy Riot staged an event in Moscow's Cathedral of Christ the Saviour, protesting the Russian Orthodox Church leader's support for Vladimir Putin during his election campaign. On March 3, 2012, two of the group members, Nadezhda Tolokonnikova and Maria Alyokhina, were arrested and charged with hooliganism. A third member, Yekaterina Samutsevich, was arrested on March 16. They were denied bail and held in custody until their trial began in late July.

On August 17, 2012, the three members were convicted of "hooliganism motivated by religious hatred," and each was sentenced to two years' imprisonment. Two other members of the group, who escaped arrest following the protest, reportedly left Russia, fearing prosecution. On October 10, following an appeal, Samutsevich was freed on probation, her sentence suspended. The sentences of the other two women were upheld. In late October 2012 Alyokhina and Tolokonnikova were sent to separate prisons in Perm Oblast and Mordovia, respectively.

opposite: Members of the Russian radical feminist group Pussy Riot performing at the Cathedral of Christ the Saviour in Moscow, February 21, 2012

Virgin Mary, Put Putin Away (Punk Prayer)

(chorus)
Virgin Mother of God, put Putin away
Put Putin away, put Putin away!
(end chorus)

Black robe, golden epaulettes
All parishioners crawl to bow
The phantom of liberty is in heaven
Gay pride sent to Siberia in chains

The head of the KGB, their chief saint,
Leads protesters to prison under escort
In order not to offend His Holiness
Women must give birth and love

Shit, shit, the Lord's shit!
Shit, shit, the Lord's shit!

(chorus)
Virgin Mary, Mother of God, become a feminist
Become a feminist, become a feminist!
(end chorus)

The Church's praise of rotten dictators
The cross-bearer procession of black limousines
A teacher-preacher will meet you at school
Go to class—bring him money!

Patriarch Gundyaev believes in Putin
Bitch, better believe in God instead!
The Belt of the Virgin can't replace mass meetings*
Mary, Mother of God, is with us in protest!

(chorus)
Virgin Mother of God, put Putin away
Put Putin away, put Putin away!
(end chorus)

*In November 2011, the Russian Orthodox Church in Moscow sponsored a traveling exhibition of a famous religious relic, the Holy Belt of the Virgin. Pilgrims waited for up to two days to see the relic, and the event conveniently monopolized news coverage as growing public protests were threatening Putin and his United Russia party.

Víctor Jara
Chile

Víctor Jara (1932–73) was a groundbreaking Chilean singer, songwriter, guitarist, and theater director. Between 1966 and 1973 he released eight albums, including *Canto libre* and *El derecho de vivir en paz*. He was a member of the Communist Party of Chile, a prominent supporter of Salvador Allende's Popular Unity government, and a leader of the New Chilean Song movement during the cultural renaissance of the Allende years. In the days following the U.S.–backed military coup of September 12, 1973, Jara was arrested, imprisoned, and ultimately murdered. His recordings were banned for many years in Chile.

Manifesto

I don't sing for the love of singing,
or because I have a good voice.
I sing because my guitar
has both feeling and reason.
It has a heart of earth
and the wings of a dove,
it is like holy water,
blessing joy and grief.
My song has found a purpose
as Violeta would say.*
Hardworking guitar,
with a smell of spring.

My guitar is not for the rich
no, nothing like that.
My song is of the ladder
we are building to reach the stars.

For a song has meaning
when it beats in the veins
of a man who will die singing,
truthfully singing his songs.

My song is not for fleeting praise
nor to gain foreign fame,
it is for this narrow country
to the very depth of the earth.
There, where everything comes to rest
and where everything begins,
song which has been brave song
will be forever new.

*Reference to Violeta Parra (1917–1967), Chilean ethnomusicologist, visual artist, and founder of the New Chilean Song movement.

opposite: Shortly before his abduction and murder, Víctor Jara (far right) leading the final rally in support of the Allende government, September 4, 1973, Santiago, Chile

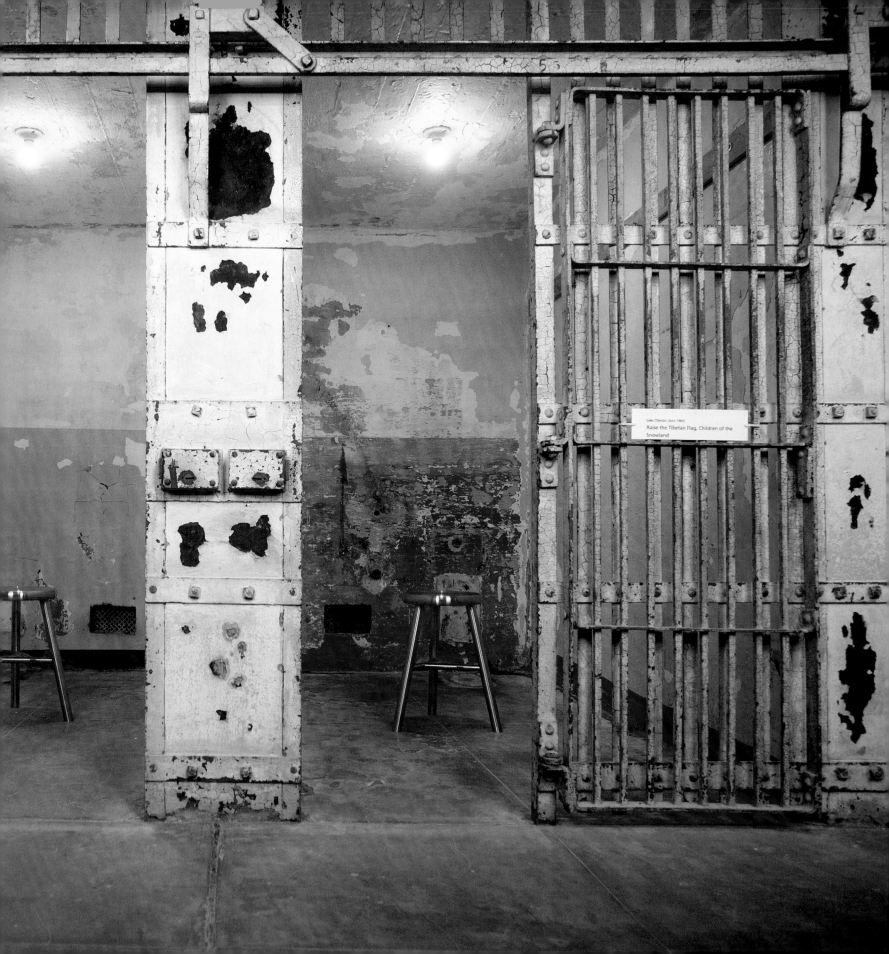

Lobo (Tibetan, born 1983)
Raise the Tibetan Flag, Children of the Snowland

Lolo
China

In February 2013 Tibetan singer Lolo was sentenced by a Chinese court to six years in prison. His crime was recording an album of fourteen songs that called for Tibet's independence, the unity of the Tibetan people, and the return of the Dalai Lama. Soon after the album's release in 2012, the thirty-year-old was arrested in eastern Tibet. He had no known links to protests or other forms of activism.

Raise the Tibetan Flag, Children of the Snowland

For the sake of protecting Tibet's independence
Our Kings resisted the red Chinese leaders
From the true meaning of the middle path
Raise the Tibetan flag, children of the Snowland!
For the sake of honoring the Snowland
And to win Tibet's complete independence
Based on the manifold truth
Raise the Tibetan flag, children of the Snowland!
For the sake of the return of the Protector
For the sake of uniting Tibetans home and abroad
From the wounds of the souls in flames
Raise the Tibetan flag, children of the Snowland!
This snow lion and snow mountain adorned flag
Is the national flag of the Tibetan people
Avenge those departed for the sake of Tibet
Raise the Tibetan flag, children of the Snowland!
Raise the Tibetan flag, children of the Snowland!

opposite: Ai Weiwei, *Stay Tuned*, 2014 (detail); sound installation: custom-made furniture, audio files, speakers; part of *@Large: Ai Weiwei on Alcatraz*, Alcatraz Island, 2014–2015

Dining Hall:

Yours Truly

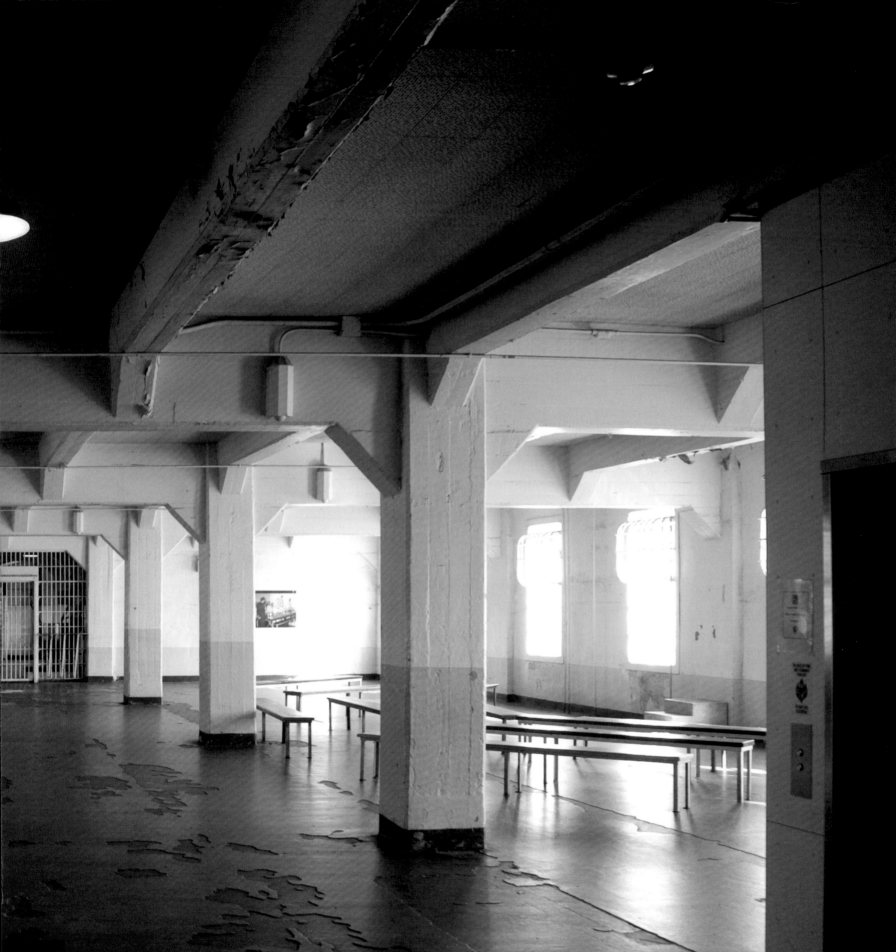

Dining Hall

In the early years of the Alcatraz penitentiary, a strict rule of silence was observed throughout the cellhouse. Any unnecessary conversation was forbidden, and a low murmur of "Pass the salt" to someone down the table might be the only words one prisoner exchanged with another in the course of a day. This rule was relaxed in 1937, and twenty-minute meals in the Dining Hall gave inmates more chances to talk—whether for strictly social reasons or for less innocent ones, such as hatching plans to escape.

However, just because it allowed a degree of social contact doesn't mean that the Dining Hall was a relaxing environment. Meals followed a tightly controlled protocol, inmates were closely watched by both unarmed guards on the floor and armed guards on the catwalk, and tear gas canisters were mounted on the ceiling. Security was tight with good reason: because each inmate had utensils that could potentially be used as weapons, the Dining Hall was one of the most dangerous places on Alcatraz. Inmates leaving the room had to pass through a metal detector, and utensils were carefully counted at the end of each meal—although some did slip through. Frank Morris and the Anglin brothers used spoons from the Dining Hall as tools in their breakout, which was made famous in the movie *Escape from Alcatraz*.

opposite: A guard standing by as prisoners enter the Alcatraz Dining Hall for supper, April 14, 1962

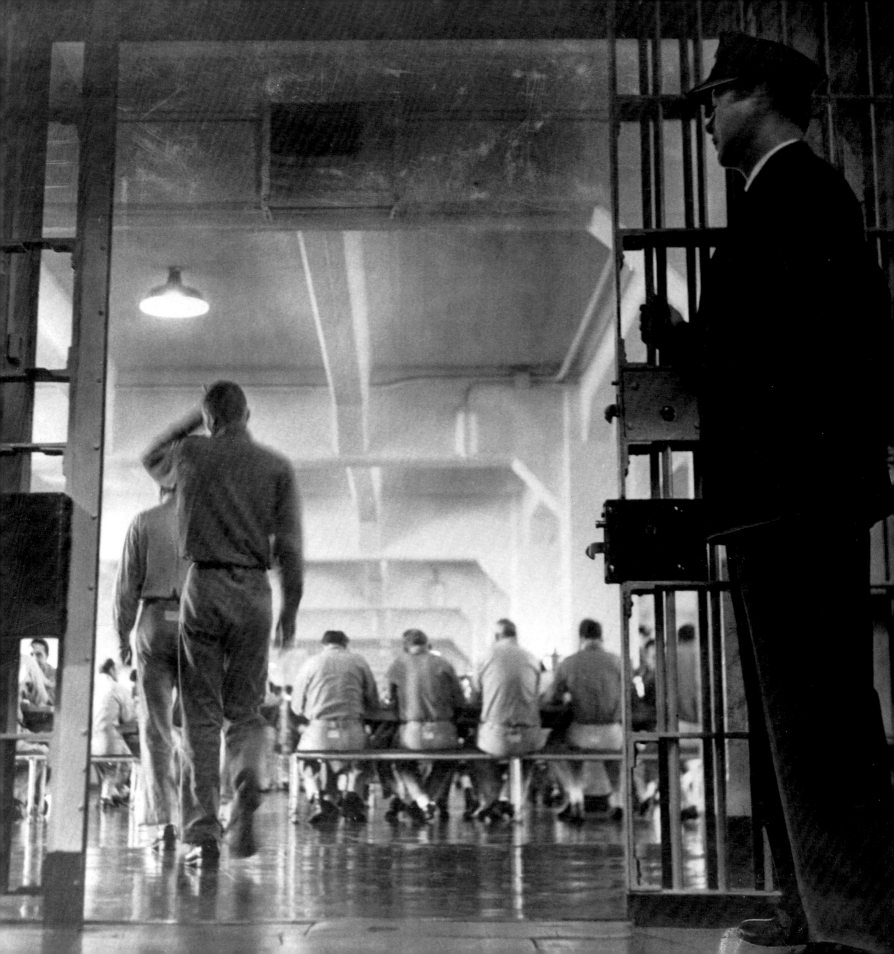

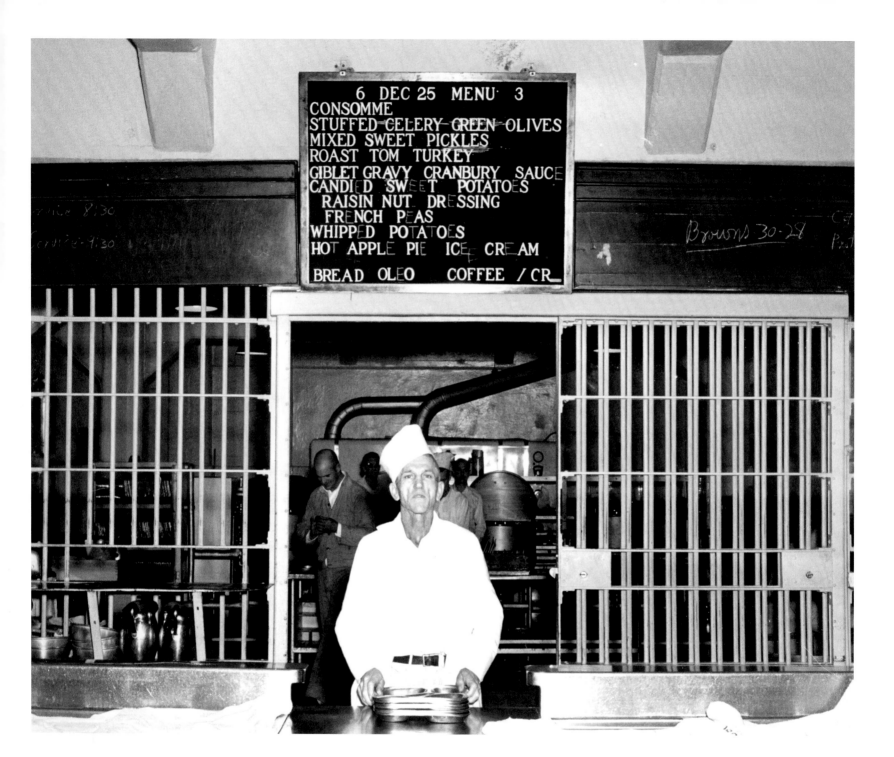

@Large: Ai Weiwei on Alcatraz

Officers and inmates ate the same food, which was prepared by inmates under supervision. The food was considered some of the best in the prison system, and Alcatraz officials claimed that the food budget per inmate was larger here than at any other penitentiary. Inmates were allowed to serve themselves as much food as they wanted within a specified limit; keeping their appetites satisfied gave them one less reason to revolt. But even in this there was a catch. "Take all that you wish … but you must eat all that you take" was the policy, and inmates could be disciplined for failing to finish their meals.

opposite: Alcatraz Dining Hall Christmas menu

above, left: The Dining Hall, present day

above, right: The Dining Hall, c. 1960

Yours Truly

Interactive installation, 2014
Custom-designed postcards,
racks, tables and chairs

While several other works in the exhibition expand visitors' awareness of prisoners of conscience around the world, this installation in the Dining Hall offers visitors the opportunity to correspond directly and personally with individual prisoners. Visitors are invited to write postcards addressed to prisoners represented in *Trace*, the series of portraits in the New Industries Building. The postcards are adorned with images of birds and plants from the nations where the prisoners are held. Cards are retrieved and mailed by *@Large* Art Guides.

Ai has spoken of the deep feeling of isolation that afflicts incarcerated people, and of political prisoners' fear that they—and the causes they fought for—have been forgotten by the outside world. *Yours Truly* is a direct response to that concern, reminding detainees that they are remembered—and reminding exhibition visitors of the detainees' individuality and humanity. In the spirit of free expression, visitors may write any message they wish. By encouraging visitors to engage in a global conversation, this work brings home some of the exhibition's core concepts: the responsibilities that we all bear as members of a community and the importance of communication as both a personal expression and a force for social change.

opposite and following: Ai Weiwei, *Yours Truly*, 2014 (detail); interactive installation: custom-designed postcards, racks, tables, chairs; part of *@Large: Ai Weiwei on Alcatraz*, Alcatraz Island, 2014–2015

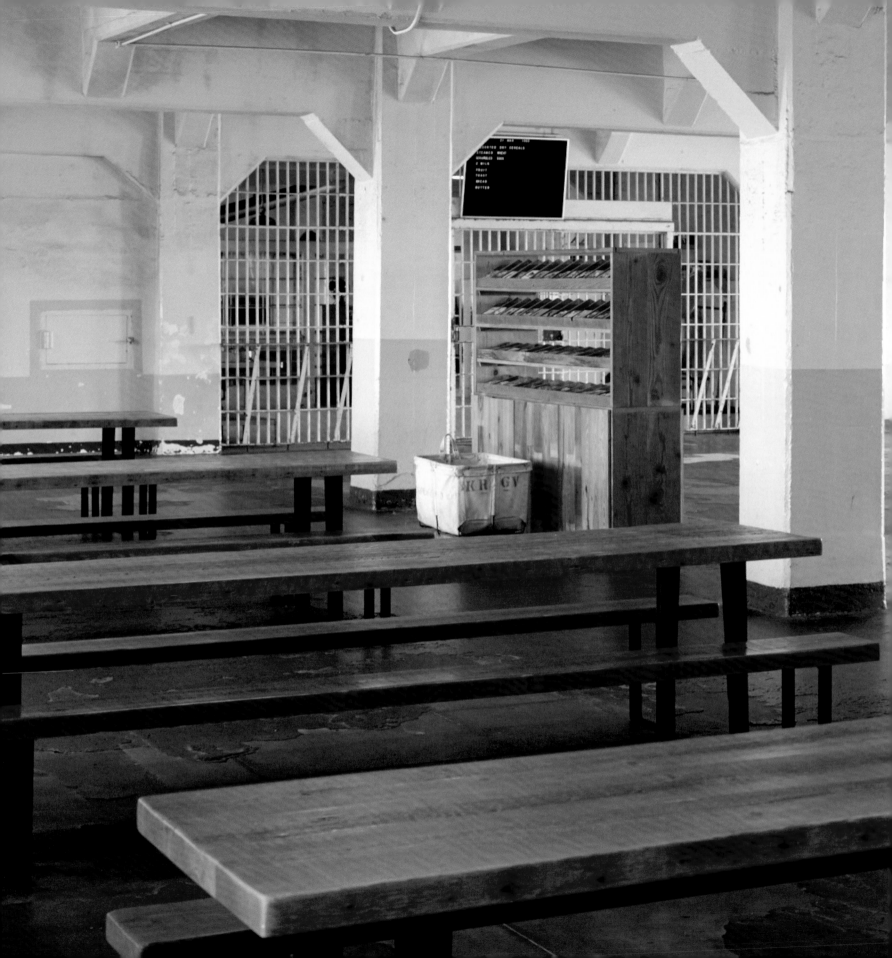

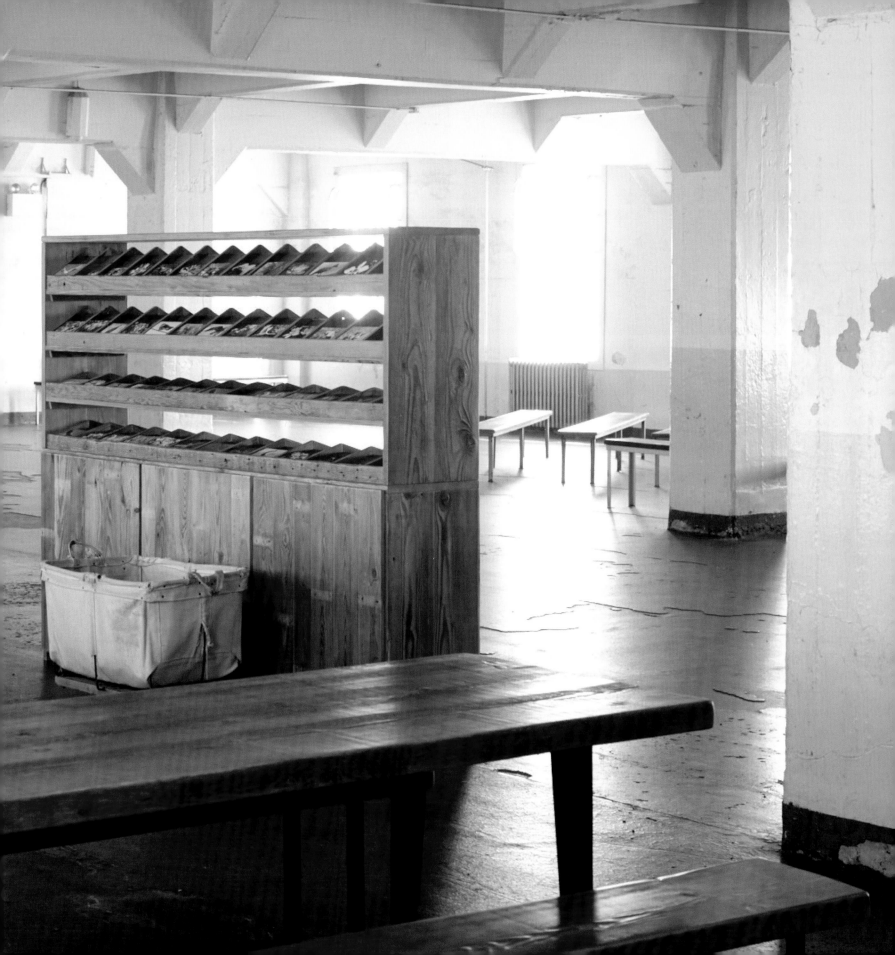

Selected postcards from *Yours Truly:*

above, top row: Bahrain: White-Cheeked Bulbul / Red Stinkwood

above, bottom row: Iran: Common Nightingale / Tulip

opposite, top row: Russia: Tundra Swan / Camomille

opposite, bottom row: United States: Bald Eagle / Rose

Interview with Ai Weiwei

Hans Ulrich Obrist

Hans Ulrich Obrist: The exhibition @*Large: Ai Weiwei on Alcatraz* is essentially a public artwork. When was the first time you went outside the gallery and into the public realm?

Ai Weiwei: I started around 2000, when I was hired by a developer in Beijing called SOHO China. I created a public sculpture in a real estate development. That was the first time I had an awareness of public sculpture. Later, for the 2002 Guangzhou Triennial, I showed a huge chandelier in a field of scaffolding. That was my second public sculpture.

HUO: Can you tell us about this first piece you did for SOHO?

AWW: The name of the piece is *Concrete*, and it's made of concrete. At that time, urban structures were rapidly developing in China, and the aesthetic of the new buildings was often copied from Western styles, inspired by royal palaces and architectural forms from the Renaissance. I made a concrete path leading into an abstract form, which is more like a tube with a gap. You can walk into it. At that time, I wanted to show that all the new urban structures had too much decoration, so I made a bare-looking or "nude" structure. The work caused arguments, because a lot of residents thought that it was unfinished. But it stayed there, and we're happy that this is probably the only concrete structure in this fashionably designed middle-class compound. All the others have since been completely covered by decoration, except that piece.

HUO: *Concrete* brings us to architecture, which is also a form of public art, so to speak. What prompted you to make architecture? Was there an epiphany? Because it is something that appeared suddenly in your work, initiating a very feverish period where you built more than many professional architects build in an entire lifetime. Then you suddenly stopped. What prompted that flaring up of architecture in your work?

AWW: It's like a love affair. There is so much involved in architecture and the issues it raises—from urban design to landscape design and interior design, and I worked on those issues for about six years. Then, after the National Stadium was completed, I got extremely tired, because you cannot really control the architecture you build in China. There are too many other issues—the political issues, the bureaucrats, and the people who do the construction—and this is also complicated by how they are going to use the building later. Obviously, architects cannot control those issues. But China is still a society that doesn't have a clear program. I don't think that the government, from any point of view, has a clear political vision or even a very practical vision, and architecture should be the most practical practice.

Very often, the design may not be exactly what the developers want, but they are just trying to impress the government or to develop the land around the site. There are many hidden issues there—the developer may be planning on selling the land to make a little profit, or hoping to get some kind of favored treatment from the government by using you [the architect] to make something very impressive. All that completely changes the meaning of architecture. Once I feel I'm involved in something that I cannot be fully responsible for, then I lose interest in it. Although there is a lot of demand for my architecture, I told myself that I could only be involved with matters for which I can take full responsibility.

HUO: You created what is probably the most visible public sculpture in recent years with the "Bird's Nest," the National Stadium you designed with Herzog and de Meuron, which was seen by billions of people—not only in person, but also on television during the 2008 Summer Olympic Games. Can you tell me a little bit about it? Do you remember the very moment that you, Herzog, and de Meuron invented the shape of the Bird's Nest and how that idea came about?

AWW: Before we started work on the stadium, I remember Jacques [Herzog] and Pierre [de Meuron] wanted to build something like a new Temple of Heaven.*

When we saw ordinary folks using a site that used to belong to the emperors—playing music and enjoying all kinds of self-organized activities—they were very impressed. During the design of the stadium, we wanted to build an urban structure that people could truly enjoy using after the Olympic Games. That was the idea: to build a very democratic structure that's totally open to the society and that will become a real instrument of the city after the games—but, of course, this was only a reflection of our ideology. This idea had been extremely publicized during the games, but after the Olympics, the structure has not been put to good use. Now it's just like a sculpture standing there; it's not really a meaningful part of the urban landscape.

HUO: Another public structure that was conceived as such is the sculpture made of many bicycles, called *Forever Bicycles*. It exists also as a series of indoor pieces, but you've done it as an outdoor work using over 3,000 bicycles, so that they almost constitute a building. Can you tell us about that piece?

AWW: *Forever Bicycles* started back when I was invited to teach an architectural course at the China Art Academy in Hangzhou. For their first class, I was asked to teach the architecture students how to build. The school thought that I was an expert in the use of brick, but I said no, we don't need to build within the traditional language of architecture; the students have to find daily objects from which to build. I brought them to a recycling center and we found some old bikes. We started to build with the bicycles, and the students discovered that within those irregular shapes, you could find a hidden logic; using that logic, you can turn a very familiar object into something completely new.

The bikes relate so much to our lives in China. When I was growing up, our bikes were still colorful, and the Forever brand bicycle was much more treasured than a Mercedes-Benz or a BMW is today. If any family got one of those bikes, children would be running after it. It's very primitive, but today, with China's

opposite: Ai Weiwei, *Concrete*, 2000; public sculpture, approx. 472.5 x 149.5 inches, Soho New Town, Beijing

following: Ai Weiwei, *Beijing Olympic Stadium*, 2007; color photograph

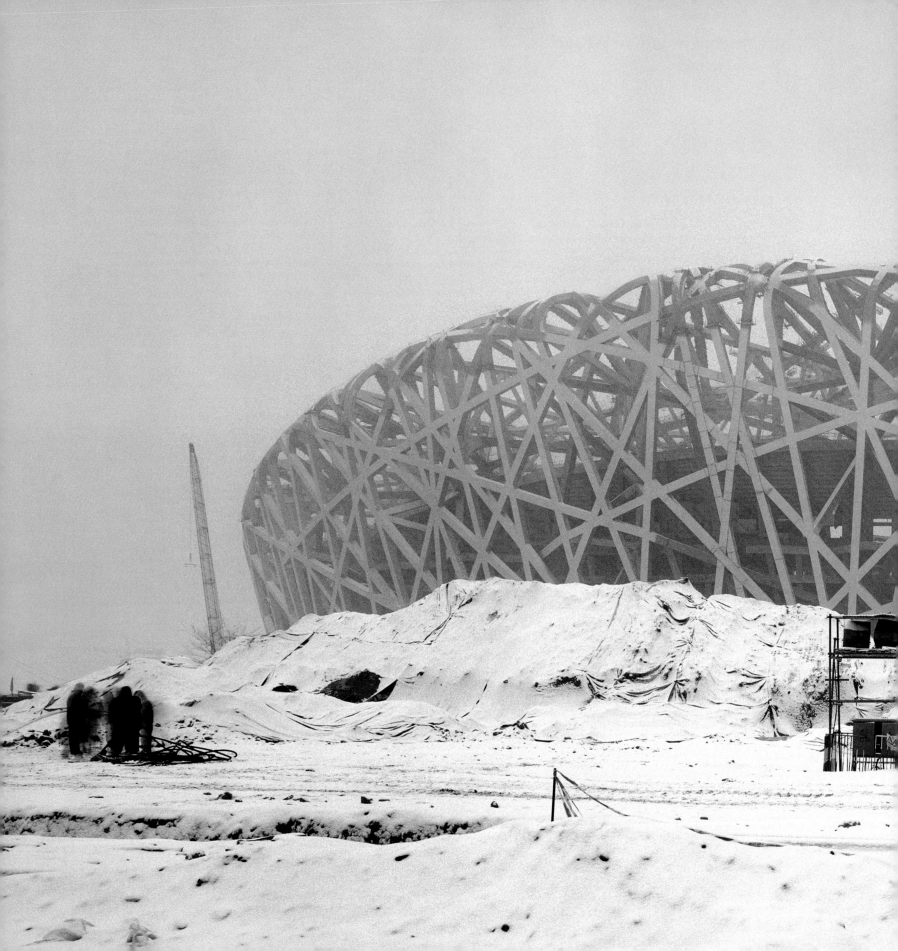

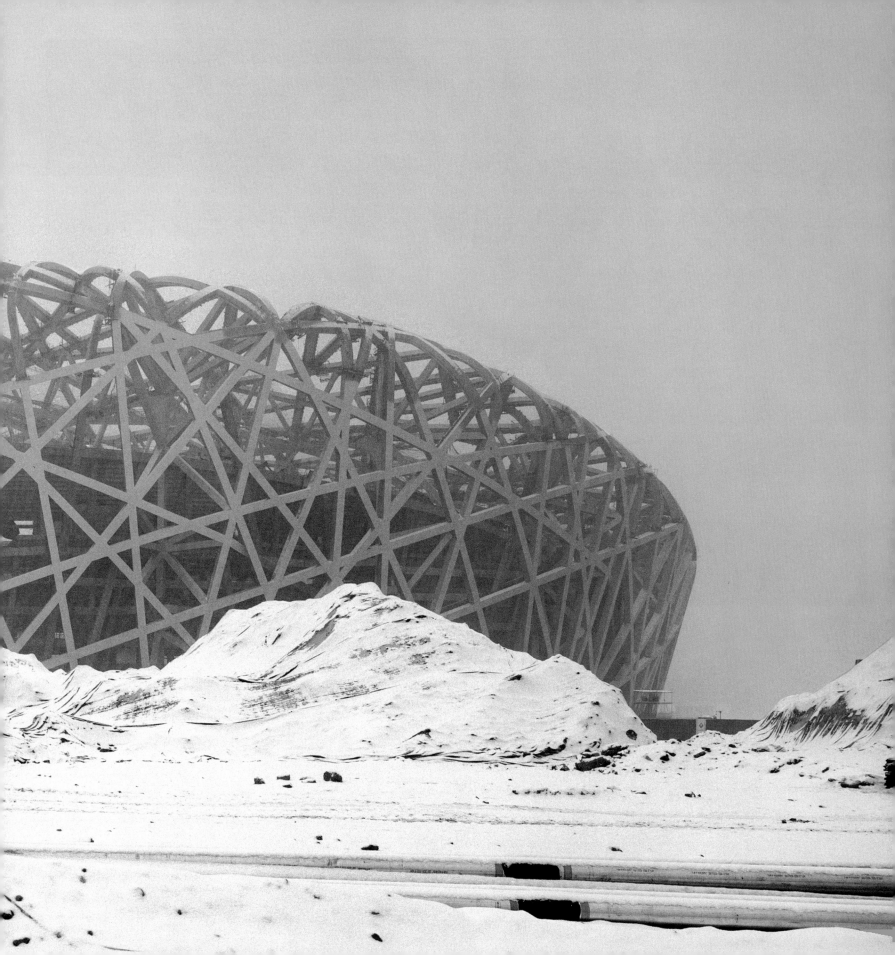

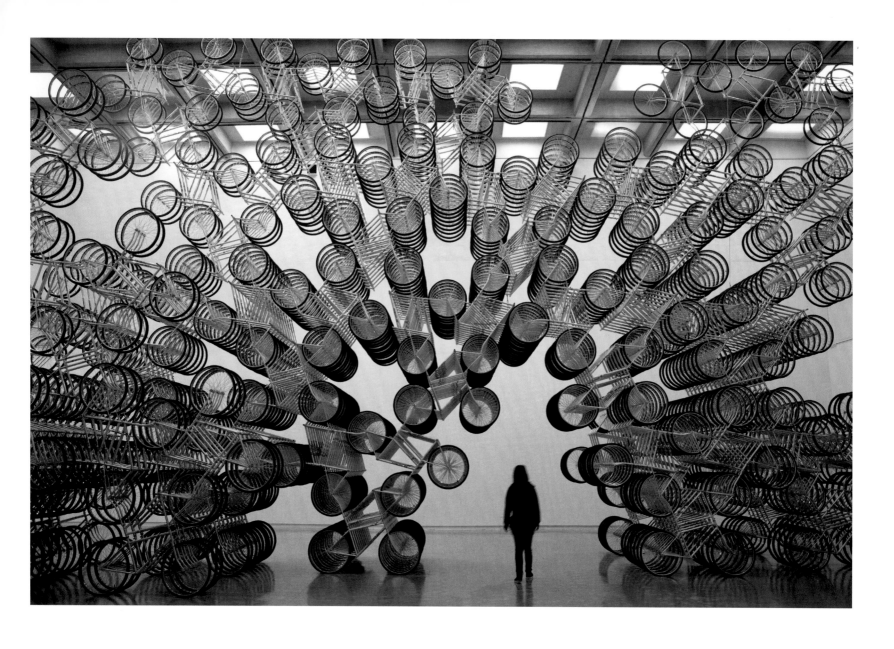

above: Ai Weiwei, *Forever Bicycles*, 2011; sculpture of 1,200 bicycles, Taipei Fine Arts Museum, Taipei, 2011

opposite: Ai Weiwei, *Circle of Animals / Zodiac Heads*, 2010; public artwork composed of twelve bronze sculptures, approx. 10 feet high (each), Somerset House, London, 2011

fast urban development, riding a bike within the city means that you must be among the poorest members of the working class—those who cannot afford to take a bus or taxi. Riding bikes has also become much more dangerous, due to the air pollution and the street traffic.

I think it's interesting to have a large quantity of these bicycles interconnected through their own parts to create such an original, crazy result. The bicycle's form has its own logic, which is why I built the *Forever* pieces. Today, as artists, we have to face reality. We have to reinterpret the past and comment on things happening now in our daily lives—to deal with memory, tradition, and current affairs.

HUO: You said that when you showed another public artwork, the *Circle of Animals / Zodiac Heads* in London in 2011, that you were fascinated by public art because "public" refers not just to the museum-going public but also to the people passing by and using communal spaces. You said that you wanted your artwork to be accessible to everyone. Can you talk a little bit about what Gilbert and George call "art for all"?

AWW: As artists, we must try to use our very limited skills, knowledge, and opportunities to maximize the possibility of speaking to more people and raising the consciousness of a broader audience. That is a new challenge today for artists: to use a form of expression that can communicate, to create works in the public sphere that can truly address all kinds of people.

Today, the world has dramatically changed—our values and the old systems have changed—so I think the most effective way to reach the public is to use very recognizable materials and spaces. This is true of the new project we're doing on Alcatraz, a site that is a tourist attraction. It has its own history and mythology. The site speaks to the human condition during incarceration within a jail cell. To take a place like Alcatraz as a ready-made and to work it into some kind of new expression, with new possibilities, is both challenging and exciting.

HUO: That brings us to what's going to happen in San Francisco. Can you tell us about the situation you're developing there for the exhibition *@Large: Ai Weiwei on Alcatraz*?

AWW: Alcatraz is a site that is run by the U.S. National Park Service [NPS] as a resource for the public. It has had very clear functions, both in the past and present. It's not exactly a museum-like condition, but because of its history, the site has been a popular attraction for many years. Every time we work, we have to deal with existing conditions, while at the same time trying to extend our efforts.

The exhibition on Alcatraz is about freedom of speech and the power of the individual. We want to create something that celebrates the spirit of freedom of speech and pays respects to the people whose acts are remarkable in the struggle to achieve freedom of speech and other basic human rights. At the same time, we have to work with metaphor to address the current conditions in today's society. These are very complex and deep

issues that, as an artist, I learn about by doing these kinds of projects. In the process, we're trying to clarify our own interpretation of these things, so that the works can be easily understood and accepted by the audience.

We have to think about what is feasible within our allotted time frame to create the exhibition, as well as dealing with the regulations regarding what can and cannot be done in this kind of space. The relationship between the studio and the FOR-SITE Foundation in San Francisco, particularly with our curator, [FOR-SITE executive director] Cheryl Haines, is essential to the process. We are also working with different organizations to assist us with our research, such as Amnesty International and Human Rights Watch, who have the knowledge and resources. Throughout the process, we have always found that there is a lot of support and a lot of new possibilities that we can explore.

HUO: How will the exhibition be structured, and how will the different pieces come together?

AWW: Regarding the conditions on this island, even as a tourist site, it really offers a dramatically different kind of space that has nothing to do with museum or gallery conditions. There are regulations regarding the use of light and sound. One has to be very sensitive, because there are birds nesting on the island. You cannot disturb those wild birds. Nor can you physically attach anything to this kind of landmark building. You can place things there, but you cannot alter the

physical structure. You cannot paint the walls or install electrical wiring. Everything has to be done with great care and sensitivity, and each thing requires the permission of our partners at the NPS.

Still, there are a lot of interesting possibilities. We are creating several different kinds of works for the exhibition. Some are installations, while others are interactive works that invite the visitors to join in. There are audio works that include both music and speeches relevant to the struggle for human rights. There will also be a lineup of public programs—including a film-screening series—related to the issue of freedom. It's quite a complicated, multilayered performance there.

HUO: The last time we spoke, we discussed your own experiences in prison. We talked about your installation *S.A.C.R.E.D.* (2011–2013), which you presented in Venice in 2013. The piece re-creates the architecture of the place you were held during your 2011 detainment. The works you're making in San Francisco are obviously different, but there is a link. You have said that an idea cannot be imprisoned.

AWW: While we were growing up, we looked up to many, many so-called revolutionaries. They all were exiled or imprisoned. Great ideas often create a tremendous confrontation with the old society.

I used to feel envious of my father's strength. He had been imprisoned for years and then later he was exiled. I would think, "Oh, he was in jail and endured. I would never make it," but suddenly I was arrested. That moment, that day, I was somehow relieved. Even though our incarcerations were nearly eighty years apart, we were in jail for the same reason—only because we have different ideas about aesthetics and philosophy.

Of course, you can lock up a person, but you cannot really destroy an idea. Very often, those people who are being put in jail are physically silenced, which puts their relatives and loved ones in such a shattered condition. There are many, many people that I'm sure

we will never hear from again because they are unfairly incarcerated. These are people who sacrificed their own freedom—peaceful creatures that insist on their beliefs and their right to speak out. Very often, they have raised their voices not just for themselves but also for others, for the society.

These prisoners form a very strong current in the show. They are still suffering in detention or jail, and some will serve a life sentence. Very often, these people are forgotten by society, but a few people remain concerned about their happiness and their safety. I sometimes ask myself, "Am I exaggerating this condition?" But reality tells me that I haven't done enough. There's much more we can be talking about and doing, because this is real. It's not a hypothetical political condition.

HUO: Now, this installation happens in this very specific prison in San Francisco, but you will not be able to travel, so that's a paradox. Can you talk about this?

AWW: I think the most powerful sentence the authorities can hand down is one that limits a person's freedom. They can tell you when to talk or what to say or what not to say; they also can tell you when to travel or not to travel.

I'm very much used to it, because for twenty years my father, Ai Qing [1910–1996], during what should have been his most productive years, was not allowed to write a word. As a poet, that is not a life. To prevent him from writing, I think that was a true punishment for an intellectual.

HUO: It's a very unusual project and on such a large scale for a public art project. Can you tell me a little bit more about how the project for Alcatraz is evolving?

AWW: The project is developing, but it's quite difficult for two reasons. The first, of course, is that I cannot go to the site, which has a very strong character. The second is that Alcatraz is a tourist attraction and quite an important landmark; for this reason, you cannot change the physical space. But we're

very excited about the show because it is related to a piece of history but also related to the tools society uses to control behavior. The exhibition deals with the loss of freedom and the price sometimes paid for freedom, which are very serious topics. We see so many people in today's world who have sacrificed their freedom for their ideology—who are forced to serve time for their beliefs. So, part of the exhibition deals with writers, musicians, political activists, and human rights activists. These people are freedom fighters, and they have lost their freedom because they are willing to fight for it.

HUO: You mentioned that you couldn't really alter the site or make changes—not only to the existing architecture but also to the visitor experience that Alcatraz already offers to its 1.4 million visitors. There is "Doing Time: The Alcatraz Cellhouse Tour," which incorporates interviews with former inmates of the prison and includes artifacts from the penitentiary years as well as implements that inmates used during the famous breakout attempt dramatized in the movie *Escape from Alcatraz* [1979]. There are even tours with a former inmate [Bill Baker]. I was wondering: With all these things already in place, how have you implemented additional elements and contextualized them with the existing visitor tour?

AWW: This the first time that this tourist attraction has been opened up to include contemporary art. We have made a continual effort to communicate with our partners in California at the FOR-SITE Foundation and to try to encourage all the parties involved in this exhibition to understand our intentions and to maximize the possibility to develop our concept for the visitors. But I think that it is important to use the architecture and to try to intervene with our limited resources within the context of these existing elements on Alcatraz. It requires a lot of struggling and constant communication to make this show, which uses the location to address our topics.

HUO: Can you tell us about the pieces you are creating for the penitentiary?

opposite: Ai Weiwei, *Chandelier*, 2002; crystals, lights, metal, and scaffolding, approx. 236 x 165 inches, Guangzhou Triennial, Guangdong Museum of Art, Guangzhou, 2002

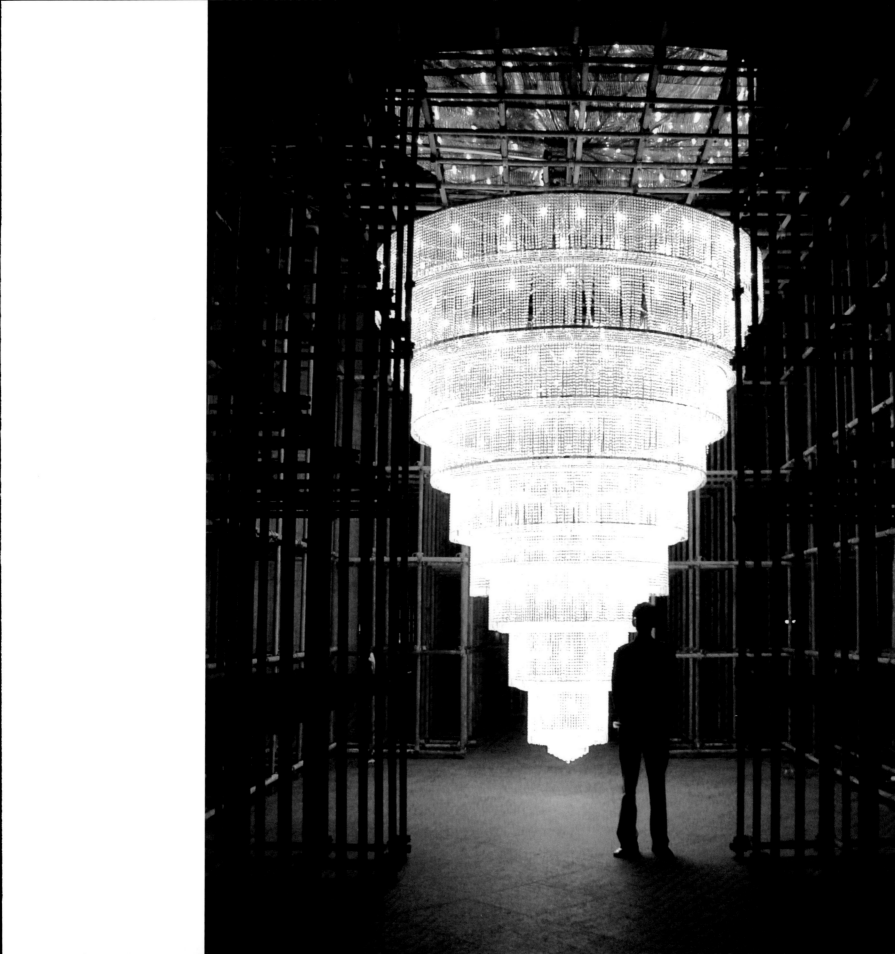

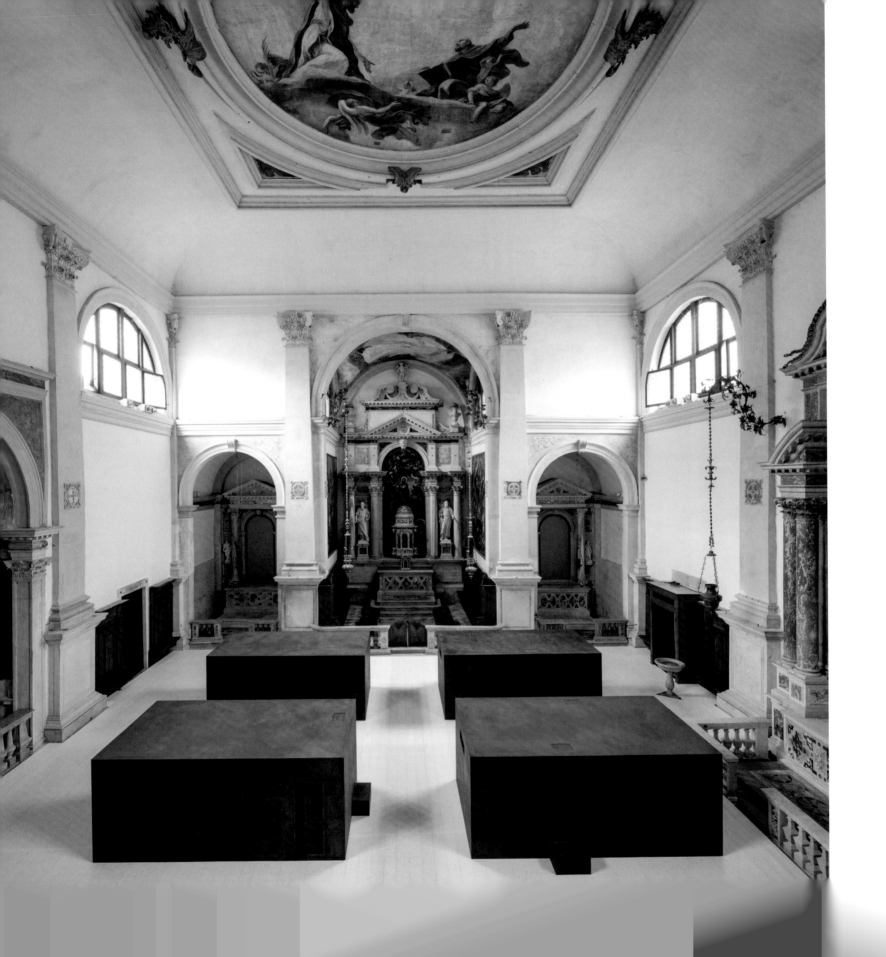

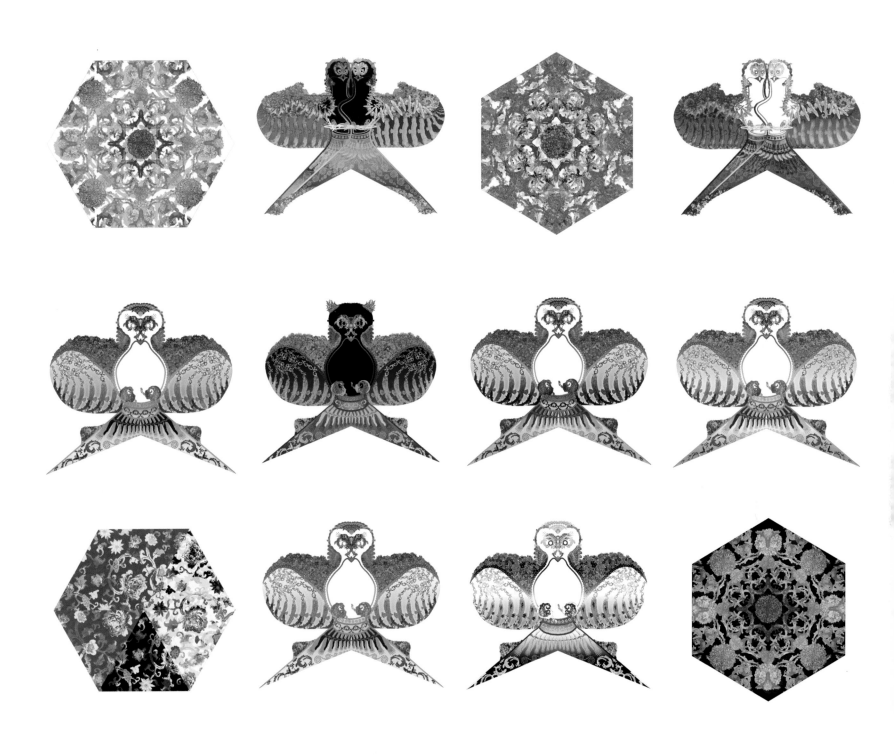

opposite: Ai Weiwei, *S.A.C.R.E.D.*, 2011–2013; six dioramas of fiberglass and iron, Church of Sant'Antonin, Venice, 2013

above: Preliminary studies for kites included in *With Wind*

AWW: For one of the works, called *Trace*, we are focusing on people who are freedom fighters. For this project, we identified about 180 prisoners, working with international organizations—Amnesty International and Human Rights Watch—to generate credible research on their stories. People are interested in seeing each of the prisoners' faces, so we are using LEGO, a household toy, to re-create images of prisoners from approximately thirty nations. Some are imprisoned at known locations; others just disappeared and nobody even knows where they are.

There are approximately 180 of these LEGO portraits, and they are very beautiful. Sometimes, the most current images available of these prisoners are blurry, so that you can barely identify the person. But with the LEGO portraits, we have transformed these photographs into something resembling digital pixels, which creates an image that is very presentable and seemingly clear. These images come together to occupy over 6,000 square feet, and visitors can walk through the installation and see all of those people's faces in a style that's quite strong.

HUO: You do a piece for the New Industries Building, where you will introduce an installation of handmade kites made out of silk and bamboo? I was very curious about this installation. Will the kites fly?

AWW: This piece is called *With Wind*. The kites are very light—almost transparent—and their designs depict images of flowers and birds. We did a preliminary study with a very classic kite craftsman to test out the overall design. China is very famous for making kites, and these are going to be very beautifully made by skillful craftsmen. The images on the kites were all created by the studio; the bird and flower motifs are related to the homelands of the prisoners of conscience that appear elsewhere in the exhibition. The kites will not fly but will be suspended, giving a different kind of look to the space.

HUO: Then there is the wing sculpture, *Refraction*. Can you talk about this idea of flying out of Alcatraz and the symbol of the bird's wing?

AWW: Yes. This work was inspired by the actual wing of a bird, which serves as a metaphor for freedom. The wind can never really move this wing, and it is being shown in a location where the audience cannot enter but must view it through windows. There is another project in some of the prison cells called *Stay Tuned* that deals with the basic human need for communication, using the human voice and other types of sound. Visitors to the exhibition can walk into a cell and listen to audio that comes from different activists and artists.

HUO: Were these recordings made for the exhibition?

AWW: They were selected for the exhibition. They are recordings of music and speeches made by people from around the world who, at one time or another, have been incarcerated for their beliefs.

HUO: And there is another piece for the Hospital cells that uses flowers. Can you tell us about this work?

AWW: Yes. There are several areas of the island that we are using that were previously closed to the public, including the Hospital and the psychiatric observation rooms. These have metal bars on each cell and contain no furniture except a sink and sometimes a toilet and a bathtub. So we decided to make porcelain flowers that actually fit into those rooms, resting inside these bathroom fixtures. The work is called *Blossom*.

HUO: My last question is about the work that utilizes postcards, *Yours Truly*, because obviously Alcatraz is a tourist site and the postcard plays a role there.

AWW: I think that the postcard is something that can be a part of contemporary communication. The signature is important, too, because the writing we do on our computer keyboards disappears. If somebody is in jail, sending a postcard is an essential form of communication.

You know, throughout the world there are many political prisoners in jail. We would like to send them postcards to show them that people still care about their condition. We want to tell these prisoners that they are not forgotten and also to show the authorities that those people in jail represent a larger ideology that is shared by the society.

It's very important that we encourage the audience on Alcatraz to sit down to write their feelings down and send them to the prisoners. Most prisoners have a receiving address. There are also cases where we have a mailing address, but we have been advised that receiving such mail could actually worsen the prisoners' situations, so we have had to exclude them from the work. The exhibition provides the possibility for people to develop their feelings about these issues and then to feel involved through the act of writing a postcard.

Unfortunately, I think the world will never be a place where we can live without fear. There always seems to be a need to fight for our basic human rights, and that what this whole show is about.

Summer 2014

*The Temple of Heaven is a complex of religious buildings situated in the southeastern part of central Beijing. The complex was visited by the emperors of the Ming and Qing Dynasties for annual ceremonies to promote a good harvest.

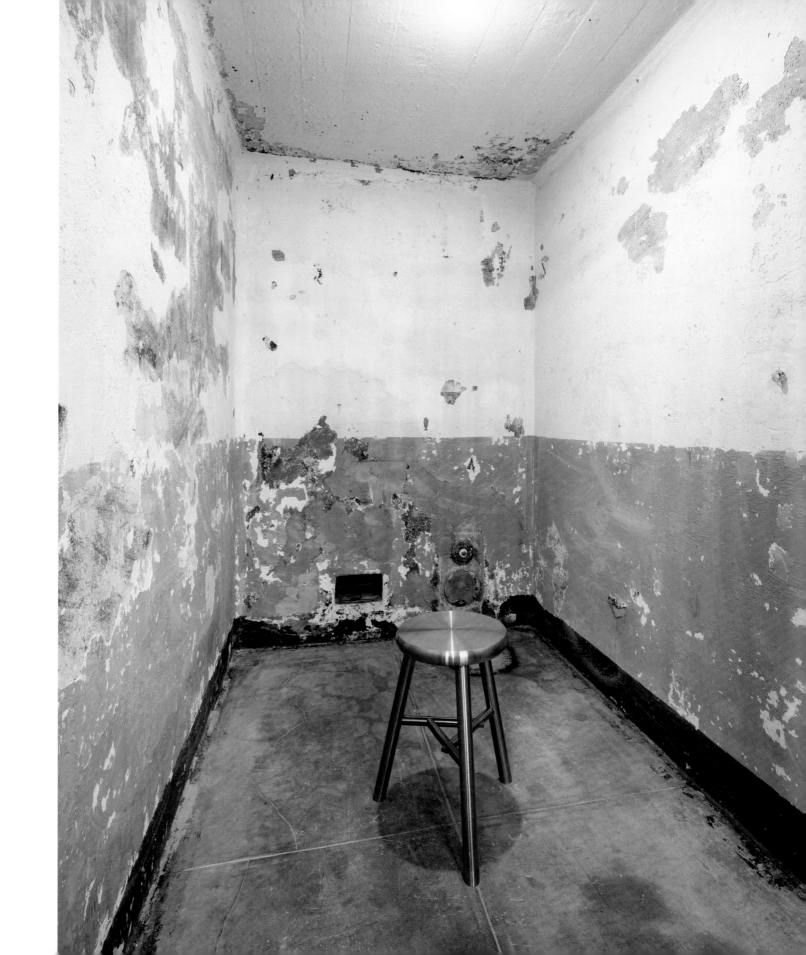

Related Readings

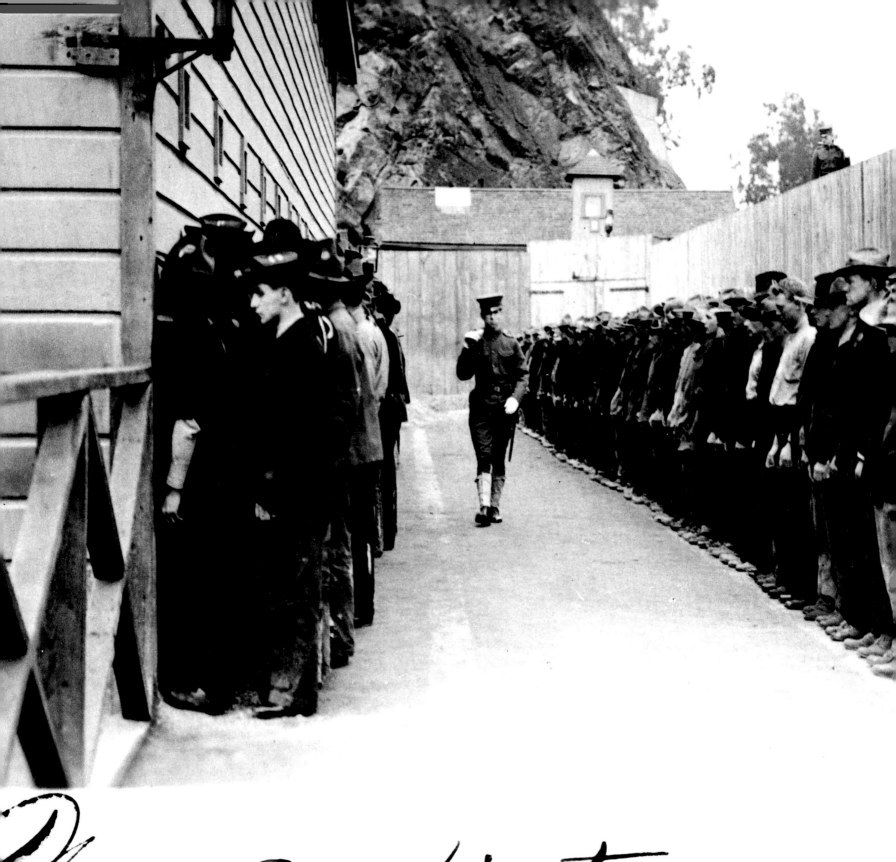

Noon verification

Uncle Sam's Devil's Island

Experiences of a Conscientious Objector in America During the World War

Philip Grosser (1933)

I was never a soldier, yet I spent three years of my life in military prisons. After I registered for the draft as an objector to war on political grounds, I refused to submit to a physical examination for military purposes and refused to sign an enlistment and assignment card. Instead of being tried for violation of the war-time conscription act, which was a Federal civil offence, I was turned over to the military and was subjected to all forms of punishment as an erring soldier, not as a civilian who refused to participate in a war waged "to make the world safe for democracy."

My name was called among the first five per cent of the draft quota in August, 1917. The military machine was not quite ready at that time, and the local Draft Board did not know what to do with me when I reported to them and told them that I was opposed to war and that I would not participate in military life; that to be examined physically for military purposes was to me the same as a military order and that I refused to submit to it. Chairman Burroughs of Local No. 5 Draft Board, Boston, told me that my case would be turned over to the Federal District Attorney. A few days later I reported to the Federal District Attorney and submitted to arrest for violation of the conscription act. I was released on a five hundred dollar bond to await the action of the Federal Grand Jury. Provost Marshall General Crowder, however, defined the draft act so that a man could be automatically inducted into the "selective" army, and in December, 1917, I was notified to report for military service, that I was a soldier under the automatic ruling of General Crowder, that failure to report according to notification received constituted desertion, and that desertion in time of war was punishable by death. I still refused to obey the military call and surrendered to the Federal District Attorney. He in turn notified the military, and a soldier from the Irvington Street Armory, Boston, with fixed bayonet on a rifle, was sent to the Federal Building to bring me in as a deserter....

On April 25, 1918, I was taken before a court-martial, charged and found guilty of the following military crimes:

> Refusing to obey a lawful command of Lt. Stanley G. Barker to go to work.
>
> Saying in the presence of officers and enlisted men that I would not obey any military orders.
>
> Refusing to stand at attention when ordered to do so by Lt. Carpenter.
>
> Attempting to create mutiny in the United States Army, by writing letters to other objectors, and urging them to stand fast, and not to submit to military authority.

My punishment, according to Court-Martial Order No. 152, Northeastern Department, Boston, was: "To be dishonorably discharged from the service, to forfeit all pay and allowances due and to become due, and to be confined at hard labor for *Thirty Years* at such place as the reviewing authorities may direct...."

In June, 1919, thirty-one prisoners and myself were transferred from the disciplinary barracks to the post guard house, and at two o'clock the following morning we were called out and some of us were chained in pairs by the wrists and others were in addition shackled in twos by the ankles. We were taken to a side track where a couple cars were ready for us. The commissioned and non-commissioned officers accompanying us wouldn't tell us our destination. "Sealed orders," they claimed. To outside inquirers, however, they gave the information that we were a gang of German prisoners being transferred to a concentration camp. We were in "irons" all the time, confined in the cars from the morning we were placed at Leavenworth until we reached Oakland, California, where we were taken to Ft. Mason docks, and placed aboard a government boat to sail to "Uncle Sam's Own Devil's Island...."

Alcatraz Island is a 12 acre rock at the mouth of the Golden Gate, capped with a white "house of silence." The fascination of the horrible clings about the misty Gibraltar whose history reaches back to the time when it was a military post in the day of Spanish domain. The Island is reached by government boats only, and the visitor must obtain a pass from the Commandant. The place is known as "The Rock," and sometimes as "Uncle Sam's Own Devil's Island."

On my arrival at Alcatraz I refused to work or to stand military formations. I was taken before Executive Officer, Lt. J. J. Meskill. He gave me the formal military order to go to work at once, and when I refused he sentenced me to 14 days solitary confinement in the "hole" and a bread and water diet. He said, "If Jesus Christ were to come to this Island and refuse to work, I would put him in the dungeon and keep him there."

Sergeant Cole, overseer in charge, switched on the electric light and took me down a flight of stairs to the basement, hollowed out of the rock under the prison. He ordered me to take up a bucket, and when I wasn't quick enough he lifted his club and yelled, "I'll knock your God damn brains out!" He showed me into a cell, locked the iron barred door behind me, and I heard his footsteps going up the stairs as I was left alone in the dungeon. Then he switched off the lights and I found myself in complete darkness. I tried to investigate the place which was to be my abode for the next fourteen days. Attempting to walk through the cell I bumped my head against the ceiling. Feeling my way, I found that the cell roof was arched and lower at the sides than a man's height, so that it wasn't safe to walk around in the dark. I sat on the door-sill waiting for something to happen. After awhile the lights were turned on and a guard came down with a few slices of bread and a pitcher of water. Trying to have a good look at my cell while the lights were still on I found that there was no furniture or toilet facilities, the only things that were to be seen were the pitcher of water, the few slices of bread, and the "old wooden bucket" which the guard told me would be emptied only once every twenty-four hours. The dungeon cells were under the prison, situated so that not a ray of daylight ever penetrated them. The air in the cell was stagnant, the walls were wet and slimy, the bars of the cell door were rusty with the dampness, and the darkness was so complete that I could not make out my hand a few inches before my face. It seemed eternity until the officer of the day and a guard came about nine o'clock in the evening. The cell door opened and the guard threw in a pair of lousy army blankets, wholly insufficient, as was evidenced by the fact that four blankets were provided for the warmer and drier cells upstairs. The prison officer had to put a searchlight on me to note that I was "present and accounted for." The light was switched off, and as no other prisoners were at that particular time confined in the dungeon I was left alone with the rats for company. The water and sewer system of the jails were located in the center of the underground dungeon in front of the cells and in case of accident, as the bursting of a pipe, a prisoner could have been drowned like a rat before anyone in the jail proper could have noticed it. I took off my shoes and coat and used them as a pillow, wrapped myself in the two blankets, and with the concrete floor as a mattress made myself a nice comfortable bed....

The things hardest to endure in the dungeon were the complete darkness, the sitting and sleeping on the damp concrete floor, and the lack of sight or sound of any human being. The eighteen ounces of bread was quite sufficient for the first few days, and towards the last I had some of the bread left over. The rats were quite peaceful and friendly. The fact that the dungeon was made a store house for the "ball and chain," straightjacket, wrist chains and other implements of medieval torture was not very pleasant.

above: Philip Grosser, c. 1934

ALCATRAZ, CALIFORNIA

O. K.

Mar. 7 1920.

From Phil. B. Grosser

To Dr. David

Street 23 Ruthven St.

City Roxbury,

State Massachusetts.

This is to inform you that I have consented to go to work in the dinning-hall of the prison, and that February 25th I was released from solitary and also from the cage or "vestibule door", as adjutant general C.P. Harris calls them. I was confined, during working hours, in the cage since Jan. 23rd. As the other Objector Simmons was released the cages are at present not in use

My health is good, and I hope to keep out of trouble as much as possible. You understand that I still have four years on my original sentences and three months additional received here in Alcatraz. However, considering the crime I committed the punishment is not very severe.

I received a letter from Dr. Steller to-day. The news and promise do not amount to any-thing. Yellow journals are not very reliable and even if the promise was made the definition and qualification might be worked so that not many will benifit by it. Regards to all. Write often

Address Envelope in Reply to

Mr. Phil. B. Grosser

Bldg. 68.

Alcatraz,

California.

After serving fourteen days in the rat-infested dungeon I was taken out in a weakened condition to the prison hospital. The prison doctor thought that eating too much bread was the cause of my sickness. I knew better. To place any human being in the "hole" for fourteen days, even if one were given a chicken diet, was enough to weaken him. It felt good to be given a soft hospital bed after the concrete floor as a sleeping place. The food, which was quite good in the hospital, was also a treat compared with the eighteen ounces of bread. Then the daylight and the association with human beings again made me feel as if I were on a holiday....

Under military regulations no prisoner can be kept in solitary for more than 14 consecutive days, and must have at least 14 days in the regular cell or normal diet before he can be returned to solitary. Being unable, therefore, to send me back to the "hole" at once, the authorities placed a special sentry over me and I was forced to parade around the windiest side of the Island for eight hours a day, while the other prisoners worked. At the end of 14 days of grace I again disobeyed a formal order to work and was returned to the dungeon....

On account of the protests of the Civil Liberties Union and others the War Department ordered an investigation and assigned Col. Phillips to investigate the doings of Col. Garrard. The Alcatraz authorities got wind that an investigation was contemplated and prepared for it. Other Objectors and I, who were serving time in the dungeon, were transferred to solitary dark cells on the ground floor of the prison. These are ordinary cells with no bed to sleep on and the barred cell door boarded up to shut out the light. Through the cracks of the boarded door I could see prisoners carrying cement bags and beds with iron springs to the dungeon. I did not know the reason. It seemed, however, that the authorities of the jail knew the reason. At the same time the Colonel allowed four blankets for men in solitary. A few days later the investigator arrived. Everything was nicely prepared, the dungeons were floored with concrete smoothly polished, all rat-holes were blocked up, the iron springs and beds arranged. A plate of freshly grated cheese was placed in one of the cells over night to prove that there were no rats. Col. Phillips had an army stenographer with him and all those in solitary that were previously confined in the dungeon were called before the investigator. I told Col. Phillips that there was no bed in the dungeon ceil where I served my 14 day stretch in, also that the concrete floor polishing was done in anticipation of his arrival, and though all my testimony was taken down by the stenographer not a word of it was reported to the Secretary of War who ordered the investigation. Col. Phillips, the military man, could hardly be expected to be dissatisfied with Col. Garrard's methods of handling men who refused to recognize military authority and who according to army regulation were justly punished. The dungeon was not officially condemned, but on the investigator's departure the dungeon, so far as Objectors were concerned, was done away with.

On completing the third term of solitary, which was served in the dark cells, I was chased out again on the rock piles. The number of non-working C. O.'s [conscientious objectors] increased to nine and all of us at that time were out of solitary. We were assigned to work on the rock pile, but refused to accept tools or to perform labor. The sentry paraded our army of the unemployed right near the quarry laborers, until one day we simply struck on the guard, refused to obey his orders to parade, sat down and did as we damned please. After numerous threats of bodily violence, the guard turned us [over] to the Executive Officer. He, not being able to place us again in solitary until our fourteen days of grace was over, locked us in the cells and did not order us out to the quarry any more....

opposite: Letter from Alcatraz, sent by the author to David Grosser, dated March 7, 1920 (front and back)

A change of administration at Alcatraz. Brigadier General James B. McDonald was appointed Commandant in place of Col. Garrard. Major Johnson became Executive Officer to replace Lt. Meskill. Old Col. Garrard was about 80 years and in his second childhood. He had been retired long before the war began. On declaration of war, however, he was called back to service and appointed Commandant of the Pacific Branch United States Disciplinary Barracks, and the destinies of hundreds of young Americans were placed in the hands of an old, deaf Southern Gentleman, who was physically unable to handle the situation. The result was that Alcatraz Prison was mismanaged by Col. Garrard's subordinates. The notoriety and publicity Alcatraz received after the arrival of the war Objectors may have been the cause of Col. Garrard's going back into retirement.

Executive Officer, Maj. Johnson, and the newly appointed Commandant thought that the army regulations for the punishment of military prisoners were too mild when applied to Objectors. The chaining up of prisoners to cell doors had been abolished by Sec. Baker in 1918, as a result of the undue attention attracted by the publicity given that practice by the C. O. prisoners at Leavenworth. The War Department News Bureau release No. 9, Dec. 6, 1918, read:

> The Secretary of War authorizes the following statement: Disciplinary regulations in force in military prisons have been modified by the War Department order. Fastening of prisoners to the bars of cells will no more be used as a mode of punishment. This and milder devices have been effective in the past in breaking the wilful or stubborn opposition of prisoners of the usual military type, who would not submit to work requirement of disciplinary barracks. Instead of being allowed to lie in the bunks while others worked, they were compelled to choose between working or standing in discomfort during working hours. Practically, under usual conditions, this has been more of a threat than an actuality, and as such it has been effective, but during recent months with the influx of political

prisoners to the disciplinary barracks, particularly Fort Leavenworth, Kansas, extremity of attitude on the part of this new type of prisoner has at times led to extremity of discipline, as provided by military regulations. These clearly were not formulated with the political type of prisoner in mind, and their effectiveness as deterrents has been questionable. Men have returned for repeated experiences of the severest form of discipline. The most extreme of these is discarded and the order is comprehensive. It applies to not merely political prisoners, but to every other type.

Not being able to chain us up, therefore, McDonald and Johnson conceived the idea of building "Iron Cages," which they afterwards named "vestibule doors," in which to confine men who still refused to work after repeatedly enduring dungeon and solitary punishment. These "coffin cages" were 23 inches wide and 12 inches deep. Each cage was made of iron bars bolted to the doors of the cells. The prisoner stands upright, with an adjustable board at his back to reduce the depth to about nine inches so as to make a tight fit—a veritable iron straight jacket. A religious Objector named Simmons and I were placed in the "Iron Maiden" for eight hours a day, alternated by sixteen hours of solitary confinement in dark cells on a bread and water diet.

By that time our underground news traveled fast, and the American Civil Liberties Union managed to have the news of the cages on the Associated Press wired the first day they were used at the Island. The cage form of punishment for Objectors to war was introduced about a year and a half after the war for democracy was fought and won, and many of our liberals thought that it was safe to protest against this form of cruel and unusual punishment. Newspaper reporters came to the Island and the authorities had to find a way to explain the torture chambers to the War Department and to the press. Commandant McDonald's explanation was as follows: "In other prisons they chain prisoners to the cell doors when they refuse to work. We place them in those standing

cages, 'vestibule doors,' and compel them to remain in an upright position during working hours only." All along the war, Objectors had puzzled the authorities. Col. Garrard had complained to a reporter,

> I have had more trouble with the C. O.'s, I. W. W.'s, than with any other prisoners. I came here from West Point in '77 and had many prisoner soldiers under my charge, but the C. O.'s I cannot understand. They refuse to work, some of them even refuse to eat. Now what are you going to do when you are faced with a situation like that?… These so called C. O.'s are yellow men not white men, and as yellow men, sir, we are so treating them when they seek to break the rules of this institution.

The undue attention or publicity was, however, successful to the limited extent that the cage punishment was not thereafter given in combination with solitary, and we who were "caged" and put in an ordinary cell, were allowed regular rations, and were placed in the torture chambers only for eight hours every day. I endured it for about two months, until I saw my reason going, and realized that brain and body could stand no more. I had made my protest—I gave in and agreed to work and was taken out of the torture cage.

Adjutant General Harris sanctioned the use of the Iron Cages. In a letter to Beatrice Kinkhead, of Palo Alto, Cal., dated April 27, 1920, he says that the cage punishment was "not cruel or unusual." The Iron Maidens are still at Alcatraz, though they have not been used of late. Adjutant General Lutz Wahl, at Washington, replied to an inquirer about the cages under date of Nov. 1928: "The arrangement of the 'double cell door' as a punishment for the military prisoners at Alcatraz, was discontinued shortly after 1920, not because punishment was believed to be severe, but rather because of the undue attention attracted to it by misrepresentation as to its severity."

Though it may be true that no one has been confined in the cages recently, I have reliable information, as late as 1929, that the "Iron Maidens" four steel cages erected in Alcatraz military prison in January, 1920, are still in their proper places as before, ready for use.

Time and again my friends were advised that if I'd ask for clemency my release might have been granted. I never asked for mercy. On November 23, 1920, Wilson and Baker were magnanimous enough to release all Objectors. My release also was signed and forwarded to Alcatraz.

On Dec. 2, 1920, the authorities of Alcatraz Island, San Francisco, California, were ordered by the War Department to set me free. They put me in solitary confinement for refusing to sign soldier's release papers which stated that I was a recruit unassigned not eligible for re-enlistment, had no previous enlistment, no horsemanship, no marksmanship, etc. My answer was that I never consented to obey the draft act, that I did not recognize the government's right to make me a soldier automatically, that I did not sign any papers to get into military jails and that I would not sign any papers to get out. A wire was sent to the War Department to have my release cancelled and to have me court-martialed again for disobedience to military orders. Evidently the War Department did not care to keep me any longer, for an order was given to let me go free without my signature. So I was inducted into the service of the United States Army automatically and was released from the service also automatically, after being transferred from one military prison to another, without serving a single day in a military barracks.

Excerpted from Philip Grosser, *Uncle Sam's Devil's Island: Experiences of a Conscientious Objector in America During the World War* (Boston: The Excelsior Press, c. 1931). Reprinted with permission from Jean Grosser, Philip Grosser Papers.

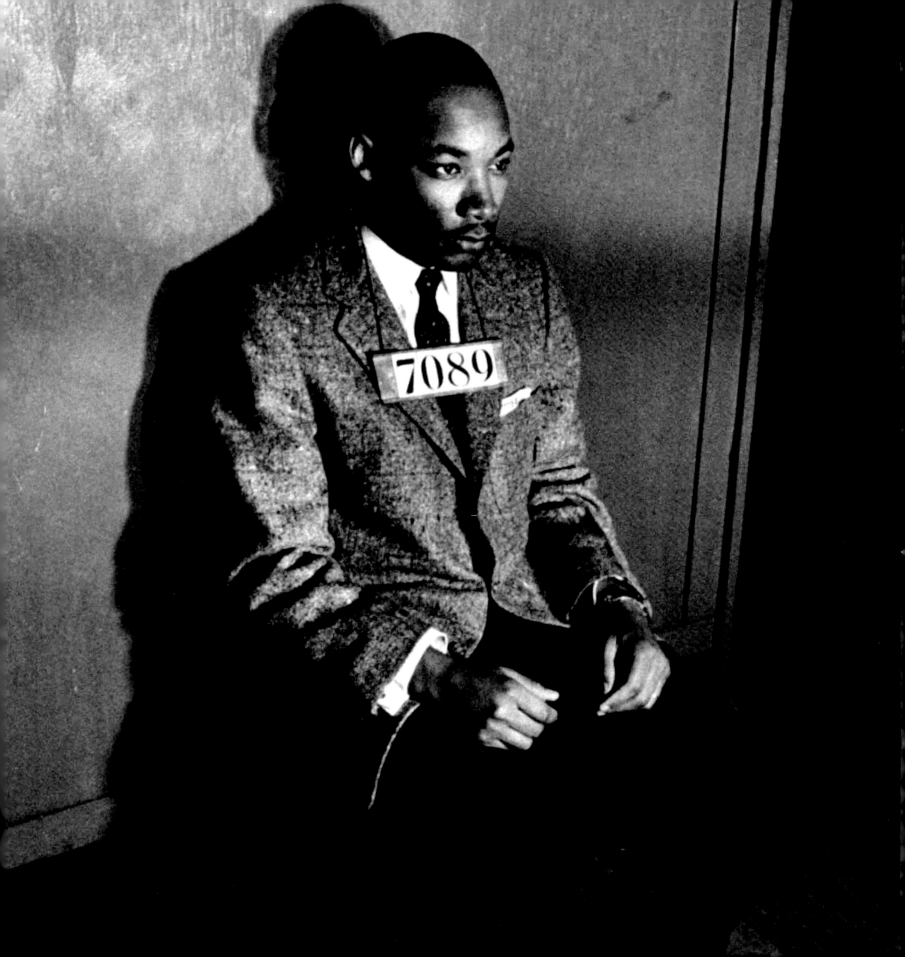

Letter from Birmingham Jail

Martin Luther King Jr. (1963)

King's famous 1963 "Letter from Birmingham Jail," published in The Atlantic *as "The Negro Is Your Brother," was written in response to a public statement of concern and caution issued by eight white religious leaders of the South. It stands as one of the classic documents of the civil rights movement.*

While confined here in the Birmingham city jail, I came across your recent statement calling our present activities "unwise and untimely." Seldom, if ever, do I pause to answer criticism of my work and ideas. If I sought to answer all of the criticisms that cross my desk, my secretaries would be engaged in little else in the course of the day, and I would have no time for constructive work. But since I feel that you are men of genuine good will and your criticisms are sincerely set forth, I would like to answer your statement in what I hope will be patient and reasonable terms.

I think I should give the reason for my being in Birmingham, since you have been influenced by the argument of "outsiders coming in...."

I am in Birmingham because injustice is here.... I am cognizant of the interrelatedness of all communities and states. I cannot sit idly by in Atlanta and not be concerned about what happens in Birmingham. Injustice anywhere is a threat to justice everywhere. We are caught in an inescapable network of mutuality, tied in a single garment of destiny. Whatever affects one directly affects all indirectly. Never again can we afford to live with the narrow, provincial "outside agitator" idea. Anyone who lives inside the United States can never be considered an outsider....

We have waited for more than three hundred and forty years for our God-given and constitutional rights. The nations of Asia and Africa are moving with jetlike speed toward the goal of political independence, and we still creep at horse-and-buggy pace toward the gaining of a cup of coffee at a lunch counter. I guess it is easy for those who have never felt the stinging darts of segregation to say "wait." But when you have seen vicious mobs lynch your mothers and fathers at will and drown your sisters and brothers at whim; when you have seen hate-filled policemen curse, kick, brutalize, and even kill your black brothers and sisters with impunity; when you see the vast majority of your twenty million Negro brothers smothering in an airtight cage of poverty in the midst of an affluent society; when you suddenly find your tongue twisted and your speech stammering as you seek to explain to your six-year-old daughter why she cannot go to the public amusement park that has just been advertised on television, and see tears welling up in her little eyes when she is told that Funtown is closed to colored children, and see the depressing clouds of inferiority begin to form in her little mental sky, and see her begin to distort her little personality by unconsciously developing a bitterness toward white people; when you have to concoct an answer for a five-year-old son asking in agonizing pathos, "Daddy, why do white people treat colored people so mean?"; when you take a cross-country drive and find it necessary to sleep night after night in the uncomfortable corners of your automobile because no motel will accept you; when you are humiliated day in and day out by nagging signs reading "white" and "colored"; when your first name becomes "nigger" and your middle name becomes "boy" (however old you are) and your last name becomes "John," and when your wife and mother are never given the respected title "Mrs."; when you are harried by day and haunted by night by the fact that you are a Negro, living constantly at tiptoe stance, never quite knowing what to expect next,

and plagued with inner fears and outer resentments; when you are forever fighting a degenerating sense of "nobodyness"—then you will understand why we find it difficult to wait. There comes a time when the cup of endurance runs over and men are no longer willing to be plunged into an abyss of injustice where they experience the bleakness of corroding despair. I hope, sirs, you can understand our legitimate and unavoidable impatience.

You express a great deal of anxiety over our willingness to break laws. This is certainly a legitimate concern. Since we so diligently urge people to obey the Supreme Court's decision of 1954 outlawing segregation in the public schools, it is rather strange and paradoxical to find us consciously breaking laws. One may well ask, "How can you advocate breaking some laws and obeying others?" The answer is found in the fact that there are two types of laws: there are just laws, and there are unjust laws. I would agree with St. Augustine that "An unjust law is no law at all."

Now, what is the difference between the two? How does one determine when a law is just or unjust? A just law is a man-made code that squares with the moral law, or the law of God. An unjust law is a code that is out of harmony with the moral law. To put it in the terms of St. Thomas Aquinas, an unjust law is a human law that is not rooted in eternal and natural law. Any law that uplifts human personality is just. Any law that degrades human personality is unjust. All segregation statutes are unjust because segregation distorts the soul and damages the personality....

There are some instances when a law is just on its face and unjust in its application. For instance, I was arrested Friday on a charge of parading without a permit. Now, there is nothing wrong with an ordinance which requires a permit for a parade, but when the ordinance is used to preserve segregation and to deny citizens the First Amendment privilege of peaceful assembly and peaceful protest, then it becomes unjust.

Of course, there is nothing new about this kind of civil disobedience. It was seen sublimely in the refusal of Shadrach, Meshach, and Abednego to obey the laws of Nebuchadnezzar because a higher moral law was involved. It was practiced superbly by the early Christians, who were willing to face hungry lions and the excruciating pain of chopping blocks before submitting to certain unjust laws of the Roman Empire. To a degree, academic freedom is a reality today because Socrates practiced civil disobedience.

We can never forget that everything Hitler did in Germany was "legal" and everything the Hungarian freedom fighters did in Hungary was "illegal." It was "illegal" to aid and comfort a Jew in Hitler's Germany. But I am sure that if I had lived in Germany during that time, I would have aided and comforted my Jewish brothers even though it was illegal. If I lived in a Communist country today where certain principles dear to the Christian faith are suppressed, I believe I would openly advocate disobeying these anti-religious laws....

I have no fear about the outcome of our struggle in Birmingham, even if our motives are presently misunderstood. We will reach the goal of freedom in Birmingham and all over the nation, because the goal of America is freedom. Abused and scorned though we may be, our destiny is tied up with the destiny of America. Before the Pilgrims landed at Plymouth, we were here. Before the pen of Jefferson scratched across the pages of history the majestic word of the

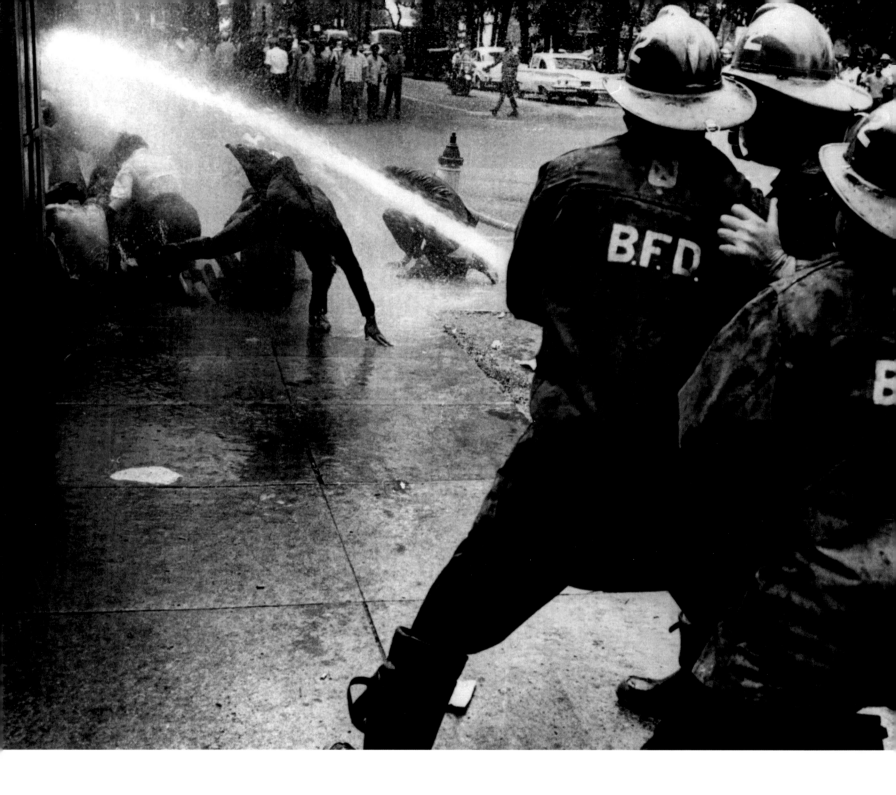

above: **Firefighters turning their hoses on civil rights demonstrators,
Birmingham, Alabama, July 15, 1963**

Declaration of Independence, we were here.... If the inexpressible cruelties of slavery could not stop us, the opposition we now face will surely fail. We will win our freedom because the sacred heritage of our nation and the eternal will of God are embodied in our echoing demands....

Never before have I written a letter this long—or should I say a book? I'm afraid that it is much too long to take your precious time. I can assure you that it would have been much shorter if I had been writing from a comfortable desk, but what else is there to do when you are alone for days in the dull monotony of a narrow jail cell other than write long letters, think strange thoughts, and pray long prayers?

If I have said anything in this letter that is an understatement of the truth and is indicative of an unreasonable impatience, I beg you to forgive me. If I have said anything in this letter that is an overstatement of the truth and is indicative of my having a patience that makes me patient with anything less than brotherhood, I beg God to forgive me.

Yours for the cause of Peace and Brotherhood,
Martin Luther King Jr.

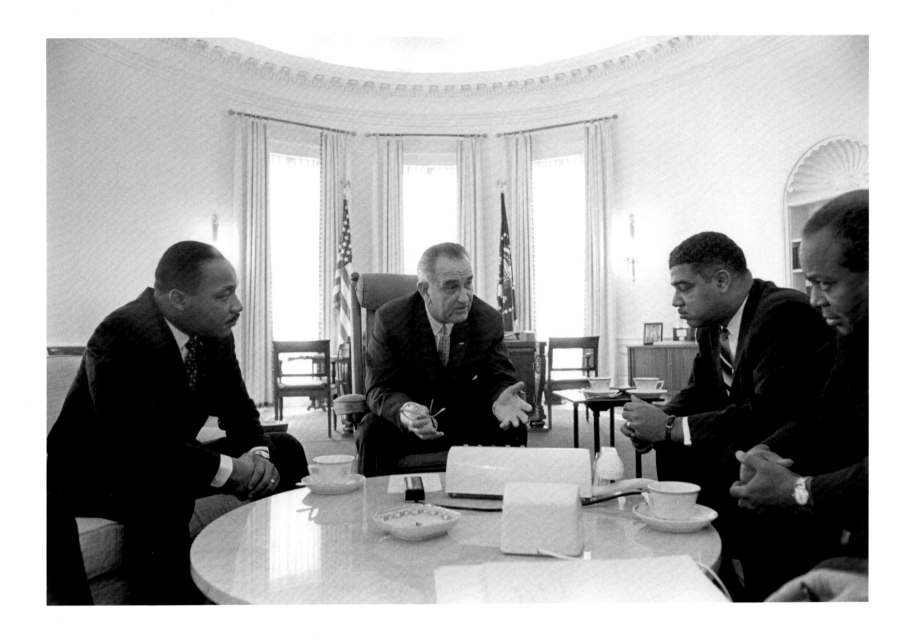

above: **Martin Luther King Jr. talking with President Johnson and other civil rights leaders in the White House, c. 1964**

On the American Free Speech Movement

Mario Savio (1964–1965)

It is a lot easier to become angry at injustices done to other people than at injustices done to oneself. The former requires a lower degree of political consciousness, is compatible with a higher political boiling point. You become slowly, painfully aware of those things which disturb you in the ways society oppresses you by taking part in activities aimed at freeing and helping others. There is less guilt to suffer in opposing the arbitrary power exercised over someone else than in opposing the equally unjust authority exercised over yourself....

And this is so because people do find it easier to protest injustices done to others: even adverting to injustice done oneself is often too painful to be sustained for very long. When you oppose injustice done others, very often—symbolically sometimes, sometimes not so symbolically—you are really protesting injustice done to yourself.... It is not as easy to see what is oppressing the subject as to see what is oppressing the others.

—*From "Berkeley Fall: The Berkeley Student Rebellion of 1964" printed in* The Free Speech Movement and the Negro Revolution, *"News & Letters," July 1965.*

I have to say that for me the deepest free speech quote is what was attributed to Diogenes. And he said, "The most beautiful thing in the world is the freedom of speech." And those words are in me, they're sort of burned into my soul, because for me free speech was not a tactic, not something to win for political.... To me, freedom of speech is something that represents the very dignity of what a human being is. If you cannot speak... I mean, that's what marks us off. That's what marks us off from the stones and the stars. You can speak freely. It is almost impossible for me to describe. It is the thing that marks us as just below the angels. I don't want to push this beyond where it should be pushed, but I feel it.

—*From an interview by Douglas Gillies, December 1994.*

There is a time when the operation of the machine becomes so odious, makes you so sick at heart, that you can't take part; you can't even passively take part, and you've got to put your bodies upon the gears and upon the wheels, upon the levers, upon all the apparatus, and you've got to make it stop. And you've got to indicate to the people who run it, to the people who own it, that unless you're free, the machine will be prevented from working at all!

—*From a Free Speech Movement sit-in speech at Sproul Plaza, UC Berkeley, December 3, 1964.*

I am not a political person. My involvement in the Free Speech Movement is religious and moral.... I don't know what made me get up and give that first speech. I only know I had to. What was it Kierkegaard said about free acts? They're the ones that, looking back, you realize you couldn't help doing....

America may be the most poverty-stricken country in the world. Not materially. But intellectually it is bankrupt. And morally it is poverty-stricken. But in such a way that it's not clear to you that you're poor. It's very hard to know you're poor if you're eating well....

As for ideology, the Free Speech Movement has always had an ideology of its own. Call it essentially anti-liberal. By that I mean it is anti a certain style of politics prevalent in the United States: politics by

compromise—which succeeds if you don't state any issues. You don't state issues, so you can't be attacked from any side. You learn how to say platitudinous things without committing yourself, in the hope that somehow, that way, you won't disturb the great American consensus and somehow people will be persuaded to do things that aren't half bad. You just sort of muddle through....

If you accept that societies can be run by rules, as I do, then you necessarily accept as a consequence that you can't disobey the rules every time you disapprove. That would be saying that the rules are valid only when they coincide with your conscience, which is to insist that only your conscience has any validity in the matter. However, when you're considering something that constitutes an extreme abridgment of your rights, conscience is the court of last resort. Then you've got to decide whether this is one of the things which, although you disagree, you can live with. Only you can decide; it's openly a personal decision. Hopefully, in a good society this kind of decision wouldn't have to be made very often, if at all. But we don't have a good society. We have a very bad society. We have a society which has many social evils, not the least of which is the fantastic presumption in a lot of people's minds that naturally decisions which are in accord with the rules must be right—an assumption which is not founded on any legitimate philosophical principle. In our society, precisely because of the great distortions and injustices which exist, I would hope that civil disobedience becomes more prevalent than it is.

—From an interview by Jack Fincher, "The University Has Become a Factory," Life Magazine, *February 26, 1965.*

It is a bleak scene, but it is all a lot of us have to look forward to. Society provides no challenge. American society in the standard conception it has of itself is simply no longer exciting. The most exciting things going on in America today are movements to change America. America is becoming ever more the utopia of sterilized, automated contentment. The "futures" and "careers" for which American students now prepare are for the most part intellectual and moral wastelands. This chrome-plated consumers' paradise would have us grow up to be well-behaved children. But an important minority of men and women coming to the front today have shown that they will die rather than be standardized, replaceable and irrelevant.

—From "An End to History," Humanity, *no. 2, December 1964.*

We committed the unpardonable sin of being moral and being successful.

—Quoted in A. H. Raskin, "The Berkeley Affair: Mr. Kerr vs. Mr. Savio & Co.," New York Times Magazine, *February 14, 1965.*

above: Mario Savio, leader of the Berkeley Free Speech Movement, Berkeley, California, 1965

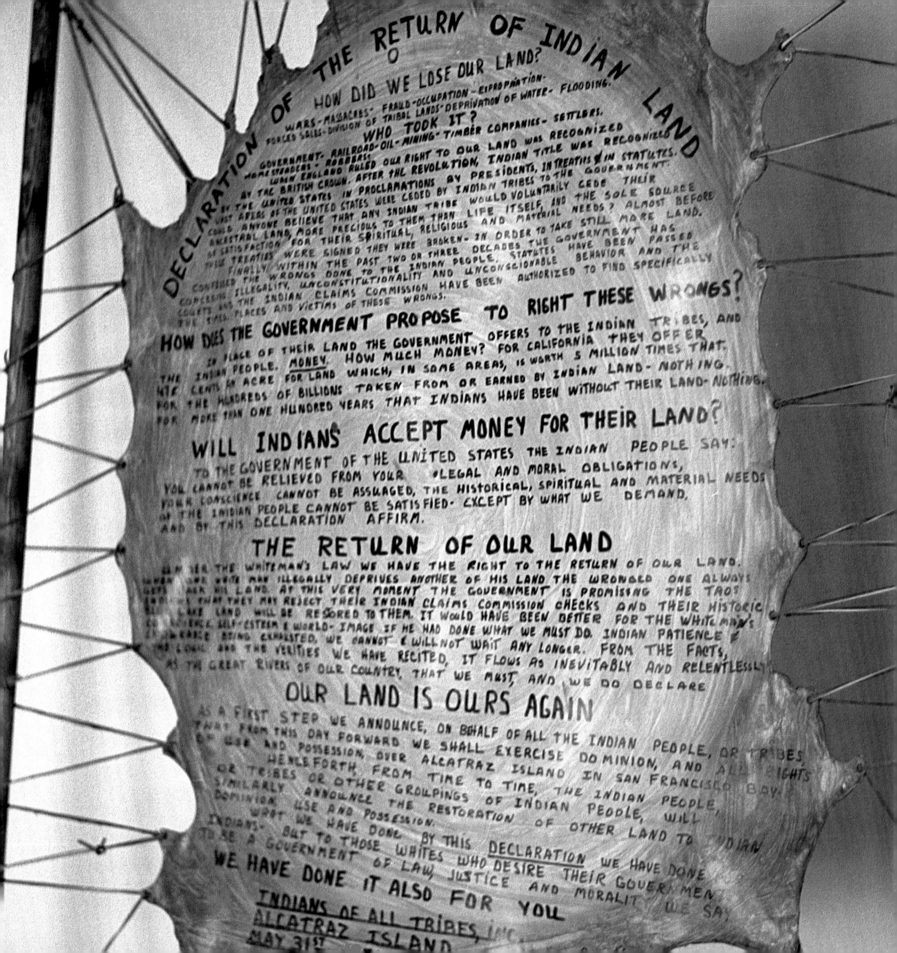

DECLARATION OF THE RETURN OF INDIAN LAND

HOW DID WE LOSE OUR LAND?

WARS- MASSACRES- FRAUD -OCCUPATION- EXPROPRIATION-
FORCED SALES- DIVISION OF TRIBAL LANDS- DEPRIVATION OF WATER- FLOODING.

WHO TOOK IT?

GOVERNMENT- RAILROAD-OIL- MINING- TIMBER COMPANIES- SETTLERS.
HOMESTEADERS - ROBBERS

WHEN ENGLAND RULED OUR RIGHT TO OUR LAND WAS RECOGNIZED
BY THE BRITISH CROWN. AFTER THE REVOLUTION, INDIAN TITLE WAS RECOGNIZED
BY THE UNITED STATES IN PROCLAMATIONS BY PRESIDENTS, IN TREATIES & IN STATUTES.
VAST AREAS OF THE UNITED STATES WERE CEDED BY INDIAN TRIBES TO THE GOVERNMENT.
COULD ANYONE BELIEVE THAT ANY INDIAN TRIBE WOULD VOLUNTARILY CEDE THEIR
ANCESTRAL LAND, MORE PRECIOUS TO THEM THAN LIFE ITSELF, AND THE SOLE SOURCE
OF SATISFACTION FOR THEIR SPIRITUAL, RELIGIOUS AND MATERIAL NEEDS? ALMOST BEFORE
THESE TREATIES WERE SIGNED THEY WERE BROKEN- IN ORDER TO TAKE STILL MORE LAND.
FINALLY WITHIN THE PAST TWO OR THREE DECADES THE GOVERNMENT HAS
CONSIDERED THE WRONGS DONE TO THE INDIAN PEOPLE. STATUTES HAVE BEEN PASSED
CONCERNING ILLEGALITY, UNCONSTITUTIONALITY AND UNCONSCIONABLE BEHAVIOR AND THE
COURTS AND THE INDIAN CLAIMS COMMISSION HAVE BEEN AUTHORIZED TO FIND SPECIFICALLY
THE TIMES, PLACES AND VICTIMS OF THESE WRONGS.

HOW DOES THE GOVERNMENT PROPOSE TO RIGHT THESE WRONGS?

IN PLACE OF THEIR LAND THE GOVERNMENT OFFERS TO THE INDIAN TRIBES, AND
THE INDIAN PEOPLE, MONEY. HOW MUCH MONEY? FOR CALIFORNIA THEY OFFER
47¢ CENTS AN ACRE FOR LAND WHICH, IN SOME AREAS, IS WORTH 5 MILLION TIMES THAT.
FOR THE HUNDREDS OF BILLIONS TAKEN FROM OR EARNED BY INDIAN LAND- NOTHING.
FOR MORE THAN ONE HUNDRED YEARS THAT INDIANS HAVE BEEN WITHOUT THEIR LAND- NOTHING.

WILL INDIANS ACCEPT MONEY FOR THEIR LAND?

TO THE GOVERNMENT OF THE UNITED STATES THE INDIAN PEOPLE SAY:
YOU CANNOT BE RELIEVED FROM YOUR LEGAL AND MORAL OBLIGATIONS,
YOUR CONSCIENCE CANNOT BE ASSUAGED, THE HISTORICAL, SPIRITUAL AND MATERIAL NEEDS
OF THE INDIAN PEOPLE CANNOT BE SATISFIED- EXCEPT BY WHAT WE DEMAND,
AND BY THIS DECLARATION AFFIRM.

THE RETURN OF OUR LAND

UNDER THE WHITEMAN'S LAW WE HAVE THE RIGHT TO THE RETURN OF OUR LAND.
WHEN ONE WHITE MAN ILLEGALLY DEPRIVES ANOTHER OF HIS LAND THE WRONGED ONE ALWAYS
GETS BACK HIS LAND. AT THIS VERY MOMENT THE GOVERNMENT IS PROMISING THE TAOS
PEOPLE THAT THEY MAY REJECT THEIR INDIAN CLAIMS COMMISSION CHECKS AND THEIR HISTORIC
BLUE LAKE LAND WILL BE RESTORED TO THEM. IT WOULD HAVE BEEN BETTER FOR THE WHITE MAN'S
CONSCIENCE SELF-ESTEEM & WORLD- IMAGE IF HE HAD DONE WHAT WE MUST DO. INDIAN PATIENCE &
THE LOGIC AND THE VERITIES WE HAVE RECITED. IT FLOWS AS INEVITABLY AND RELENTLESSLY
AS THE GREAT RIVERS OF OUR COUNTRY, THAT WE MUST, AND WE DO DECLARE

OUR LAND IS OURS AGAIN

AS A FIRST STEP WE ANNOUNCE, ON BEHALF OF ALL THE INDIAN PEOPLE, OR TRIBES
THAT FROM THIS DAY FORWARD WE SHALL EXERCISE DOMINION, AND ALL RIGHTS
OF USE AND POSSESSION, OVER ALCATRAZ ISLAND IN SAN FRANCISCO BAY.
HENCEFORTH, FROM TIME TO TIME, THE INDIAN PEOPLE,
OR TRIBES OR OTHER GROUPINGS OF INDIAN PEOPLE, WILL
SIMILARLY ANNOUNCE THE RESTORATION OF OTHER LAND TO INDIAN
DOMINION, USE AND POSSESSION.
WHAT WE HAVE DONE BY THIS DECLARATION WE HAVE DONE
INDIANS- BUT TO THOSE WHITES WHO DESIRE THEIR GOVERNMENT
TO BE A GOVERNMENT OF LAW, JUSTICE AND MORALITY, WE SAY

WE HAVE DONE IT ALSO FOR YOU

<u>INDIANS OF ALL TRIBES, INC.</u>
ALCATRAZ ISLAND
MAY 31ST

Proclamation and Letter Regarding the Native American Occupation on Alcatraz Island

Adam Fortunate Eagle / Indians of All Tribes (1969)

The Proclamation

Proclamation to the Great White Father and All His People:

We, the native Americans, re-claim the land known as Alcatraz Island in the name of all American Indians by right of discovery.

We wish to be fair and honorable in our dealings with the Caucasian inhabitants of this land, and hereby offer the following treaty:

We will purchase said Alcatraz Island for twenty-four dollars ($24) in glass beads and red cloth, a precedent set by the white man's purchase of a similar island about 300 years ago. We know that $24 in trade goods for these 16 acres is more than was paid when Manhattan Island was sold, but we know that land values have risen over the years. Our offer of $1.24 per acre is greater than the 47¢ per acre that the white men are now paying the California Indians for their land. We will give to the inhabitants of this island a portion of that land for their own, to be held in trust by the American Indian Affairs [sic] and by the bureau of Caucasian Affairs to hold in perpetuity—for as long as the sun shall rise and the rivers go down to the sea. We will further guide the inhabitants in the proper way of living. We will offer them our religion, our education, our life-ways, in order to help them achieve our level of civilization and thus raise them and all their white brothers up from their savage and unhappy state. We offer this treaty in good faith and wish to be fair and honorable in our dealings with all white men.

We feel that this so-called Alcatraz Island is more than suitable for an Indian Reservation, as determined by the white man's own standards. By this we mean that this place resembles most Indian reservations in that:

1. It is isolated from modern facilities, and without adequate means of transportation.
2. It has no fresh running water.
3. It has inadequate sanitation facilities.
4. There are no oil or mineral rights.
5. There is no industry and so unemployment is very great.
6. There are no health care facilities.
7. The soil is rocky and non-productive; and the land does not support game.
8. There are no educational facilities.
9. The population has always exceeded the land base.
10. The population has always been held as prisoners and kept dependent upon others.

Further, it would be fitting and symbolic that ships from all over the world, entering the Golden Gate, would first see Indian land, and thus be reminded of the true history of this nation. This tiny island would be a symbol of the great lands once ruled by free and noble Indians.

opposite: The Declaration of the Return of Indian Land, written on stretched cowhide, May 30, 1970

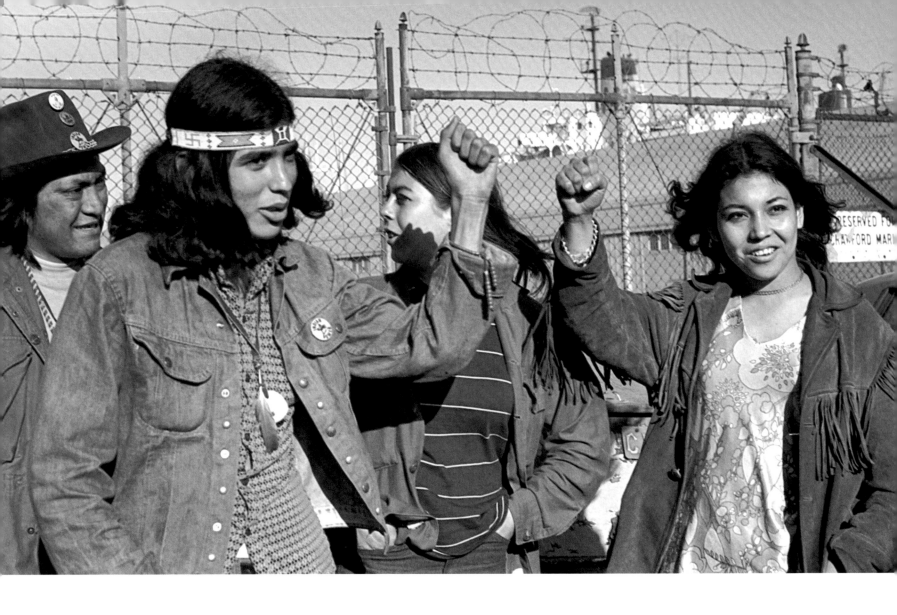

above: Occupiers of Alcatraz moments after their removal from the island, June 11, 1971 (from left: Harold Patty, a Paiute from Nevada; Oohosis, a Cree from Canada; Peggy Lee Ellenwood, a Sioux from Wolf Point, Montana; and Sandy Berger from Fort Hall, Idaho)

opposite: Native American occupation on Alcatraz, November 1969

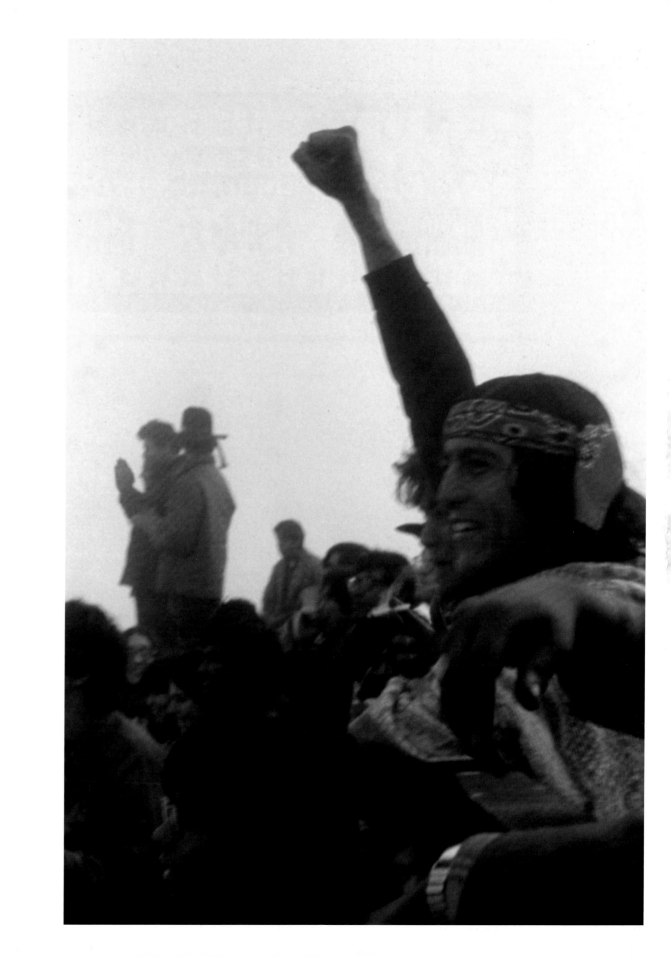

Vol. 1 No. 1 NEWSLETTER January 1970

The Letter
December 16, 1969

Dear Brothers and Sisters:

This is a call for a delegation from each Indian nation, tribe, or band from throughout the United States, Canada, and Mexico to meet together on Alcatraz Island in San Francisco Bay, on December 23, 1969, for a meeting to be tentatively called the Confederation of American Indian Nations (CAIN).

On November 20, 1969, 78 Indian people, under the name "Indians of all Tribes," moved on to Alcatraz Island, a former Federal Prison. We began cleaning up the Island and are still in the process of organizing, setting up classes, and trying to instill the old Indian ways into our young.

We moved onto Alcatraz Island because we feel that Indian people need a Cultural Center of their own. For several decades, Indian people have not had enough control of training their young people. And without a cultural center of their own, we are afraid that the old Indian ways may be lost. We believe that the only way to keep them alive is for Indian people to do it themselves.

While it was a small group which moved onto the island, we want all Indian people to join with us. More Indian people from throughout the country are coming to the island every day. We are issuing this call in an attempt to unify all our Indian Brothers behind a common cause.

We realize that there are more problems in Indian communities besides having our culture taken away. We have water problems, land problems, "social" problems, job opportunity problems, and many others.

And as Vice President Agnew said at the annual convention of the National Congress of American Indians in October of this year, now is the time for Indian leadership.

We realize too that we are not getting anywhere fast by working alone as individual tribes. If we can gather together as brothers and come to a common agreement, we feel that we can be much more effective, doing things for ourselves, instead of having someone else doing it, telling us what is good for us.

So we must start somewhere. We feel that if we are going to succeed, we must hold on to the old ways. *This is the first and most important reason we went to Alcatraz Island.*

We feel that the only reason Indian people have been able to hold on and survive through decades of persecution and cultural deprivation is that the Indian way of life is and has been strong enough to hold the people together.

We hope to reinforce the traditional Indian way of life by building a Cultural Center on Alcatraz Island. We hope to build a college, a religious and spiritual center, a museum, a center of ecology, and a training school.

We hope to have the Cultural Center controlled by Indians, with the delegates from each Indian nation and urban center present for the first meeting on December 23, and at future meetings of the governing body.

We are inviting all our brothers to join with us on December 23, if not in person, then in spirit.

We are still raising funds for Alcatraz. The "Alcatraz Relief Fund" is established with the Bank of California, Mission Branch, 3060 16th Street, San Francisco, California 94103, and we are asking that donations of money go to the bank directly.

Many Indian Centers and tribal groups from throughout the country have supported the people on Alcatraz by conducting benefits, funded [*sic*]

drives, and so forth. We are deeply appreciative of all the help we have received, and hope that all Indian people and people of good will, will join us in this effort.

We are also asking for formal resolutions of support from each organized Indian tribe and urban center. We can have great power at the bargaining table if we can get the support and help of all Indian people.

We have made no attempts at starting a hard and fast formal organization. We have elected spokesmen because someone has had to be a spokesman. We feel that all Indian people should be present or represented at the outset of a formal national Indian organization.

We have also elected a Central Council to help organize the day-to-day operation of the Island. This organization is not a governing body, but an operational one.

We hope to see you on December 23rd.

Indians of All Tribes

Reprinted with permission from University of Oklahoma Press. Text appears in Adam F. Eagle and Tim Findley, *Heart of the Rock: The Indian Invasion of Alcatraz* (Norman, OK: University of Oklahoma Press, 2002). © 2008 CCC Republication.

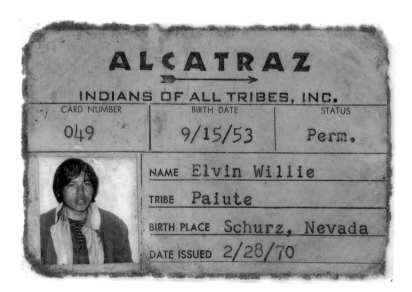

above: Indians of All Tribes Alcatraz I.D. card

opposite: Two Indian children play on abandoned Department of Justice equipment. Alcatraz Island, 1970

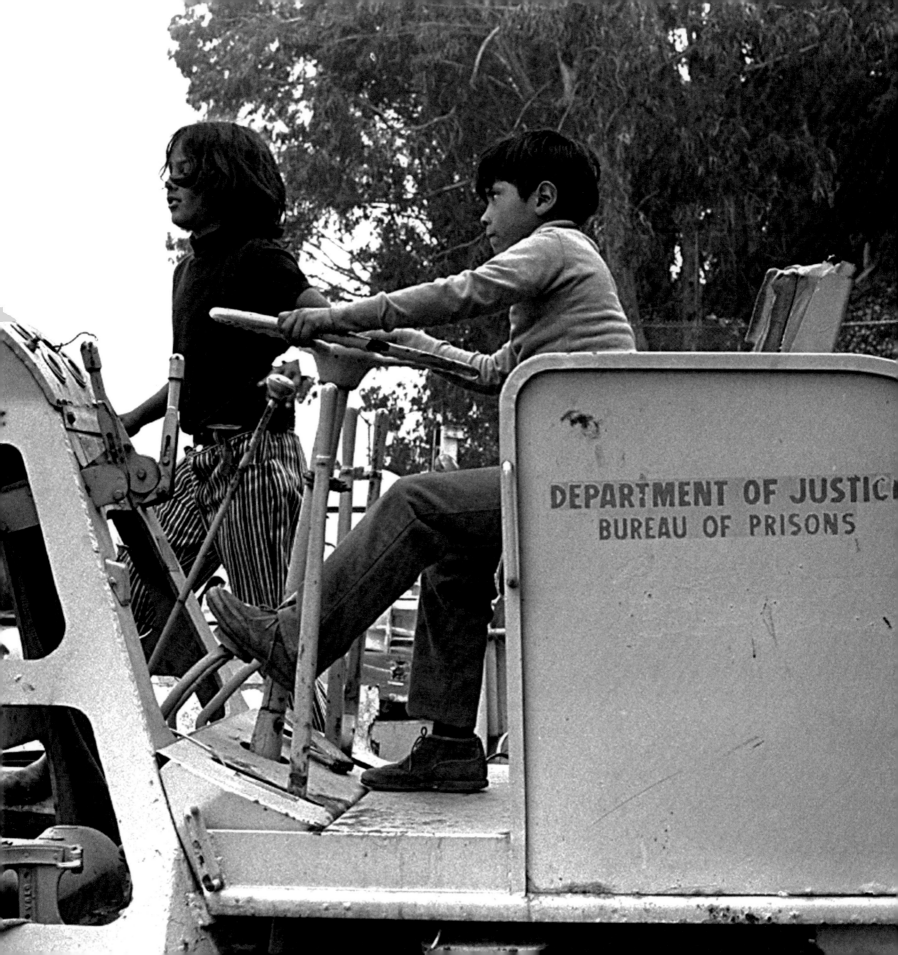

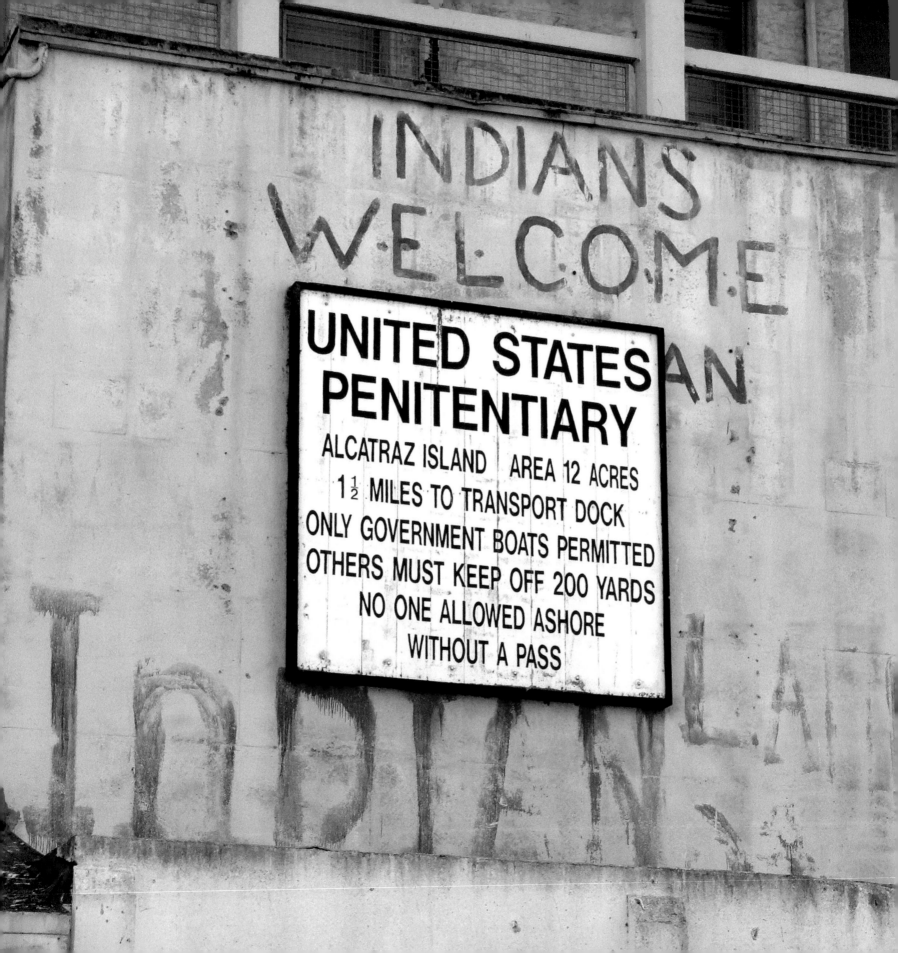

Direct from Alcatraz:
Interview with John Trudell

Al Silbowitz (1969)
Radio Free Alcatraz, Pacifica Radio

Al Silbowitz: For tonight's Radio Free Alcatraz program, I'll be talking with John Trudell. John is a young Santee Sioux who comes from Nebraska. John is communications director for the Alcatraz Council for the Indians on Alcatraz and has been conducting programs on Alcatraz for KPFA and the other Pacifica stations since they began on December 22.

John, to begin with, I'd like to ask you a little bit about yourself. You've told me previously about some of your background. You spent some time on the reservation in Nebraska and you've done a lot of other things. I think some of them would be of interest to our audience.

John Trudell: I stayed on the reservation until I was about five or six, and then my family moved. I went back in 1961, when I was fifteen, I think. I stayed there until the summer of 1963 and I joined the navy and I left. I stayed in the navy four years. After I got out of the navy, I went to work as a shoe salesman. That lasted about four months, and then I quit to go to school, which I was doing when the Alcatraz movement took place. I dropped all my studies and moved up here so I could work on this.

AS: What were you studying at the time?

JT: Radio and television programming and production.

AS: It's fortunate we ran into you.

JT: Yes. I find this to be much more satisfying than sitting in school learning. Time to put into practice a little of what I picked up the last couple of years.

AS: How old are you, John?

JT: Twenty-three.

AS: You have a family, I understand.

JT: Yes, I have two little girls, and we're expecting in August.

AS: Are all of you living on the island?

JT: Yes, we've been living on the island since I guess about the 5th of December. I came up the last weekend in November to check the situation out, and I liked what I saw so I went back to San Bernardino and got my family. I just dropped everything there and relocated up here.

AS: Our audience has come to understand that Alcatraz is kind of barren—there is not much in the way of food or water, electricity is intermittent at best, and there's no telephone service and so on. You said something to me some time ago about the fact that for a reservation it's actually in very good condition.

JT: Yes, I know the GSA [General Services Administration] and the Public Health Department made the statement one time that they were going to have to rip us off the island because of improper sanitation facilities. If they're going to take us off the island for that, then I think they're going to have to improve conditions on the reservations, because although we have no central heating and we haven't got any steady electricity here, water is not a problem. When the army stops giving us water, then we're going to run into some hassle. Even with all these problems, it's the same as being on the reservation.

I've had people say that it's really courageous for you people to be doing this. We've all been through it before, just in a different place. It's the same game—it just has a different name now. Alcatraz is nothing but a rock to many people, but it's our rock. We can develop it and we can make things work for the Indian people, so it's more than just a rock to us. It's maybe a stepping stone to a better future—we would like to think of it as [one].

AS: I've heard many Indians now saying that the Alcatraz invasion is the Alcatraz movement. What does that mean?

JT: With Alcatraz, we have a chance to unite American Indian people as they've never been united before or never had the opportunity to do. Because when we were still fighting with the United States government, the government put a policy in effect that they would break down the Indian people so that they would never become a threat, never be able to fight the United States government again. Part of this program was to break down the Indian nations, break down the tribes, break down the families, break down the individuals, give us nothing constructive to do, and then time will take care of the rest.

AS: Also to exploit the divisions between the tribes.

JT: Yes.

AS: The fact that there were so many small groups…

JT: It's just pitting man against man and family against family, tribe against tribe, because there are many tribes in the United States, and for many of us the East Coast Indians didn't know anything about the plains Indians or a thing about the West Coast Indians. They have many culturally different backgrounds, just [due to] the way we are situated geographically. It's been easy for the government once they accomplished this, taking children away from their families and sending them off to school, so [they] broke down the family unity, tore down our religion—took everything we had except our pride in being Indian, something they can't take.

I'd like to think we've never been defeated. Maybe we've been stopped for a while, but we haven't been defeated. I think this is one way of showing you can kick a dog so long, and then the dog's either gonna die or get up and bite you, and we're not ready to die.

AS: I think many people in our audience may not realize, if they're not scholars in history, that many, many battles that took place—armed confrontations between Native Americans on the plains, for example, and United States Calvary, as they were called then—ended in Indian victories.

JT: Especially around the time that Custer got what he had coming to him.

AS: That's right, Custer had it coming.

JT: The Sioux people fought three major battles in that period of time with the United States troops and won all three of them.

These battles were predicted by some of the visionary men of the tribe. I've done some reading on battles of the past and various other Indian and white dealings. Like with the Sand Creek Massacre that Reverend Colonel Chivington led, the army had a great policy of killing women and children, but if the man had the gun, then stay away from the man. No sense in me getting killed while I'm killing you…. Basically, they would come up in the mornings, get the Indians by surprise—basically get the women and children, stop the reproductive cycle. I believe this is a form of genocide, but they did it then. They waged war on our women and children.

AS: This was, by the way, an articulated policy of the United States government. There was a policy of extermination.

JT: Yes, the United States government. Well no, I can't say the United States government on this other deal, but various governments—territorial governments or whatever—used to pay bounty for Indian scalps. In this area, in the western area, the bounty ranged [so that] if you got a woman or a child you got more money. On the East Coast, in the early 1700s it was something like forty pounds for a man's scalp, and forty pounds in those days—that's a lot of heavy bread.

AS: A lot of money.

JT: Yes.

AS: Well, without dwelling on the past, this time it'll be much more, I'm sure, covered in later programs from Alcatraz. Tell us about some of your plans and hopes for the Radio Free Alcatraz project. What do you think we can do? You spoke about some unification possibilities for the future uniting [of] Indian people.

JT: Well, with Radio Free Alcatraz and with the island itself, we have a chance here of getting urban Indian people and reservation Indian people active. This island and the radio project on the island—this doesn't just belong to the people on the island. It belongs to Indian people. If they have any governmental problems, like where their water rights are being taken away from them or their land, we want them to let us know or come out here and they can speak. We've got to get this information out. We've never had a chance to do this before.

One of my own personal foes is the Bureau of Indian Affairs. I dislike that agency very much, because of what they have done to Indian people in the past and what they're continuing to do. I think many of these things have to be exposed. We've been an invisible people for too long. To be completely truthful about it, the government did to us what the American public let them get away with. They just kind of turn their backs so the government can do these things to us.

Well now we're going to try and stop all that. We're going to try and change it, because we've been around for a long time and our numbers are increasing. I'd say we are going to be around for quite a while to come yet and we might as well have a good life while we're here, just as well as the next man.

AS: You talked to me about a possible tape network or tape service that could be conducted to involve reservations as well as Indians in urban areas. Can you tell us a little bit about what you might plan on that?

JT: Yes, with the tape service, we would be doing tapes on the island, taping talks with leaders or people there, on various important things and items that the reservation should be aware of…but they don't have access to this through other media. We're going to put this on tape and send it to the reservations so that they can get this information also. What they can do for us in return is they can put their problems on tape. Any information they have for us they can send back to us because with the station we hope to bring out, as I stated earlier, governmental problems. We want to renew our cultural awareness and we want Indian poetry and the songs and the old stories because no matter how people have put us down we had a lot on the ball and there's a lot of beauty in some of the old stories. The beauty is in the Indian philosophy, because ours was a philosophy of "I'll respect my brother's dream and he'll respect mine."

Vine Deloria once said that…the people in the Western Hemisphere had a civilization of wisdom and Europeans [who] came and took from us had a civilization of knowledge. Well, look what knowledge has gotten us. Maybe we ought to get back to a little bit of wisdom.

AS: Knowledge as we know is power, and power is not necessarily wise.

JT: People are still fighting wars, still taking things that don't belong to them. Power brings on more greed. What do we need with greed? That won't solve any problems.

AS: Are there things, John, that our listening audience might be able to do to assist? For example, you asked on the air for people to write to you. I think that would be helpful, and perhaps we ought to tell them to do that again.

JT: If anyone has any questions, and I will try to answer these letters personally…I will answer over the air as many as possible, because if anyone's interested, we want them to have the information that they would like to have. Also, for support, all people have to do is—if you can't give money or other materialistic things—write a letter. Write a letter to President Nixon or to [Secretary of the Interior Walter] Hickle or to your congressman. Just write a letter and say we support what is going on on Alcatraz.

AS: Thank you, John Trudell. This has been tonight's program, Radio Alcatraz. On succeeding evenings, you will be able to hear live from Alcatraz John Trudell, many other Indian people, visitors to the island who come from reservations from around the country, spokesmen from various tribal groups, to discuss Indian history, Indian culture, and Indian affairs.

We look forward to those programs and hope they may continue for quite some time. John, thank you for coming in and talking with us.

JT: Oh, yes, thank you.

Edited transcript of this radio broadcast transcription printed with permission from the Pacifica Radio Archives.

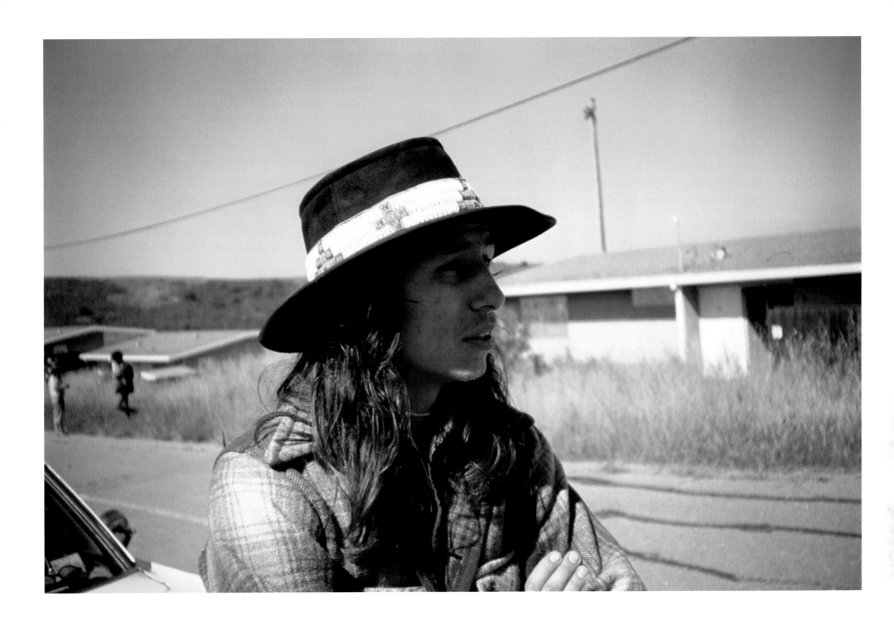

above: **John Trudell, June 14, 1971**

Address to the World Congress of the International PEN Club

Václav Havel (1994)

Ladies and gentlemen, dear colleagues:

Several times in my life I have had the honour of being invited to a world congress of the International PEN Club. But the regime always made it impossible for me to attend. I had to live to the age of fifty-eight, go through a revolution in my country, become the nation's president, and see the World Congress held in Prague to be able to participate in this important event for the first time in my life. I am sure you will understand, therefore, that this is a very moving moment for me.

I also know you will understand that I must welcome you all to Prague first and foremost as a colleague who is delighted to be able to meet here with so many authors I have long held in high esteem, and only secondarily as a representative of the Czech Republic, which has the honour of hosting your gathering. I trust that your presence will introduce important spiritual and intellectual stimuli into this sometimes too materialistic and somewhat provincial setting, and that for a while at least you will help draw the attention of my fellow citizens to matters that transcend the narrow horizon of their everyday cares and concerns.

To you, then, I extend the wish that your stay here be a pleasant one, that your debates be lively and fruitful, and that you might also find some time to explore this magic city, whose streets were once trod by fascinating people like Rabbi Loew, Tycho Brahe, Johannes Kepler, Arcimboldo, Gustav Meyrink, Franz Kafka, Franz Werfel, and Jaroslav Hasek.

This congress is to be devoted to the theme of tolerance, and it will therefore have to deal with the theme of intolerance as well.

National, racial, religious, social, and political intolerance has been the lot of humanity for millennia, and it is unfortunately deeply rooted in the human psyche, and in the spirit of entire human communities. The problem is that like many other things, this phenomenon—now that we live in a world with a single global civilization—is far more dangerous than it has ever been before. The time when conflicts between peoples, empires, cultures, and individual civilizations had only local impact is gone forever. On today's overpopulated planet, girdled by dense networks of political and economic relations, and of information and communication links, everything that happens now inevitably touches and concerns us all far more and in far different ways, than it ever did before. The many horrors of the world today have an impact on us that is not just moral—since these are evils done by some human beings to others—they touch us more and more in an almost physical sense as well, as something that directly threatens us. Yes, we live in a remarkable time. It is not just that we now learn, almost instantaneously, about all the deeply shocking atrocities that take place in the world; it is also a time when every local conflict has the potential to divide the international community and become the catalyst for a far wider conflict, one that in many cases is even global. Who among us, for instance, can tell where the present war in Bosnia and Herzegovina may lead, to what tragic confrontation of three spheres of civilization, if the democratic world remains as indifferent to that conflict as it has been so far?

This alarming state of affairs has not yet come home to a large part of humanity, particularly those who do not yet feel directly threatened by any of the contemporary ills of civilization. Nevertheless, it is precisely this state of affairs, when human malice ceases to be a mere assault on our feelings and becomes a direct threat to us, that can lead to a reawakening in people of a sense of responsibility for the world. But how can that change in awareness be brought about? How can people be made to understand that every act of violence against individuals ceases to be just a reason to feel compassion, and

becomes a real act of violence against us all? How can it be explained to politicians and the public that a short-sighted focussing on purely personal or group interests, on immediate interests, is only paving the road to hell?

I think that in these matters, writers and intellectuals can and must play a role that only they can fill. They are people whose profession, indeed, whose very vocation is to perceive far more profoundly than others the general context of things, to feel a general sense of responsibility for the world, and to articulate publicly this inner experience.

To achieve this, they have essentially two instruments available to them.

The first is the very substance of their work—that is, literature, or simply writing. A deep analysis of the tangled roots of intolerance in our individual and collective unconsciousness and consciousness, a merciless examination of all the frustrations of loneliness, personal inadequacies and the loss of metaphysical certainties that is one of the sources of human aggression—quite simply, a sharp light thrown on the misery of the contemporary human soul—this is, I think, the most important thing writers can do. In any case, there is nothing new in this: they have always done that, and there is no reason why they should not go on doing so.

But there is another instrument, an instrument that intellectuals sometimes avail themselves of here and there, though not nearly often enough in my opinion. This other instrument is the public activity of intellectuals as citizens, when they engage in politics in the broadest sense of the word. Let us admit that most of us writers feel an essential aversion to politics. We see entering politics as a betrayal of our independence, and we reject it on the grounds that the job of the writer is simply to write. By taking such a position, however, we accept the perverted principle of specialization, according to which some are paid to write about the horrors of the world and human responsibility, and others to deal with those horrors and bear the human responsibility for them. It is the principle of a rather doubtful division of labour: some are here to understand the world and morality, without having to intervene in that world and turn morality into action; others are here to intervene in the world and behave morally, without being bound in any way to understand any of it. It reminds me of the kind of specialization that happens among scientists: some invent chlorofluorocarbons, others investigate the consequences of the holes in the ozone layer that the hydrofluorides cause. A writer with an aversion to politics seems to me like a scientist studying the holes in the ozone who is not bothered by the fact that his superior is inventing hydrofluorides.

I once asked a friend of mine, a wonderful man and a wonderful writer, to fill a certain

political post. He refused, arguing that someone had to remain independent. I replied that if you all said that, it could happen that in the end, no one will be independent, because there won't be anyone around to make that independence possible and stand behind it.

In short, I am convinced that the world of today, with so many threats to its civilization and so little capacity to deal with them, is crying out for people who have understood something of that world and know what to do about it to play a far more vigorous role in politics. I felt this when I was an independent writer, and my time in politics has only confirmed the rightness of that feeling, because it has showed me how little there is in world politics of the mind-set that makes it possible to look further than the borders of one's own electoral district and its momentary moods, or beyond the next election.

I am not suggesting, dear colleagues, that you all become presidents in your own countries, or that each of you go out and start a political party. It would, however, be wonderful if you were to do something else, something less conspicuous, but perhaps more important: that is, if you would gradually begin to create something like a world-wide lobby, a special brotherhood or, if I may use the word, a somewhat conspiratorial mafia whose aim is not just to write marvellous books or occasional manifests, but to have an impact on politics and its human perceptions in a spirit of solidarity, and in a coordinated, deliberate way—if necessary with the kind of personal commitment Susan Sontag showed in Sarajevo—and in many visible and invisible ways, to help open its eyes.

Politicians, at least the wiser ones, will not reject such activity but, on the contrary, will welcome it. I, for instance, would welcome hearing, in this country, a really strong and eloquent voice coming from my colleagues, one that could not be ignored no matter how critical it might be, a voice that did more than merely grumble, or engage in esoteric reflection, but became a clear public and political fact.

Dear colleagues, if it seems to you that I have used, and perhaps abused, this platform to deliver a small sermon, I ask you to forgive me. And if I have asked something of you that you have already been engaged in over the years, I apologize all the more.

Let me conclude with one final plea: do not fail to raise your common voice in defence of our colleague and friend Salman Rushdie, who is still the target of a lethal arrow, and in defence of Nobel Laureate Wole Soyinka, who is unable to join us here because his government prevented him from coming. I also beg you to express our common solidarity with all Bosnian intellectuals who have been waging a courageous and unequal struggle on the cultural front with the criminal fanaticism of the ethnic cleansers, those living examples of the lengths to which human intolerance can eventually go.

I thank you for your attention, and wish your congress every success.

November 7, 1994
Prague

opposite: Václav Havel, March 1997

Contributors

Ai Weiwei is among the world's most celebrated contemporary artists and one of China's most outspoken critics. His sculptures, photographs, installations, and public artworks often repurpose recognizable Chinese forms and materials to address today's most pressing contemporary social concerns. An outspoken human rights activist, Ai was arrested by Chinese authorities on April 3, 2011, and held incommunicado for eighty-one days. Since his release, he has been prohibited from traveling abroad and subjected to ongoing government surveillance. Despite these restrictions, Ai continues to extend his practice across multiple disciplines, using exhibitions and social media to communicate with a global public. *@Large: Ai Weiwei on Alcatraz* is Ai Weiwei's largest site-specific project to date.

Cheryl Haines is principle of Haines Gallery and founding executive director of the FOR-SITE Foundation, both organizations located in San Francisco. For over twenty-five years, Haines has developed exhibitions and site-specific public programming that has advanced the discourse on art about place. Haines's dynamic curatorial stance presents challenging and provocative exhibitions by artists who explore cultural and environmental issues through a wide range of media. Over time, this position has expanded to include producing public, site-specific commissions on a national scale. Haines is the curator of *@Large*.

Maya Kóvskaya, based in Delhi and Beijing, is an award-winning political cultural theorist, art critic, curator, and independent scholar with two decades of combined experience in the Chinese and Indian art and cultural worlds. She has written extensively about contemporary art and the changing topologies of the public sphere and is currently conducting research for a book of "epistemological investigations" into the performative politics of art viewed in relation to ecology in Asia. Kóvskaya holds a PhD from the University of California, Berkeley.

Hans Ulrich Obrist is one of the art world's leading public intellectuals. He is co-director of exhibitions and programs and director of international projects, Serpentine Gallery, London. Previously, he was curator of the Musée d'Art Moderne de la Ville, Paris. Since 1991 he has curated over 150 exhibitions internationally. A prolific writer and interviewer, Obrist has produced numerous publications forming an encyclopedia of contemporary art and ideas from the 1990s onward. His recent publications include *Ai Weiwei Speaks* (Penguin, 2011) and *A Brief History of Curating* (JRP|Ringier, 2008).

David Spalding is an internationally recognized writer, curator, and editor based in San Francisco. Over the past decade, he has published over one hundred texts on contemporary art, contributing regularly to monographs and periodicals such as *Artforum* and *Frieze*. His most recent book projects are *King of Kowloon: The Art of Tsang Tsou-choi* (Damiani Press, 2013) and *Doublethink: Kata Legrady and Wang Luyan* (Pékin Fine Arts, 2014). Previously, Spalding was curator at the Ullens Center for Contemporary Art in Beijing.

Credits

This book has been published on the occasion of the exhibition *@Large: Ai Weiwei on Alcatraz*, on view from September 27, 2014, to April 26, 2015.

The exhibition is presented by the FOR-SITE Foundation in partnership with the National Park Service and the Golden Gate National Parks Conservancy.

Library of Congress Cataloging-in-Publication Data available.

Trade ISBN: 978-1-4521-4276-0
FOR-SITE Foundation ISBN: 978-1-4521-4275-3

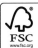

MIX
Paper from responsible sources
FSC® C016245
www.fsc.org

Manufactured in Canada.

Editor: David Spalding
Designer: Public, San Francisco
Copy editor: Mark Chambers
Research: Tyler Reed

10 9 8 7 6 5 4 3 2 1

FOR-SITE Foundation
49 Geary Street, Suite 205
San Francisco, CA 94108
www.for-site.org

Chronicle Books LLC
680 Second Street
San Francisco, California 94107
www.chroniclebooks.com/custom

Image Credits

Photographs included in this book come from a variety of sources and are either copyrighted or may have other use restrictions. Please contact the individual or archive cited with use-related questions.

All historical photographs of Alcatraz are from the Golden Gate National Recreation Area/Park Archives and Records Center unless otherwise noted.

All images of artworks by Ai Weiwei courtesy Ai Weiwei Studio unless otherwise noted.

Additional Image Credits

Ben Fash, courtesy Golden Gate NRA: pp. 4–5, 50–51, 95 (top), 96; Robert Divers Herrick, courtesy FOR-SITE Foundation: pp. 8, 27, 42, 61, 62–63, 64, 66, 69, 70–71, 82–83, 85, 86–87, 89, 90, 91, 99, 100–101, 102, 103, 104, 105, 107, 113, 114–115, 118, 121, 138–139; Monique Deschaines, courtesy FOR-SITE Foundation: p. 9; Ben Blackwell, courtesy FOR-SITE Foundation: p. 11 (left); Jan Stürmann, courtesy FOR-SITE Foundation: pp. 15, 16, 19, 52–53, 88, 112, 128, 130–131, 135 (left), 190–191; Eric Gregory Powell, courtesy Ai Weiwei Studio: pp. 12, 65, 67, 122–123, 137, 153; National Archives and Records Administration Collection: p. 20; Collection of the Mennonite Library and Archives, Bethel College, North Newton, Kansas: p. 21 (left); Weed/McPherson Family Alcatraz Photograph Collection, courtesy National Park Service/Golden Gate NRA: p. 22 (right); San Francisco Public Library Collection: p. 24; Courtesy the artist and Haines Gallery: p. 37; © UN Photo: p. 47 (all photos); Betty Wallar Collection, courtesy Golden Gate NRA, Park Archives: pp. 55, 57; Carl Sundtrom Alcatraz Photograph Collection, courtesy Golden Gate NRA, Park Archives: p. 56; Alison Taggart-Barone, courtesy Golden Gate NRA: pp. 58, 92–93, 95 (bottom); © Jock Fistick: p. 108; © Robert Alexander/Getty Images: p. 109; Wikimedia Commons/Robert N. Dennis collection of stereoscopic views, New York Public Library: p. 110; Courtesy USC Libraries Special Collections: p. 111; Don DeNevi Research and Manuscript Collection, courtesy Golden Gate NRA, Park Archives: p. 117, 154; © Sergey Ponomarev/AP: p. 125; © Marcelo Montecino/Flickr Vision/Getty Images: p. 127; © Bettmann/CORBIS:

pp. 133, 183; Sheppeard Alcatraz Collection, courtesy Golden Gate NRA, Park Archives: p. 134; Phil Dollison Alcatraz Collection, courtesy Golden Gate NRA, Park Archives: p. 135 (right); Philip Grosser Papers, courtesy Jean Grosser: pp. 159, 160; © Don Cravens/The LIFE Images Collection/Getty Images: p. 164; © Bill Hudson/AP Photo: p. 167; © Universal History Archive/Getty Images: p. 169; © Bill Ray/The LIFE Picture Collection/Getty Images: p. 171; © Ilka Hartmann: pp. 172, 174, 179; Bob Kreisel Indian Occupation Collection, courtesy Golden Gate NRA, Park Archives: p. 175; Courtesy Elvin Willie: pp. 176, 178; Wikimedia Commons, Username: Tewy: p. 180; © Sovfoto/UIG via Getty Images: p. 184; © Chris Niedenthal/The LIFE Images Collection/Getty Images: p. 186; Henrik Kam: pp. 190–191

Text Credits

All artwork and site descriptions: Juliet Clark

pp. 29–45: "Ai Weiwei @Large on Alcatraz" essay © Maya Kóvskaya.

p. 125: Pussy Riot's "Virgin Mary, Put Putin Away (Punk Prayer)" first appeared in *Pussy Riot! A Punk Prayer for Freedom* (New York: Feminist Press, 2013). Reprinted with permission from Maria Alyokhina and Nadezhda Tolokonnikova.

p. 126: Víctor Jara's "Manifesto" first appeared in Martín Espada, ed., *His Hands Were Gentle: Selected Lyrics of Víctor Jara* (Middlesbrough, UK: Smokestack Books, 2012). Words © Joan Jara and Amanda Jara, English translation © Joan Jara and Adrian Mitchell. Reprinted with permission from Smokestack Books.

p. 129: Lyrics and English translation of Lolo's "Raise the Tibetan Flag, Children of the Snowland" courtesy High Peaks Pure Earth. For more information, see http://highpeakspureearth.com.

LEGO® is a trademark of the LEGO Group of companies.

following: Ai Weiwei, *Trace*, 2014 (detail); installation: LEGO plastic bricks; part of *@Large: Ai Weiwei on Alcatraz*, Alcatraz Island, 2014–2015

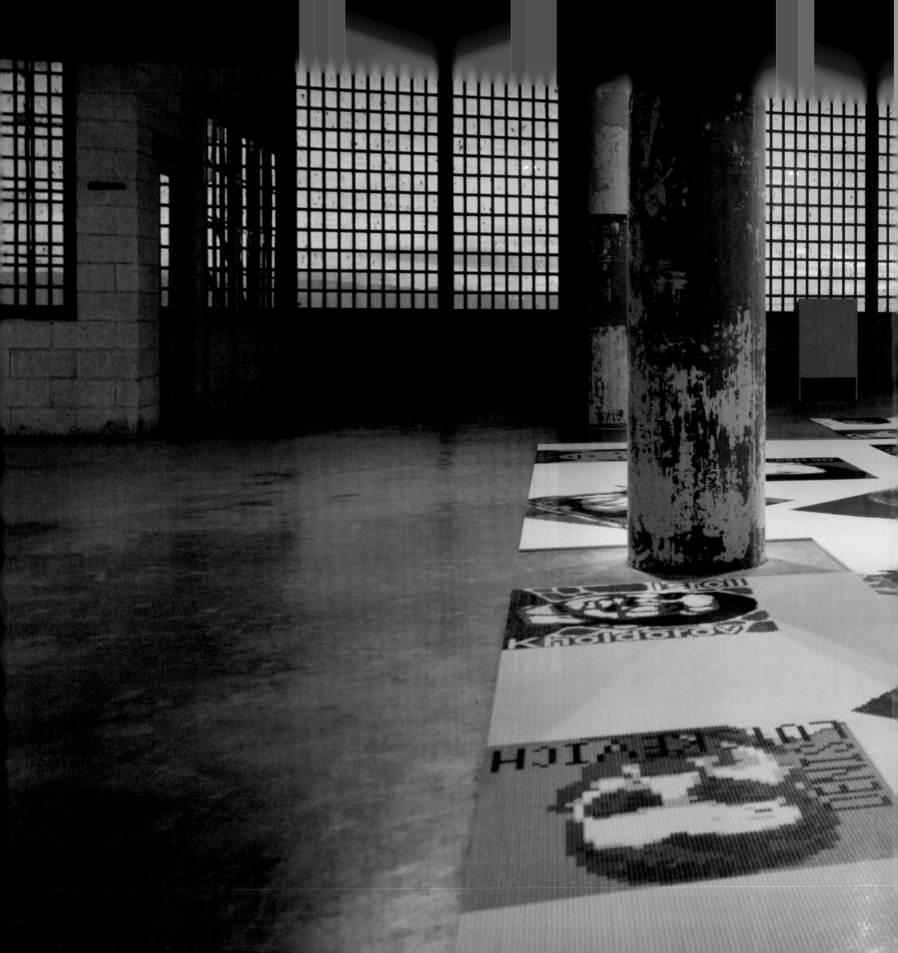